Roland and Sabrina Michaud

The Orient in a Mirror

With 160 colour illustrations

Thames & Hudson

For Jean-Claude Michaud

A book based on the theme of mirrors ought simultaneously to reflect and to encourage its readers to reflect. The aim of *The Orient in a Mirror* is to reflect images of sheer beauty – Beauty as an absolute – while reflecting or meditating upon the culture and civilization of Islam. If we accept, like the Prophet Mohammed, that 'God is beautiful and loves beauty', then it must be true that the only beauty is absolute Beauty. Plato asserts that 'beauty is the splendour of truth' and for anyone who is in doubt the Arabic poet suggests quite simply that they 'contemplate a red rose'.

The traditional Muslim greeting 'As Salam aleykum' (Peace upon you) elicits the response 'Aleykum as Salam' (Upon you Peace), in which the words of the response mirror those of the greeting. What follows then is a dialogue. In *The Orient in a Mirror*, the dialogue is between art and life, between past and present; it is between two modes of expression – the pictorial communication of early Oriental miniaturists and the creative output of two contemporary photographers with a passion for the Orient. Despite cultural and technical differences, a strong sense of continuity, of convergence and identity emerges.

The images in this book present certain aspects of Islamic life and enable us to ponder upon their spiritual foundations. As images, they are inevitably limited, but they become considerably more interesting in the way they confront one another, each image enriching and completing the next. They ask questions and offer answers. As in a game, they pass the ball back and forth, sending back echoes more intensely alive through their proximity. The photographs (charmingly known in Arabic as 'drawings done by light') cover a period of almost half a century and the miniatures accompanying them span some eight hundred years of history. Geographically, they represent the entire Islamic world, from its heart in Arabia to Morocco in the west and China in the east. In looking for similarities, we have sometimes started with the miniature, sometimes with the photograph. Occasionally, we have photographed miniatures for which we have never been able to find an equivalent in everyday life, just as for some of our most beautiful photographs we have never been able to find a pendant in painting. The two have tended to be photographed at different times and in certain instances with an interval of many years. The most

extreme example relates to the photograph on page 96, which illustrates a barber bleeding his client in a country souk in Morocco during the summer of 1958. The Arabic miniature facing it shows a doctor engaged in blood-letting in front of a group of onlookers. This miniature is in the Institute of Oriental Studies in St Petersburg and was photographed in 1994 – the two photographs are separated by an interval of thirty-six years. More astonishing, the miniature was painted in Iraq in around 1240, in other words, 718 years before the first photograph was taken.

Our approach has inevitably been slow, but it has been blessed with a number of happy coincidences, which we describe as 'gifts from heaven'; the coat images on pages 122 and 123 are a good example as they were photographed only two months apart. Some of these photographs could never be retaken: Mahmad Niyaz (page 149) has departed this world, as has Mohammed Ben Harbit (page 100), the last lute-maker in Fez. The Dhow Port in Bombay (page 41) no longer exists and the Tashqurghan bazaar in Afghanistan, where several photographs of artisans were taken (pages 69, 74, 79), was completely destroyed during the Soviet invasion of Afghanistan. Finally, one small point needs clarifying: some of the mirrors act as mirrors not in a literal but a figurative sense. An ordinary Turk with nationalist leanings will be shocked to see a man selling donkey saddles in an Afghan bazaar (page 149) facing an image of Sultan Mehemet the Conqueror, one of the greatest sultans of his country. Yet, this mirror offers a religious truth – in the spiritual hierarchy, an artisan may climb higher than a sultan.

I have been fascinated for many years by the theme of mirrors. While playing truant from school with my brother Jean-Claude in Persia in 1955, I was amazed to discover that the Palace of Forty Columns in Ispahan has in fact only twenty columns; the number is doubled because each is reflected in the water. Years later, on a visit to the Taj Mahal in Agra, for me the most moving monument in the world, I learned that the buildings facing one another symmetrically on opposite sides of the mausoleum are each called a *djawab*, meaning 'response'.

My wife Sabrina is as passionate as I am about pictures and what they tell us about different civilizations, and we both ask a great many questions. Once we were acquainted with the enchanting universe of the Persian miniature, with its light, its colours and its transparency, we were eager to move beyond this virtual reality and engage with something concrete. We

wanted to feel, to taste, to touch. We were desperate to see with our own eyes whether the Orient encapsulated by the miniatures still existed. So, sacrificing everything to this all-consuming quest, I gave up my post as an English teacher at the Lycée de Janson de Sailly and my wife ended her position as a hostess in a private club, and we set off for the East.

Our first trip across Asia by car lasted four and a half years without once returning to France. The journey was a revelation and taught us that the true luxury of our era is not money but the opportunity to take our time. We learned that despite the gulf separating the idealized world of the miniatures from the reality of daily life in the East, something of the past, something essential and profound, endures. It was this something we hoped to capture in our photographs and we set to work with enthusiasm, determined to bear witness to the very best aspects of tradition. We focused on similarities rather than differences and discovered that we shared the same vision. Sabrina became my collaborator, and so began an enriching journey across Asia during which we were able to provide a joint testimony to all that we experienced and we became a kind of privileged 'mirror couple'. The centuries gradually slipped away and past and present began to merge. We set ourselves the task of creating images that abandoned all reference to time. Space too began to lose its reality since the same scenes occur everywhere, in the East as in the West, and the same emotions are experienced universally. It seems to us that the images imprinted on our minds from childhood are so powerful that we have no choice but to reproduce them. Photography does not create, it simply restores; but with God's help and with a great deal of diligence on our part, our best photographs end up coinciding with our dreams.

The mirror is a symbol of richness and of infinite possibilities. It is even the symbol of symbolism. Its primary function is to reflect our image, permitting us to see ourselves. A mirror is therefore an instrument of knowledge – the word 'speculation' (meaning 'supposition' or 'theory') is related to the Latin word for mirror, *speculum*. Self-knowledge was viewed as the basis of wisdom for Socrates and the Ancients generally. Functioning in an active and a passive capacity, the mirror invites us to experience a reciprocal consciousness. 'The believer is the mirror of the believer', states a famous hadith. Prayer is a mirror, a secret appeal, an exchange between the Creator and His created: 'Remember Me. I will remember you.' A mirror thus enables us to

pass from one plane to another. The Koran specifies, 'He who knows himself knows the Lord'. A mirror expresses our duality composed of light and dark, but if it is the light we seek, we must struggle to reach it. This is the deeper significance of the jihad, meaning 'conflict', the war we wage against the darkness in ourselves. We must fight the dragon whose seven heads – corresponding to the seven divisions of hell – represent pride, covetousness, lust, envy, anger, avarice and hatred (the counterparts of Christianity's seven deadly sins).

The Muslim mystics, or Sufis, regard the human heart as the organ of intuition capable of outstripping reason and compare it to a mirror that has become dirty and, as it were, blind. The heart must be cleansed of its rust and impurities; it must somehow be polished so it can reflect the rays of the divine Sun. The role of the spiritual master is to help his disciple to purify his own heart. Only after such purification is the heart capable of discrimination. 'If you are thirsty and you drink water from a cup, it is God whom you see in the water. He who is not a lover [of God] sees his own image in the water', says Rumi in his *Rubáiyát*.

The fact is we only see what we are capable of seeing and the majority of us are blind. There is a story that tells how the caliph Harun al Rashid in Baghdad, hearing of the great love of Majnun for the celebrated beauty Leila, decided that he would like to see for himself the lady in question. He ordered Leila to come to his palace, but found nothing extraordinary about her beauty. He then summoned Majnun and said to him, 'This Leila whose beauty has so unsettled you is really not so very beautiful'. Majnun replied, 'Leila's beauty is faultless; it is your eye that is at fault. To see how beautiful she really is, you need to have Majnun's eye.' The goal of every mystic or pilgrim or seeker after truth is to look beyond appearances or, as Frithjof Schuon so admirably puts it, to contemplate the 'metaphysical transparency of phenomena', the absolute. In a sacred hadith God declares, 'I was a hidden Treasure. I wished to be known. I created the world.' Now this world, the Sufis tell us, is like a mirror. Mahmud Shabestari develops this theme in the thirteenth-century *Mystic Rose Garden*:

'Know that the whole world is a mirror,

in each atom are found a hundred blazing suns.

If you split the centre of a single drop of water,

a hundred pure oceans spring forth.

If you examine each particle of dust,

a thousand Adams can be seen…

A universe lies hidden in a grain of millet;

everything is brought together at the point of the present…

From each point along the circle

thousands of forms are drawn.

Each point, as it revolves in a circle,

is at times a circle, at others a turning circumference.'

Creation may be seen as the mirror of God. In *The Wisdom of the Prophets*, Titus Burckhardt's translation, with notes and commentary, of the work by Ibn Arabi, we read, 'Man is to God [*al haqq*] as the pupil is to the eye [the pupil is called in Arabic "the man in the eye"], the pupil being the means of our vision; for through him [that is, universal Man] God contemplates His creation and dispenses His mercy upon it.' By contemplating God or Truth or Beauty, we see ourselves and by contemplating us, God contemplates his names. According to a well-known hadith, 'God has ninety-nine names, a hundred minus one, for He, the Uneven Number (the One and Only) likes (to be called by these Names) one by one: whoever knows the ninety-nine names enters Paradise.' The hundredth name is said to be ineffable, known by him alone to whom God communicates it. It seemed to us appropriate, therefore, that there should be ninety-nine mirrors in this book, in memory of the ninety-nine beads of the Muslim rosary, which symbolize these beautiful names of God.

We have supplemented the visual images with quotations taken principally from the Koran and *The Thousand and One Nights*, but also from handwritten scripts. Arabic calligraphy, one of the finest expressions of the spirit of Islam, plays repeatedly on the mirror motif and consequently has its place in this book. The life of every Muslim is suffused by a love of the Arabic letters, and at the age of four years, four months and four days every Muslim enters symbolically into the world of learning. This is when he learns the *basmalah*, the form of words that runs 'bismillahi-r-rahmani-r-rahim' – 'in the name of God the Merciful, He who shows Pity'. This dedication is spoken prior to every sacred recitation and every ritual, even profane, act. The child, dressed for the ceremony as a young bridegroom (and known in India and Pakistan as the fiancé of the *bismillah*), receives thereby an official initiation into the universe of the Sacred Book.

We may variously describe ourselves as poets, travellers and photographers, but what we remain before all else are created beings asking ourselves the eternal questions about the meaning of life and our place in the cosmos. The mirror offers a response to our interrogations.

We are overawed by the beauty of Creation and the meaningfulness that things assume in the light of tradition. We are constantly moved and amazed by such beauty. We see ourselves as eternal lovers seeking to capture reflections of divine beauty, and convinced that love, lover and beloved are ultimately one and the same.

Roland and Sabrina Michaud

The Orient in a Mirror

To begin with, two stories: one solemn, the other frivolous. They reflect mutually, each in the other; like the play of light from two mirrors, they are two refracted images.

First, the meeting between Averroës and Ibn Arabi, according to tradition. The former is the master of physical science. The latter, still young when the visit takes place, will become the master of metaphysical knowledge.

Averroës was the physician; it was he, for Europe, who founded rationalism and who 'composed the commentary of Aristotle' – 'colui che il gran Commentario feo', as Dante will write. Moukh ud-Din Ibn Arabi was, for the Orient, the mystic, 'sheikh al akbar', the greatest of the sheikhs, the spiritual initiator.

With this harsh confrontation between two truths, the real value of existence would be revealed. Averroës – admired, famous and craftsman of a remarkable work – is curious to sound out the wisdom of young Ibn Arabi. Word of his intuitive vision had been spreading. Averroës thus rises upon seeing the young Ibn Arabi, who enters. Ibn Arabi can sense the generosity of Averroës, who warmly greets him with open arms and extends to him the wealth of his thought and the fruits of his science. He offers none other than the vast stores of positivity painstakingly acquired through a life of rigorous reflection, methodically conducted upon the basis of concrete experimentation with reality. To all this, Ibn Arabi responds, 'Yes'. Averroës breaks into a broad smile.

Then Ibn Arabi responds, again with a single word, 'No'. Analytically verifiable science, demanding of the facts it observes, plying its strategies, consuming tangible experience, is very possibly efficient and useful. To this science, yes. But it ensnares itself without understanding any other end than itself, and would presume its own authority as the ultimate discourse. In this case, it can only close itself off, confined to its own interior, imprisoned in its own positivity.

In the too rapid expression of joy Averroës exhibited, a certain complacency is revealed: intellectual comfort, with the hollow certitude of knowledge, fat and satisfied with itself. Thus, 'No'.

Averroës comments, again as tradition would have it, 'Within the space of this "yes" and this "no", my demise is lodged; and heads are wrenched from the neck, and souls from the body.' 'Wrenched from the neck', a brutal image for disarticulation quickly followed by a rupture. The mind is hurled into a vacuum, and this abrupt rift in the very night of reason eliminates all points of reference, all security.

The second story concerns a banquet. There were in Baghdad two viziers in the caliph's service. It was unclear which of the pair was the more refined, so superlative was the taste and splendour of each. The caliph's court urged him to put them to the test: he consented, and decided as the criterion that each should arrange a banquet. He who organized the most elegant display would be the ultimate authority on taste and etiquette. Thus the day arrived for the first of the competitors. Upon entering the banquet hall, what was to be found? Perfection itself. All without flaw: the guest selection, the quality of the menu, the embellishment of the hall uniting fresh elegance with brilliant lighting, all lacking any obvious artifice. There were poems recited, music and dance, edifying but friendly conversation, at times erudite, but always witty. All was truly perfect; to imagine a better presentation was impossible. The other contestant seemed doomed. Some already mourned his defeat. Others, more enterprising, commenced paying their court to the obvious victor.

One week later, the night of the second banquet arrived. There was at first extreme curiosity, then great surprise, finally a profound disappointment. Surprise and disappointment arose because of the nature of this second banquet: it was in every way, point by point, identical to the previous one. The same guests were invited, the hall's arrangement and decoration a repetition. Identical were the poems, the melodies and dancing. There were the same flowers and the same fragrances. Conversation took up again as a repetition of itself. Echoes and reflections. It was impossible for the frustrated guests to criticize the plagiarist; holding their tongues, they began to enjoy themselves.

After a short while, the caliph announced, 'Today's banquet has won. May the Lord's benediction follow its maker always, just as will our delighted appreciation for the exceptional moment he has given us, and which we shall forevermore savour in our memories.'

The stunned hall showed no reaction. What if the caliph spoke ironically? This supposition seemed likely, and, in fact, was the only possible explanation.

Finally, the great vizier came forth, urged on by the crowd, and dared ask, 'Oh great and illustrious caliph! In your unsparing justness, you perhaps wanted to laugh at the impertinence of this unlucky one, or else, in your boundless wisdom, you have seen what our eyes were not capable of seeing. If your limitless indulgence would accept to clear up this matter for us, please share the reasons for your choice.'

And the caliph responded, 'I do not know what to say, in truth, because the reason is subtle and avoids clear explanation.

'We had almost forgotten that moment we lived but a week ago. Now, this vizier's art has restored through a dreamlike repetition all the magic that had disappeared, all the evaporated perfume from the shattered flask. What occurred the other night simply occurred. But the reflection we saw this evening was a true act of creation: this reflection has tapped and actually restored our flow of happiness in its spontaneous perfection. In addition, it gave us three other treasures: memory, recognition and victory over the annihilation of the past. No success is sweeter than this!'

In more modern terms, the caliph announced that the first banquet was simply a natural fact; the second was fully and consciously a cultural phenomenon. 'Verweile doch, du bist so schön' – stop, wait – or again, 'endure, linger, for you are so beautiful', Goethe's Faust will say at the moment of accomplished perfection, before consenting to die. Goethe was among the first Europeans to love the Orient. Western and modern he remained, however, because the instant of which he speaks concerns not a feast, but a task. And, the *West-östlicher Divan* neglects so many things! The repetition that enchants the caliph recaptures the fortuitous event. Through the force of style, which re-creates, and memory, which recalls, that event is given eternal value. In so doing, it also preserves its freshness, fragrance and taste. Herein lies true art.

These two tales concern the juxtaposition of two realities mirrored: both in the dialogue between the two masters as with the two banquets in Baghdad. Here, as there, it is the refraction of the 'nearly similar', the slight slippage from the similar to the same, which creates and brings forth inner truth.

Captured by Roland and Sabrina Michaud, the pictures contained in this book reveal, through a play of mirrors, a reality that confronts itself. The past and present gaze at each other: permanent truths of Muslim civilization emerge. Faced with this confrontation, the viewer should especially beware of any nostalgia for the past, anachronistic folklore or resigned stagnation. Here, these facile clichés have never been more inappropriate. Such judgments have often been applied to those who sincerely love Islam, as, in fact, to Islam itself. At bottom, however, the movements and gestures presented here are not anachronistic, but outside time, ordinary and yet forever vibrant. These photographs must not be seen simply as beautiful, noble or humble (although they are most often all three at once); they rather recall, through their reflection, a permanence. In turn, this permanence is not the sign of stiffness due to decline and old age, but reveals a source of life and fidelity that, in the people, guarantees Islamic cultural identity.

Actually, the division does not come between the so-called traditional cultures and those that are modern. The true distinction concerns the separation between authentic cultures – lived, loved, those that give meaning to life, essentially fulfilled and without 'class' distinctions – and artificial or borrowed cultures. People of these latter wear culture as a coat, from the outside; they are stereotypes of escapism, even if they do benefit from an enormous 'mass media'.

Sabrina and Roland Michaud have looked at the Orient with lively and life-giving eyes. They have loved it for itself, in its essence and beyond all trends of fashion. It was, incidentally, their passion for Afghanistan that put me in contact with them. They have imported the most beautiful images of it.

I am reminded of how, in certain areas, marriage engagement festivities open with the waiting at the mirror. I am not sure if the custom exists elsewhere in the world of Islam, but I imagine that it does.

See her enter, the promised fiancée. Having never yet been seen, she appears for the first time. She advances, emerging from the distance and moves from the background, outside the field of vision, into the immediate, almost tactile, presence of the mirror. Emergence from darkness into light. Her discovery is thus indirect, by refraction. It is also intimate, the very closeness of a prolonged gaze into this mirror, placed just in front of the viewer. The surface may even be slightly steamed up from his breath as he waits. Through this cloudy surface, in these quivering reflections projected by the dancing candlelight, the emerging image becomes confused with his waiting face. There is a fusion of reflections. Meanwhile, the reflection that unites them also throws them back, blurred, into another space, but which is also their innermost being: refraction upon refraction, light upon light. Thus the great play of one and of two is already beginning. Play of mirrors, but also of civilizations, from one period to another. 'The double exile where the double melts into one.' Thus spoke Catherine Pozzi. She had resumed the tradition of the former Lyonnaise, Louise Labé. But, in turn, this dialogue echoes, in style and in spirit, blazons and courtly love from the *langue d'oc* and the *dolce stil nuovo*, just as the abundant Arab, Persian and Turkish languages recall Leila and Majnun, Yusuf and Zuleika, wild Andalusian love, and yet farther back, the Hedjazians, Yemenites and, still farther, the great hermetic and Platonic themes, until the very immemorial myths where the distinction between West and East is abolished.

It is thus not surprising that this theme is used in spiritual initiation as well. In certain Sufi orders, the first challenge of the initiation consists in a confrontation – solitary and silent – between the person and his shadow as seen in a mirror. The image is reflected in its identical, or rather, near identity.

Either the imperfections of this ancient mirror or its very depth, giving the smooth surface an opaqueness, returns a slightly pale, fuzzy image: the lines are imperceptibly effaced. While trying to recognize yourself in the captured image, it simultaneously flees and approaches you in its doubling of a repetitive displacement. Yes and no. Between this 'yes' and this 'no'. . . .

A confrontation between the self and the Self, between a fleeing identity, subject to death, and this other identity. . . . But how can we indicate the inconceivable? The masters of this, which we have isolated only through a reflection of it, call it respectfully the 'Sirr', secret or mystery, to avoid any vain attempt to name it.

'As in a glass darkly', Muslim tradition finds a Christian echo: 'He is revealed only in veils of shadow and light. For without this mercy, the world would instantaneously burst into flames confronted with His Face, and, as quickly, fall into ash.'

Reality cannot be grasped. It cannot be split apart or reduced down. Any conceptual philosophy is thwarted a priori. Only negatively are we permitted any expectation or hope (perhaps also any merit) that the veiling of being and the unveiling of the revelation take place. For mankind, only in the 'no' is the 'yes' made possible. This sighting through the shadows of a 'yes' and 'no' is expressed in Muslim art by means of the arabesque.

At first sight, the arabesque is a whimsical play of forms composed of traces of writing, organic motifs, angles and bends. Its splendour seems to be self-sufficient, like life itself. But beyond the lines, which melt and turn over one another, behind the colourful mirroring, close scrutiny reveals a stable geometry. The unfolding forms are actually constructed from simple figures – triangles, pentagons and others – that engender the lines and their folds infinitely. The physical marks seem to give way to abstract rhythm, in turn producing a secret proliferation, appearance and multiplicity. The projected, blended figures, seemingly whimsical in their meanderings, are based on stable relationships.

It is in this major way that 'the arabesque is the most ideal of all forms', as Baudelaire will write. Similarly, snow, beyond its soft, melting whiteness, is based on a crystalline structure of strict mathematical regularity, but which can be extended indefinitely.

The tracing of the arabesque is thus the shadow of a reality that transcends all description. By means of a network of lines, it provides the sensory impression of an absolute, like a metaphor for the invisible. An untenable claim, it would seem, but only the art through which Islam is expressed can make it.

Numerous examples of figurative art exist, it is true, but the art of Islam is not naturalistic. For the most part, Muslim art long ago turned away from the parody of creation, describing the exterior appearance of things. Muslim art does not concern itself with an imitative doubling of nature, a sterile repetition; rather it evokes the source of all creation. This evocation of the ungraspable can only be managed through indirect allusion. There is just enough form to animate space: thus the arabesque, the shimmer of glazed faience, the illumination. Just enough sound to make the silence vibrate: thus Oriental music.

The arabesque is therefore both respect for transcendency and a commentary on the infinite unfolding of creation – not as things in creation, but as its very principle as revealed in rhythm and in musical and visual harmonies. Form returns to life, music to sole musicality. Exegesis in theology or in Muslim law, commentary in philosophy, metaphor in literature: all these give witness to the same respect for ultimate reality as the arabesque or monody. Too often exterior analysts have interpreted these aspects of classical Islam as a lack of creative power in the artist, or even as a lack of originality. That completely misses the point.

The point is truth. Respect for that ultimate reality demands that we avoid reproducing the simulacrum, the exterior form, in order to better call up, from the interior – in the very spirit of the viewer, listener or thinker – the spark that allows us to perceive the source of all creation, truth or beauty. This spark, however short-lived, opens up into the absolute. The work of art strikes and flares up, translucence illuminating consciousness. 'No construction of concepts,' said Jalal ud-Din Rumi, 'I want an all-consuming fire.' Through arabesque, commentary or metaphor, the decisive imaginative and creative act belongs no longer to an individual author, but to whoever perceives and feels. Thus we understand the uniqueness of the poem: simultaneously an aesthetic, spiritual and moral vision that, in verbal economy, turns the reader toward himself. The place of tales also comes to light: verbally profuse, they abruptly invite one of the listeners to tell another story within the story, on to infinity. This endless setting in the narration tends to abolish the distance between author and listener, all the while multiplying – as in a play of reflections – the tale's shimmer and reverberation.

The thousand and *first* night. The importance of this extra night has been noted by the Lebanese poet Saleh Stetie, whose work holds a major significance, in French as in Arabic. The thousand and first night, in reality neither first nor last, signals the rupture with symmetry – a symmetry mortal in its undifferentiated regularity. This extra night signifies the skip outside of the established, the barely perceptible warp in the reflection that lets there 'be something rather than nothing'. In this way an asymmetry or imperfection is worked into fine tapestries. As opposed to a naturalistic theatre of actors, the various theatres that make use of shadows, puppets and masks also find their reason in this slight irregularity, not only in Islam but everywhere in the Orient. The theatre and its double. But in this refraction, which one is the double?

The Catholic Church's ancient mistrust of acting and its hesitation to bury an actor on consecrated ground stem from the same principle as the arabesque and shadow in Muslim art. God must measure souls in their truth. Man must not complicate the rules by pretending to be something he is not. Translated into humanistic terms, the same reticence appears in Montaigne, in his essay about the danger of imitating infirmity and illness. This reluctance can be explained by an ancient fear of suddenly being enslaved by the imitation, captive of the counterfeit. A counterfeit art: I have finally come upon the expression I have been looking for. It describes the naturalistic type of art. It counterfeits, gives depth and thickens contours; that, Islam rejects.

But suspicion of the figure 'which produces shadow' reaches far back in history, into the sensibility of the peoples who later transmitted Islam. Even the pre-Islamic Arab poems begin with the discovery of an abandoned camp. After this necessary introduction, the remainder of the poem belongs to memory, digging up the past. The text is in the past tense, or, more precisely, is translated by the future perfect. Right away, the poem is told as a poem, and only as a poem. It is literary re-creation and not pretense to create a world rivalling nature. Here again, it does not simulate; rather, it indicates. This is why the style is so important. It is precisely in this way, through style rather than juxtaposition, that Roland and Sabrina Michaud create the spark that, for a passing instant, lights up the eternal.

There is a continuity in these Central Asian landscapes, where, abruptly, the steppe and the garden meet. Here are the dreams of mankind: aridity and work have nurtured blossoms in the heart of the desert. These two adjacent scenes create a calligraphy, so frequent in these places where the object is inscribed into a background of drought.

There is a calligraphy here, in one of the images, to the point of showing how the written trace is produced with almost the same spirit and movement as the line of a tree. The images reminds us that Islam is embedded in the geography of antiquity. Between civilizations assured of their centrality, it established a space of communication. It reached out over a vast common area to permit economic, financial, intellectual and trade exchanges. Peoples of the Mediterranean and the Middle East, Byzantines and Sassanids, India and China, all were attached to this enormous new space of communication. Outside the 'urbs' and 'polis' of the Central Empires, only the barbarians had posed a threat. Now even they were reunited with civilization under Islam's umbrella. Soon the barbarians themselves will found new dynasties and lead empires.

Within this image offered to us, we are reminded that Islam, 'median' or 'intermediate community' as the Koran itself says, is not only at home in a Mediterranean mixture, but also within the borders of India, Central Asia and China. And we find yet another pair of images: in this flat, open space of communication, whether desert or steppe, Islam has settled within an archipelago of cities connected by a commerce of caravans. Man settles where he raises his tent. This is an impermanent habitation where movement is always possible; the only stable orientation is fixed by faith, toward Mecca, the only true city grouping all Muslims in an extraterritorial city.

Within this nomadic world, Roland and Sabrina Michaud show us how a horse is captured. Taoist Chinese imagery showed us the proper steps for capturing a cow. Here we see the same rapid prehension, the same force concentrated on the object with the same mindful – or even spiritual – presence. It is a stunning act of vitality, commanded in an instant by consciousness in the very awareness of its concentration. This spiritual presence thus coincides, again through mirrored reflection, with the tumultuous flow of the events themselves.

This recalls certain images of dervishes from then and now, some calm in their silent meditation, others bursting with hilarity and even breaking into dance. 'Malengs', or mad masters, wise beyond sanity and madness – these conceptual pairs being simple appearance – have been photographed to show that the type has not yet died out. I once sent a European to Central Asia to work with a certain master. He confided to him that he no longer knew exactly where he was, somewhere between consciousness and forgetfulness, between his profession and his temptations, between different cultures, as if fighting all sorts of contradictory currents. The answer from the master came in a single word: 'Flow'. This direct response was one of life, turning this visitor inward toward himself, toward his centre, what he had previously been fleeing. Centrifugal. 'I fled out of myself toward you, when I heard a voice crying from myself into me', utters the Muslim mystic. Perhaps the most striking picture of this album is the dancer in the snow, simultaneously wise and regally mad; in fact, his spinning is beyond sanity and madness.

Doesn't this ecstatic knowledge overflowing with joy, this presence showing no concern for the snowfall, dusting all, this full 'yes' to life, recall someone? Nietzsche, perhaps, and his Dionysus, but especially his Zarathustra. Jubilation in a snowy solitude – dancing knowledge. Zarathustra seized in his homeland. 'Vaterländischer Wiederkehr', return to the hearth, and passing through the focal point of the Orient – this is the visual beauty of Roland and Sabrina Michaud.

Face to face, skipping not only centuries but also social conditions: the sultan and the destitute smell the same flower. Here one can dance to the principle of renewal: 'the renewal of creation at every instant'. Different from the linear flow of time, Islam knows another time, where the instant is pregnant with eternity, where each new minute echoes the noise of creation on its first day. Thus each moment has the glowing vitality of this horse we saw struggling against its fetters or the freshness of this flower. The portrait of the sultan also reveals a meeting between the Orient and the West. Look first at the miniature, then at the photograph. This is what so moved the Bellinis. The style, if not the treatment, remains traditional, especially the gesture. The conqueror is not shown as the soldier spurring his horse. He is a lawmaker; he is not shown as a

sovereign. Sitting cross-legged, he gazes at nothing. The picture gives us the simple detour of a passing instant: this fragrance. The pictures of this album fold over on themselves: repetition, confirmation, but also a slight difference into which our own reflection tumbles. The distance here is not one of exoticism. This rediscovery is no longer naive, a simple gesture equal to itself both in the past and in the present. More subtle, this fold is both more intimate and impossible to complete: it separates us from ourselves. It comprises our innermost being.

Here, I am reminded of a Hindu phrase, as if by ricochet, because it comes by way of contemporary Latin American literature. It is from Julio Cortázar. 'When two things are perceived with the same consciousness of the interval between them, you must place yourself in that interval. In this way, the two things are eliminated, and Reality will shine forth.' That is the sixtieth stanza of the Vijnana Bhairava. It also seems to illustrate what these photographs show, pair by pair.

But let me go on to another confrontation, this time not between two illustrations, but between two living beings. Pilgrims are arriving at the Kaaba at Mecca. Everywhere else, they stand side by side, only an abstract expression on their faces. But at Mecca itself, at the end – or rather at the very centre – of their journey, the faithful group around, not linearly but in a circle, toward one axial point. Here in this place, the straight bends, the linear is transformed into a circle. At that moment, the Muslim discovers another face on the side opposite him. On this route, in the absence of any icon, altar, or tabernacle, the last meeting is not with a symbol, but another living, breathing being. Having come from the opposite horizon, but with the same intention, that other being seems to reflect him. There is physical as well as intentional symmetry. Verification could be made by folding the circumference over the central point. As if reversed in a mirror, the community is still one. The circle is complete.

There exists a fraternity in the community, all the more powerful because it passes through a central absolute reference. The other being, opposite, could be rich or poor, strong, able or oppressed. Any and all differences are abolished. 'Praise', says the parable, 'to Him who erases all names, conditions, professions and qualities to allow simply for being.' Everyone is unified even in their appearance, for they wear the *ihram*, the shoulder- and loincloth of a uniform white. All are effaced behind this

whiteness, all newborn, all already in the beyond. Similarly, the Koran begins with the Fatiha, a praise of the Unique, and closes with the 'surat an-nas', the chapter of humanity. This word 'nas', 'people', is repeated five times in six measured verses. The Koran closes on itself as if ready for a new reading, just as the pilgrimage to Mecca closes with a new departure.

The uninterrupted reading of the Koran repeats the first verses, which overlap the last ones. Thus, man's presence is echoed in the consciousness of Unity, itself then repeated in the human sphere. The community is unified and transcended while the One and Transcendent remains.

But it is in Islam's profession of faith, the Shalada, where this symmetry between the relative and the absolute is most firmly expressed. 'La ilaha illa Allah.' 'Nothing divine if not God.' No being if not Being. But, remember, this is not a duality. The two parts of the formula do not indicate a progression of binary opposition. We are as far as possible from dialectics. Exactly that which has been negated, in disjointed and ephemeral form, is affirmed, in unity.

The name that is above all being, 'huwa', 'Him', when produced in a certain hand is written in a right-to-left symmetry, as if in a mirror.

Similarly, the two parts, negative and positive, of the profession of faith mirror each other in the finite and the infinite. In the middle of the utterance, a rift or caesura is produced by holding one's breath.

Exactly as the rosary contains ninety-nine beads, the hundredth being the very breath of the chanter, the silence, between the 'yes' and 'no' of the Shalada takes place within the believer's very being. 'Within the space of this yes and this no, the neck is wrenched from the shoulders.' Within this caesura between the two terms of the profession of faith, in this disclosure of being, this vacuum of any conceivable meaning, the unutterable comes to be inscribed.

Najm ud-Din Bammat

From Arabia to China

For you certainly know nothing of the seven extraordinary voyages

that I have undertaken, and how each of these voyages

is in itself a thing so prodigious

that merely to think of it leaves one speechless

and amazed beyond all amazement.

The Thousand and One Nights, 313th night
Story of Sindbad the Sailor

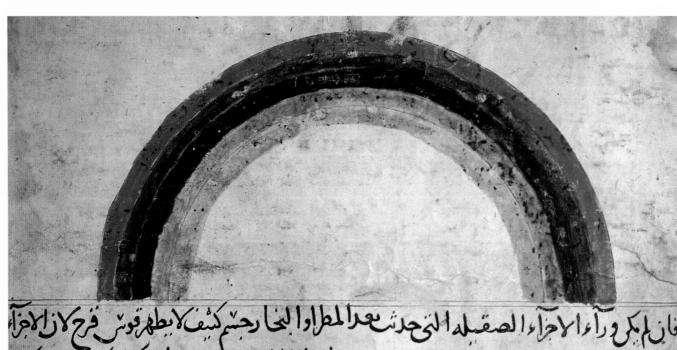

فان لم يكن ورآء الأجزاء الصقلة التي حدث عنها المطر والبخار جسم كيف لا يظهر قوس قزح لان الأجزاء الشفافة يتمدد شعاع البصر منها كالنور اذا جعلته في مقابلة الشمس من غير ان يكون ورآه جسم كيف لاينعكس عند شعاع البصر قال ... بعضهم سبب اختلاف الوانها فهم از الشمس وبعدها فان ما يرى منها أحمر فقريبه من الشمس وما يرى منه ابعد من الأحمر وما يرى احوانها

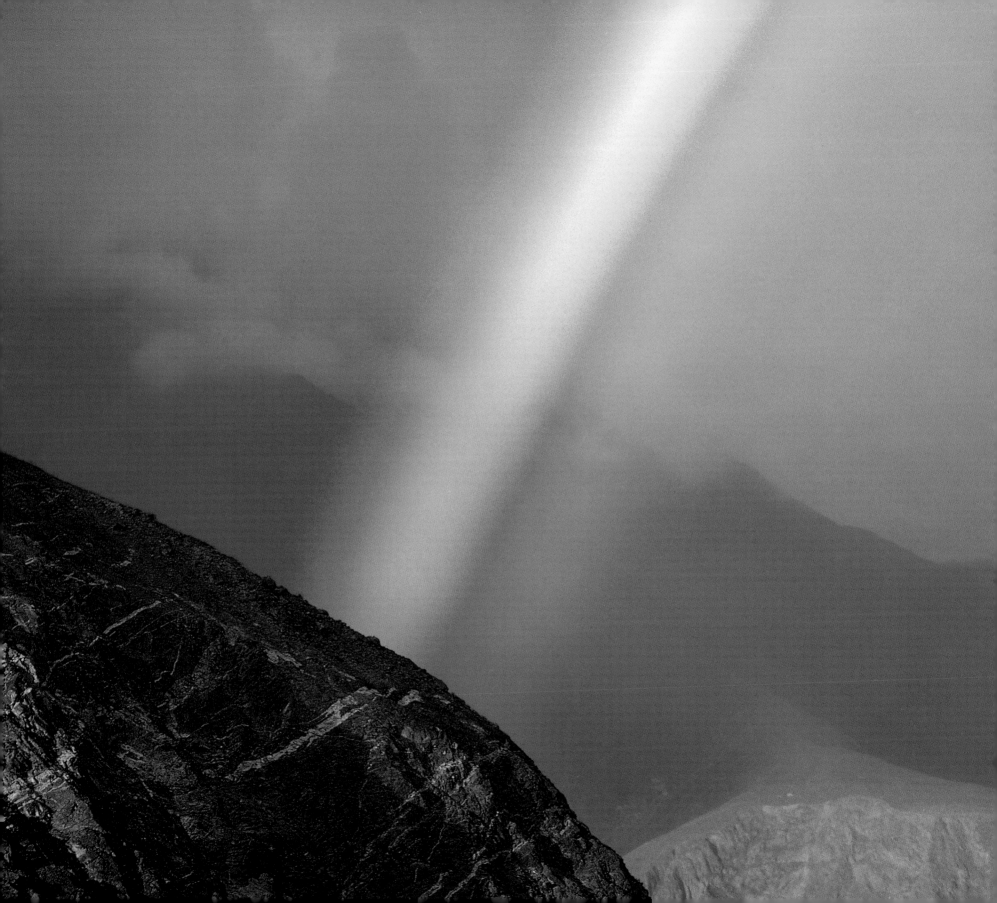

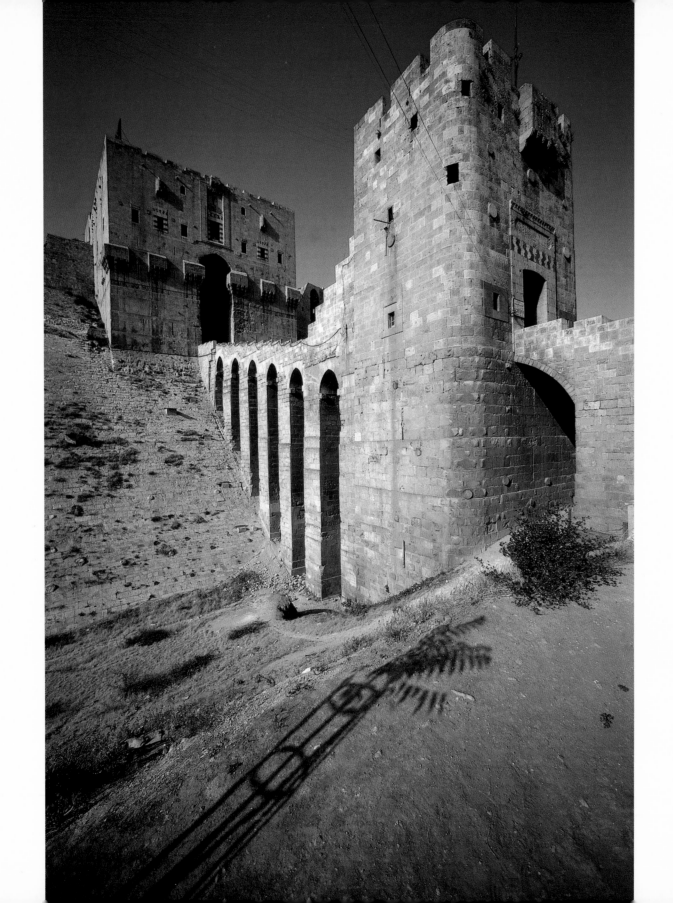

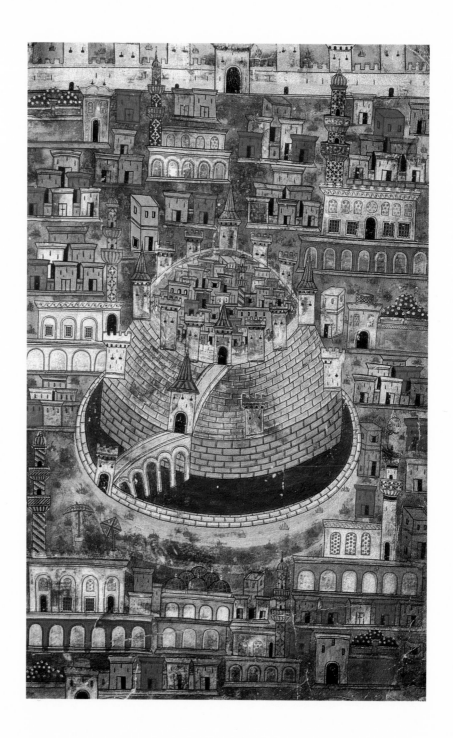

34

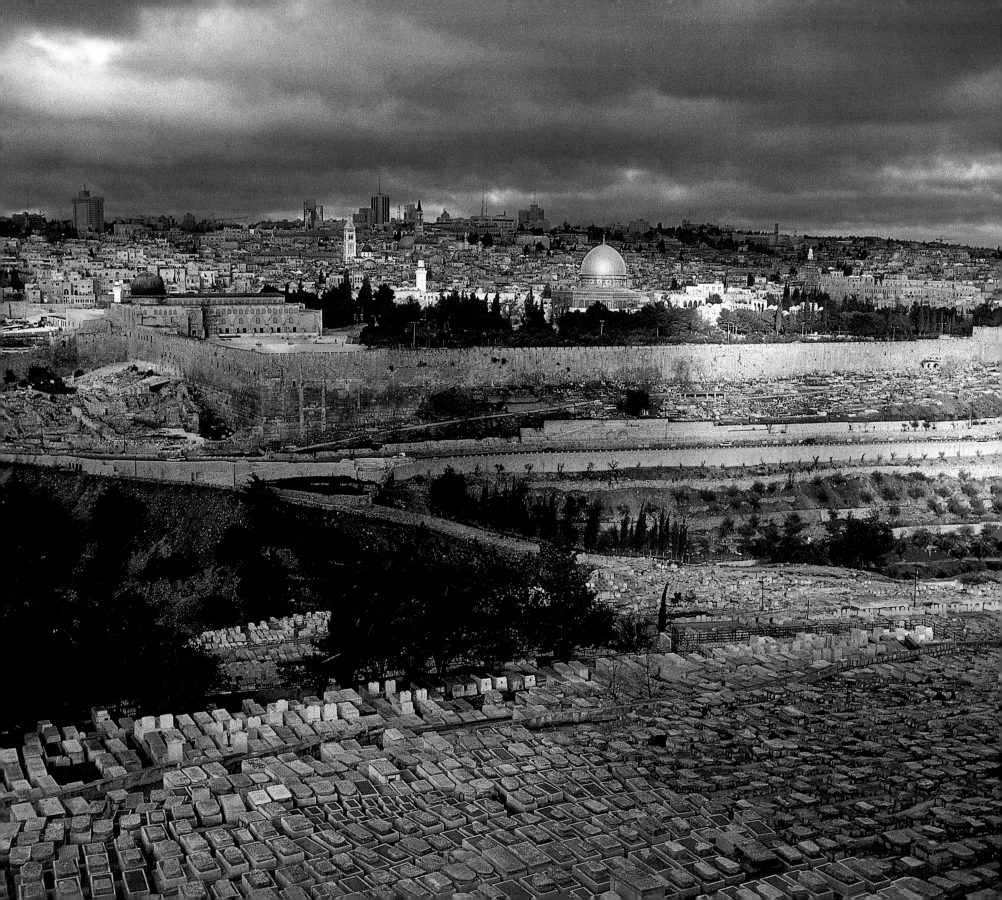

My name is Sindbad the Sailor!

They call me this on account of my great sea voyages

and the extraordinary events

that befell me,

which, if they were written with needles

in the corner of an eye, would serve as a lesson

to attentive readers!

The Thousand and One Nights, 313th night
Story of Sindbad the Sailor

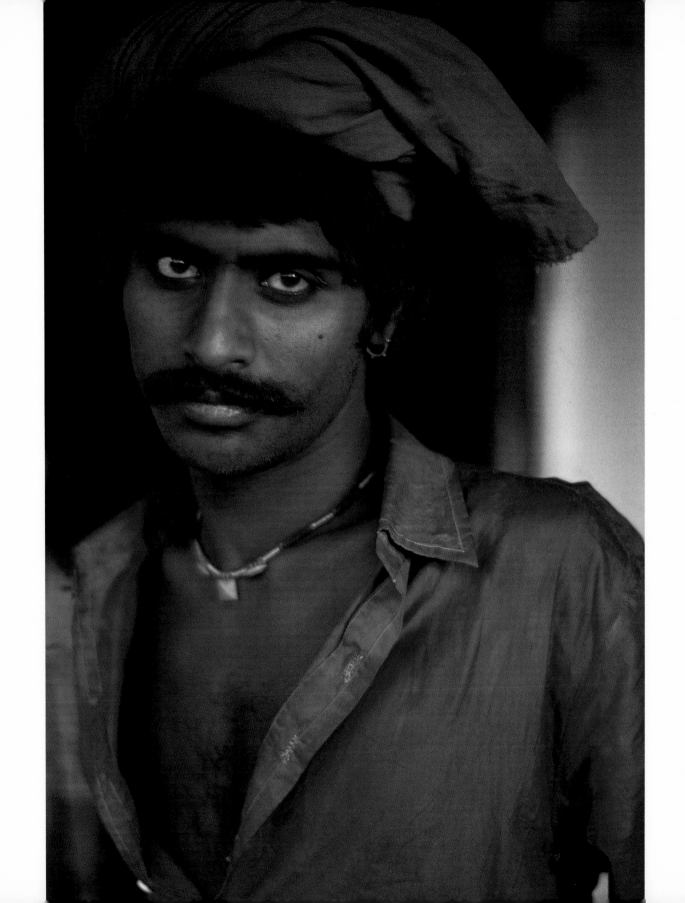

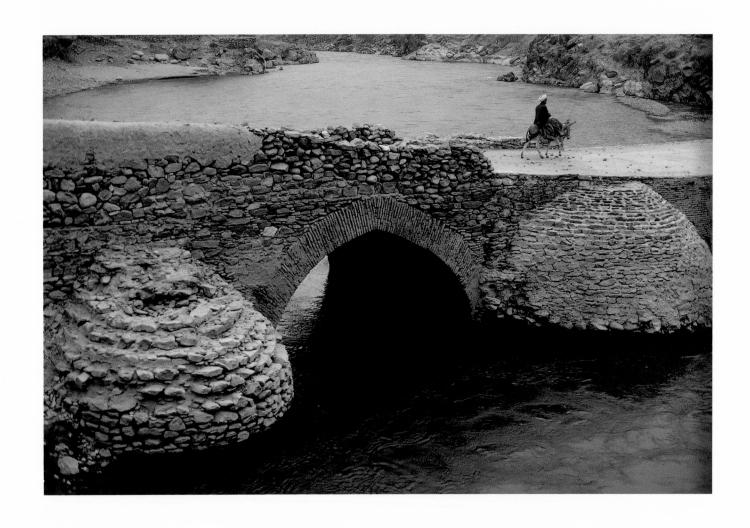

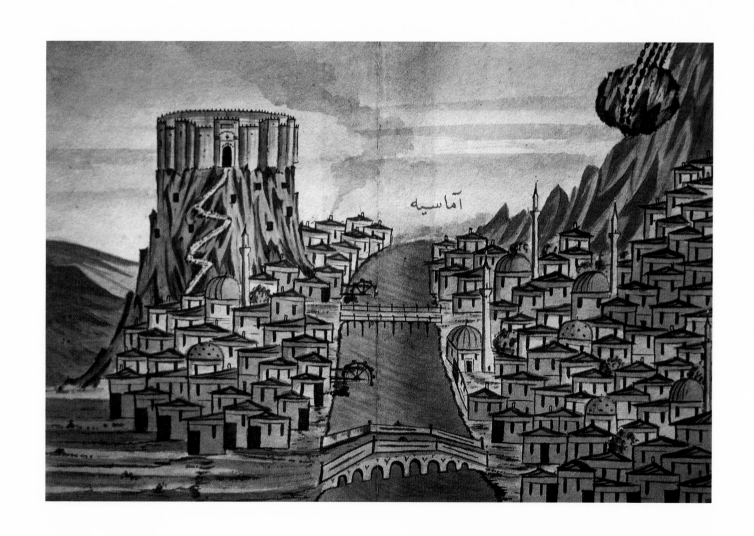

آماسیه

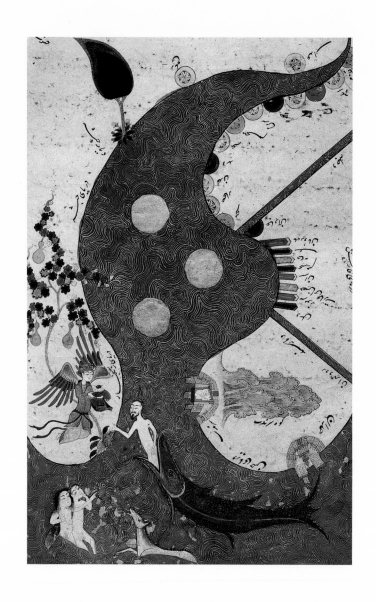

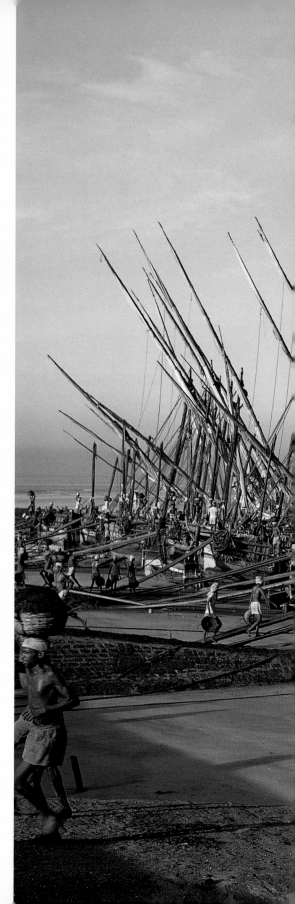

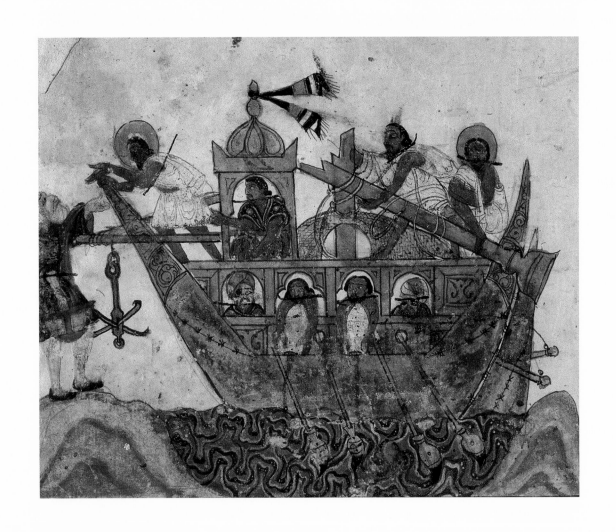

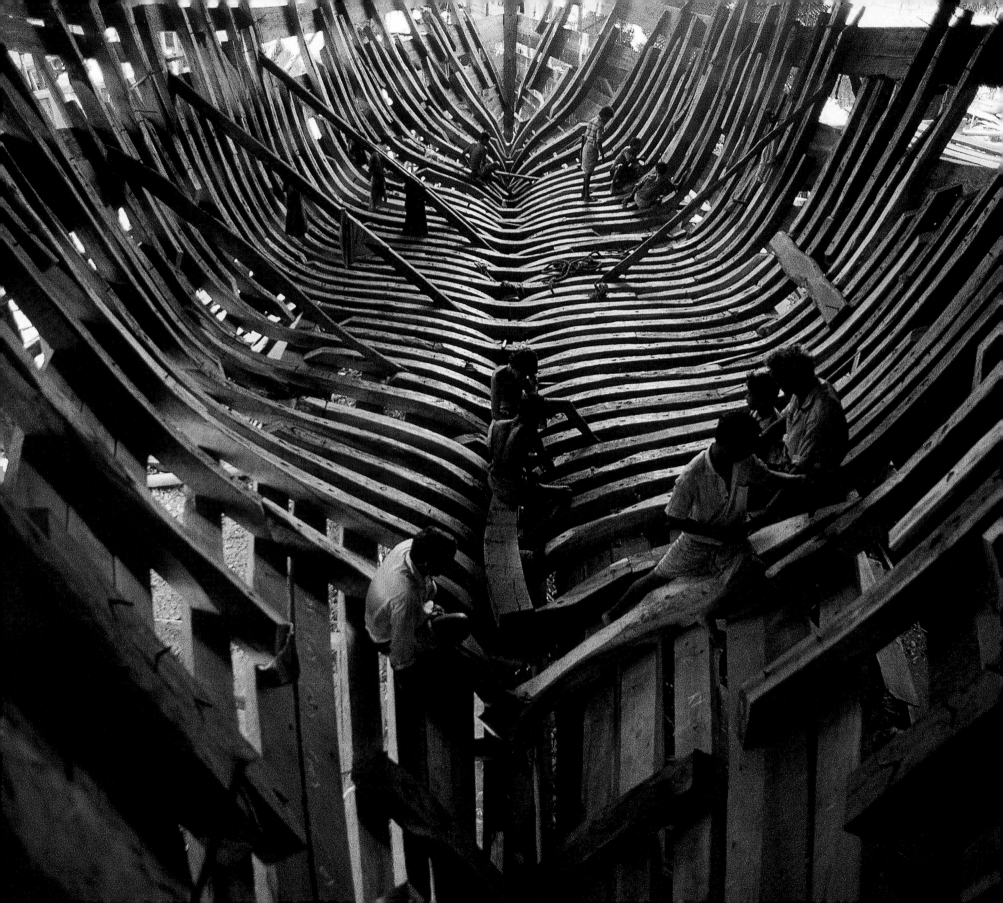

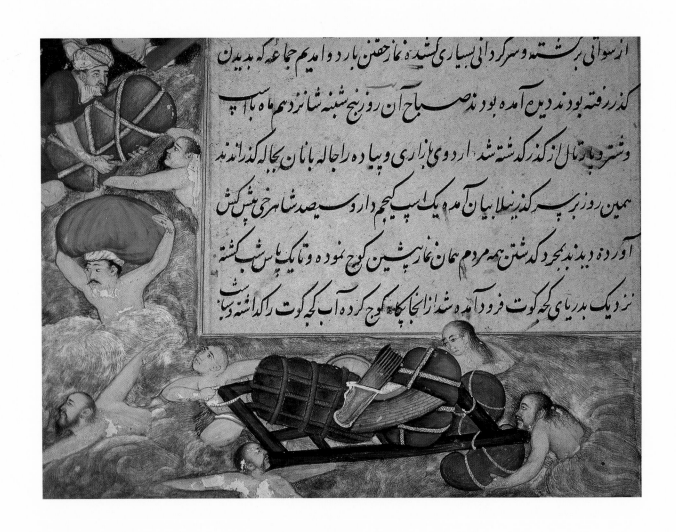

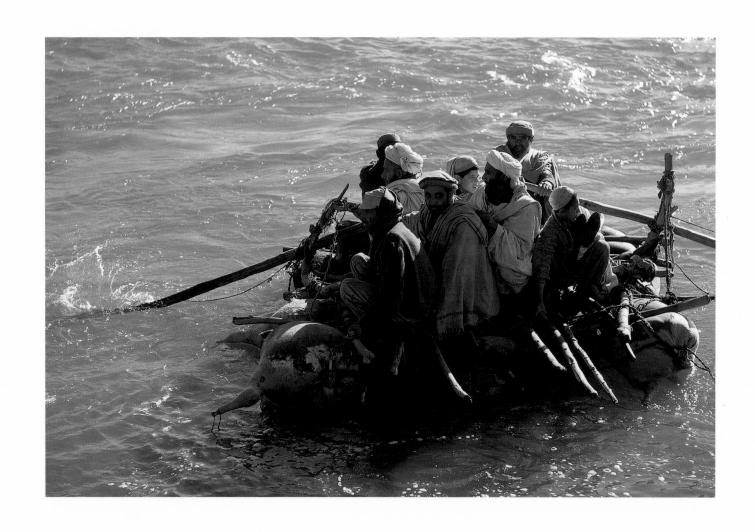

And He it is Who has made the stars for you that you might follow the right way thereby in the darkness of the land and the sea.

The Koran, sura VI, 97

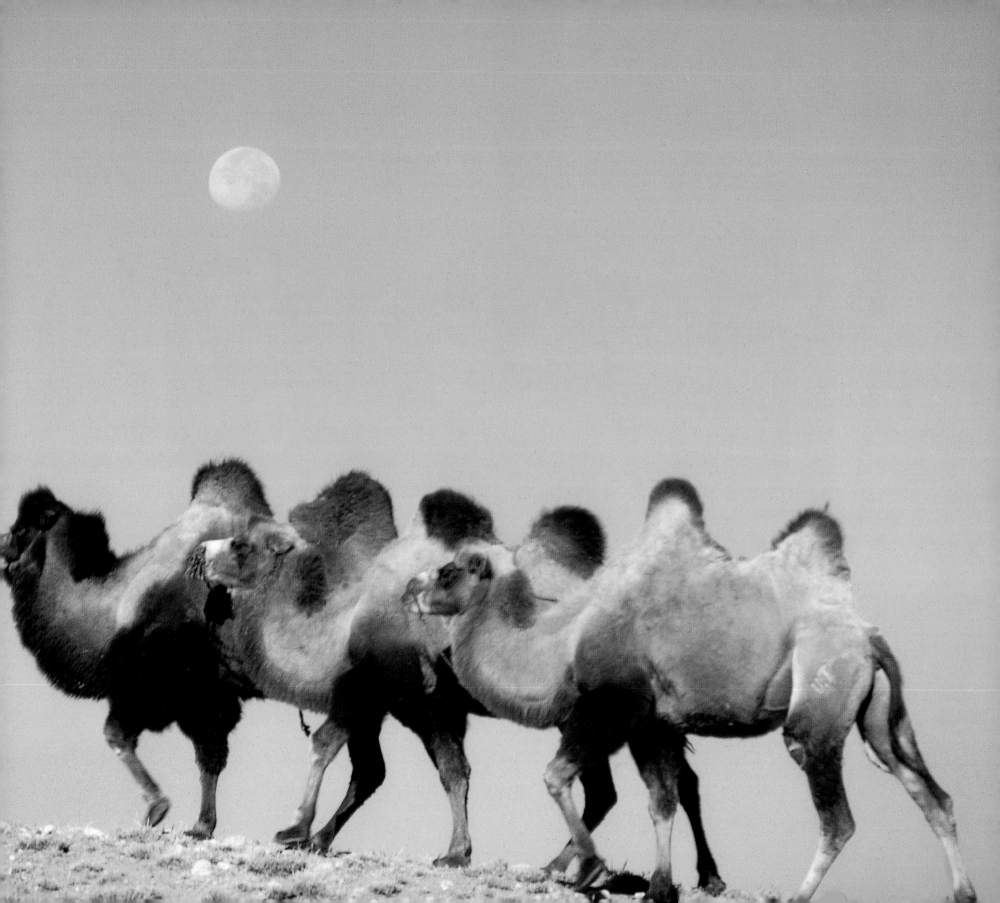

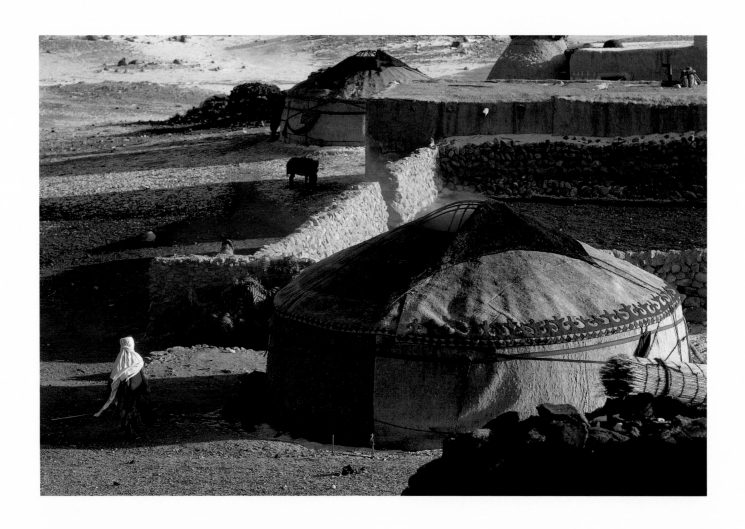

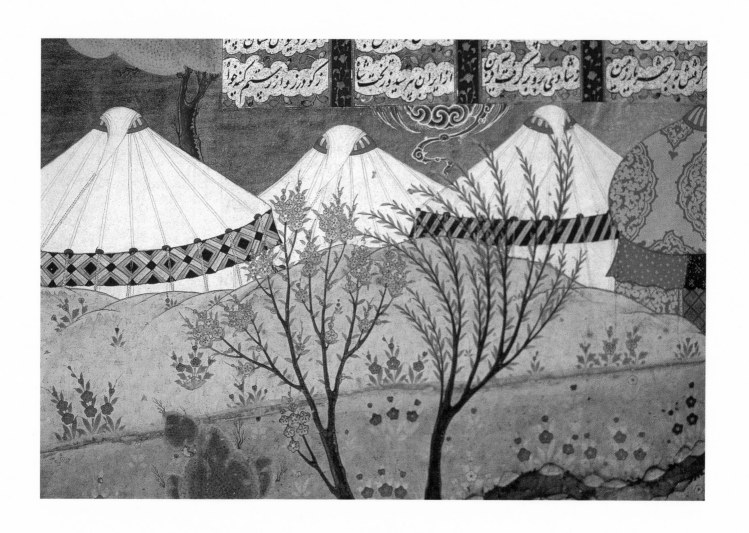

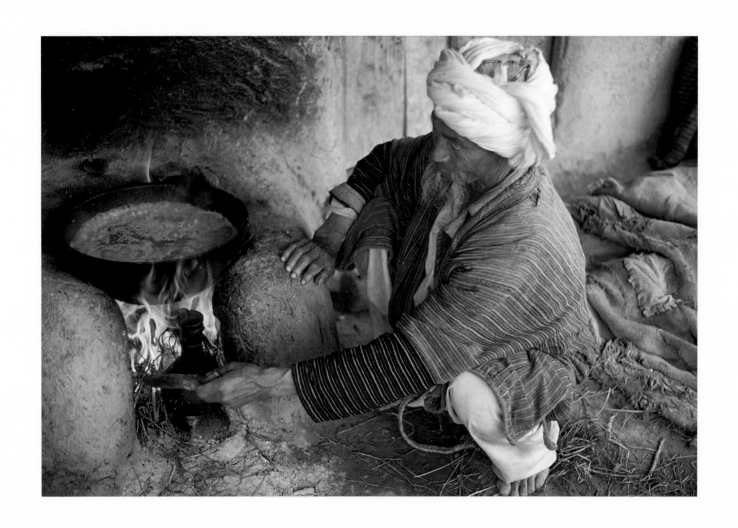

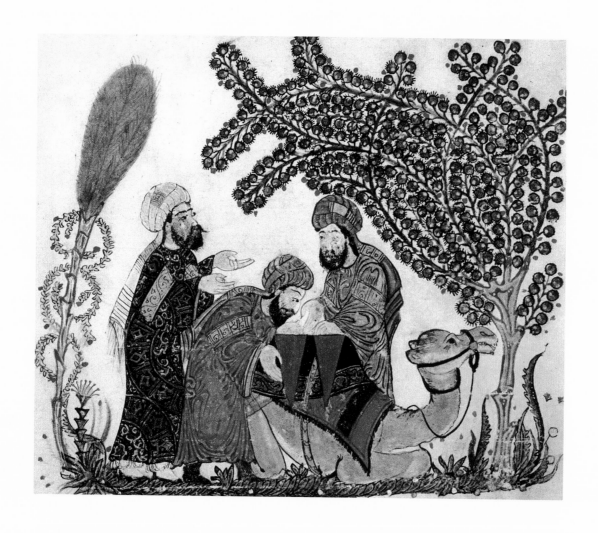

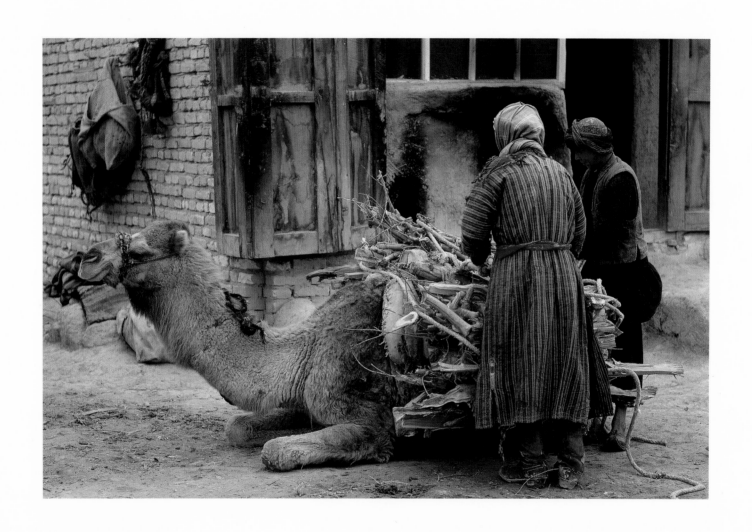

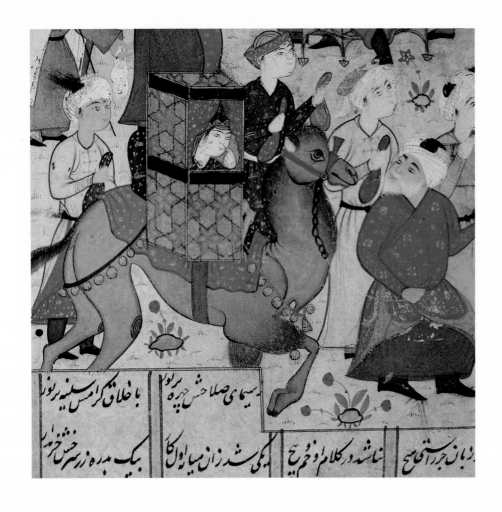

با خلاق تكرامس لندیه پرنوز دسیمای صلاحش جهره پریش
نماشد درکلاماوخم پیچ
ژبان جیرر آستی بیح
یکی شد زیان میاواک کار
بیک بدره زرر بشرخش خروار

54

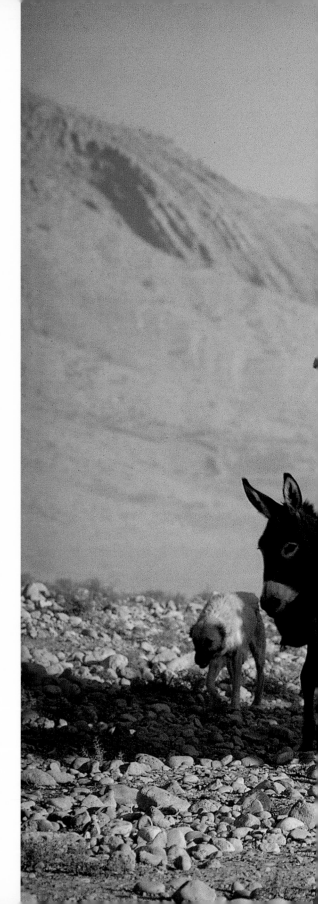

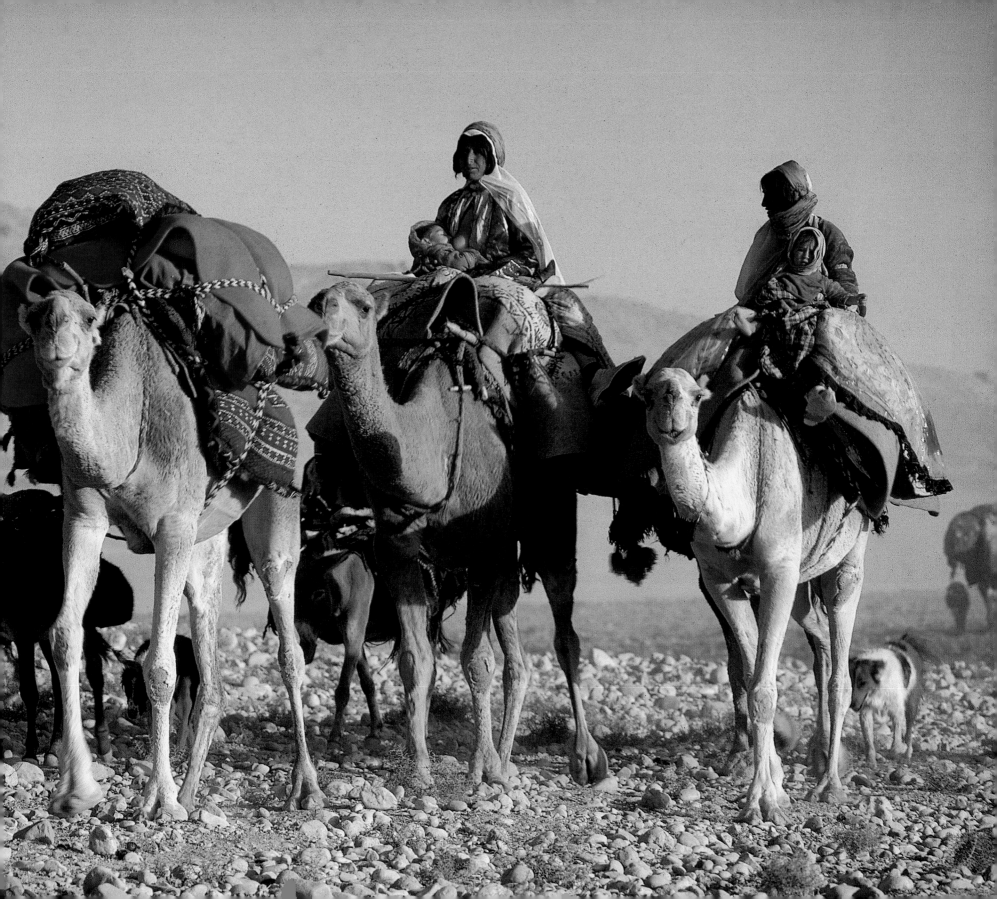

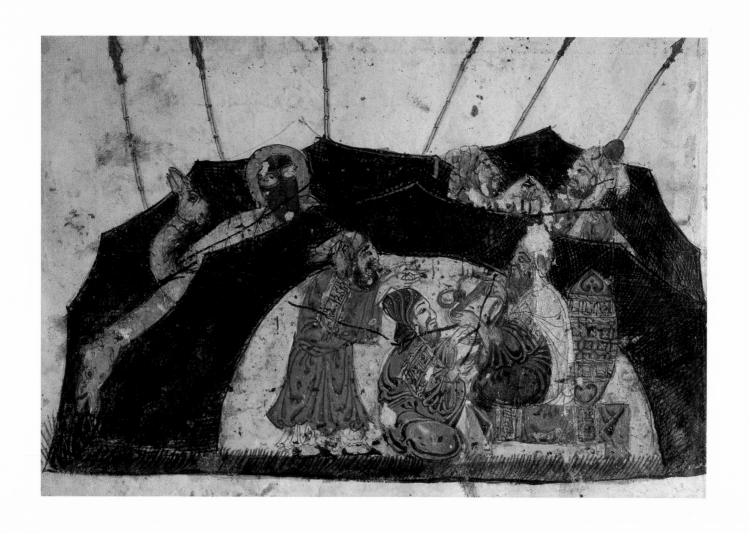

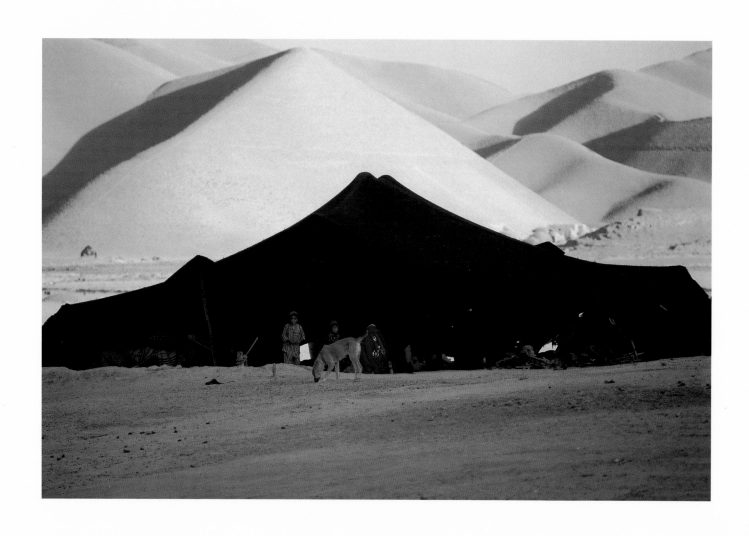

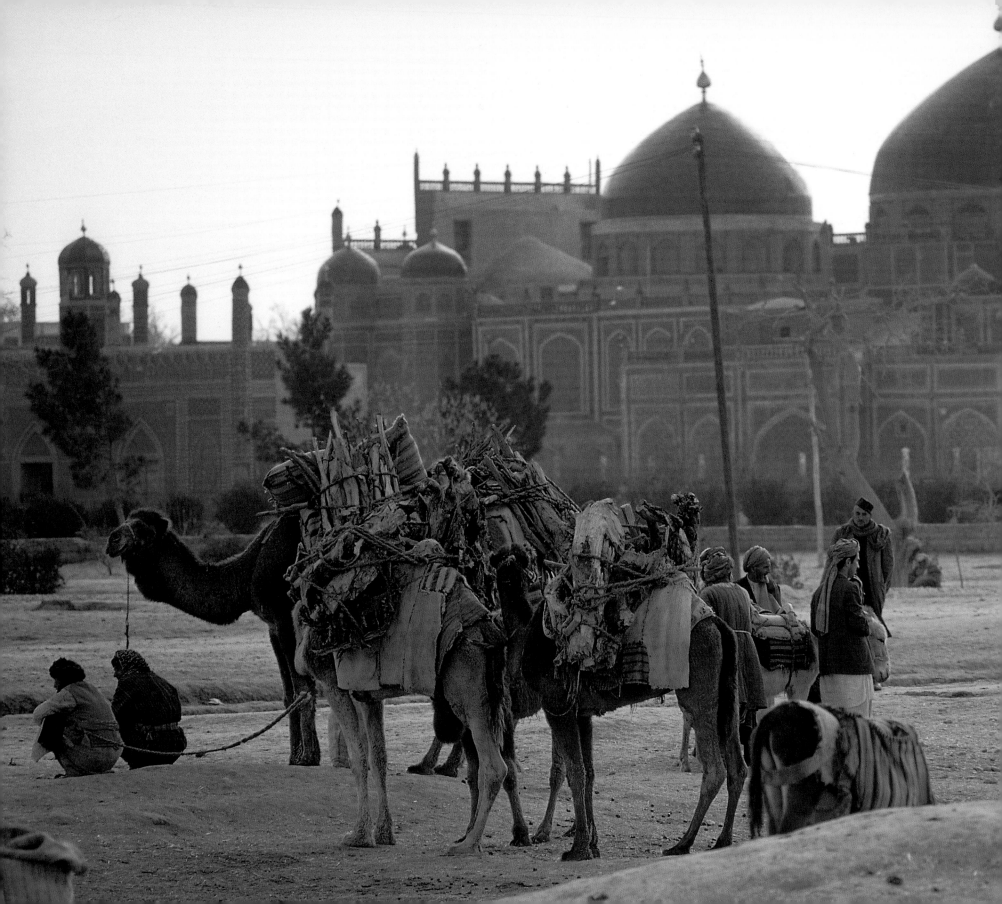

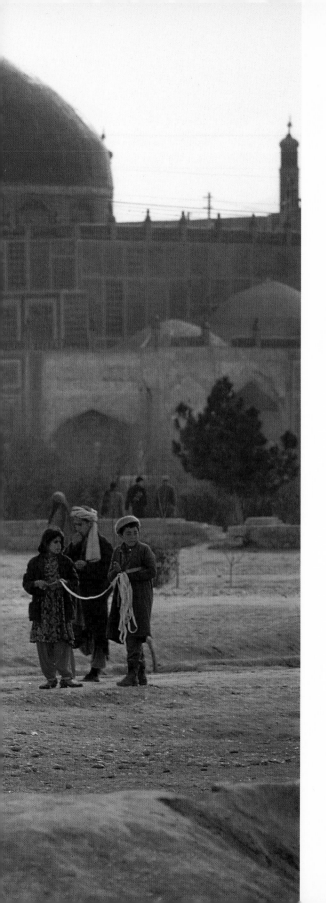

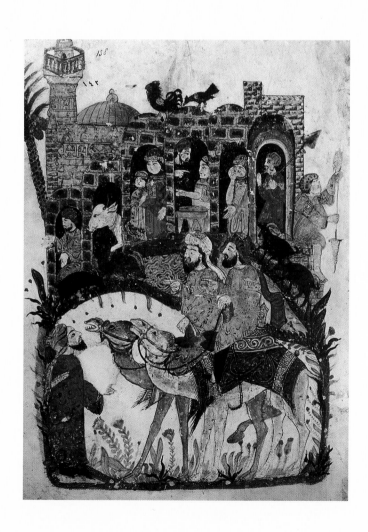

What earth is empty of You

So that we fly to search for You in the heavens?

You see those who regard You in the full light of day

But the blind see nothing.

Hallaj, *Mystical Poems*

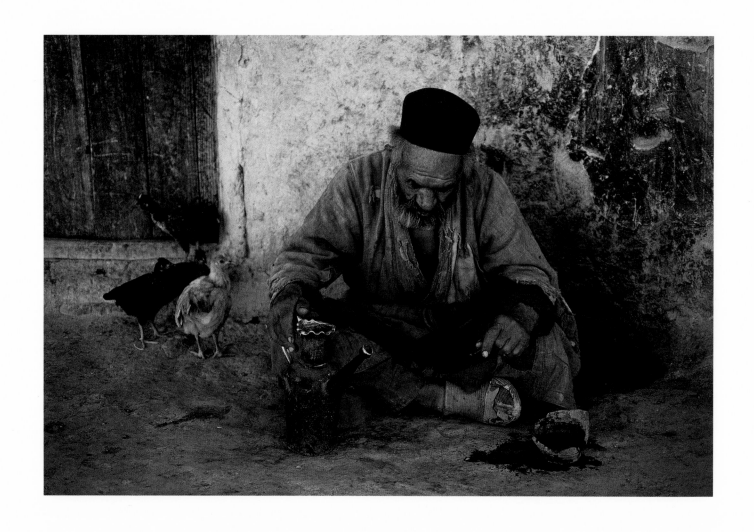

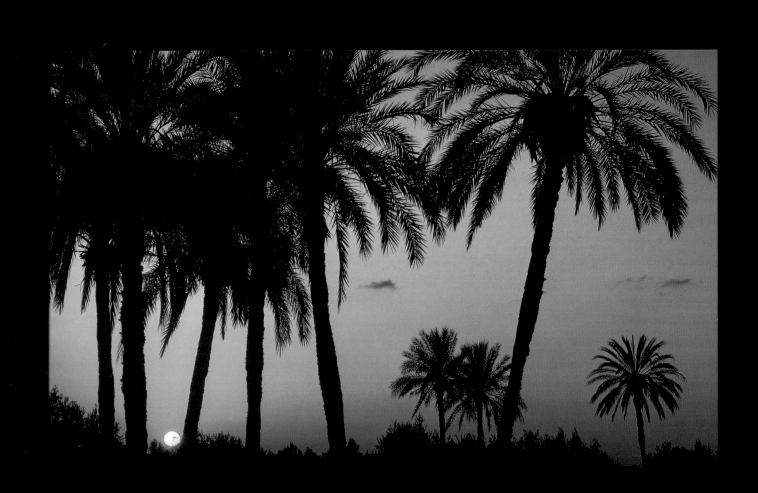

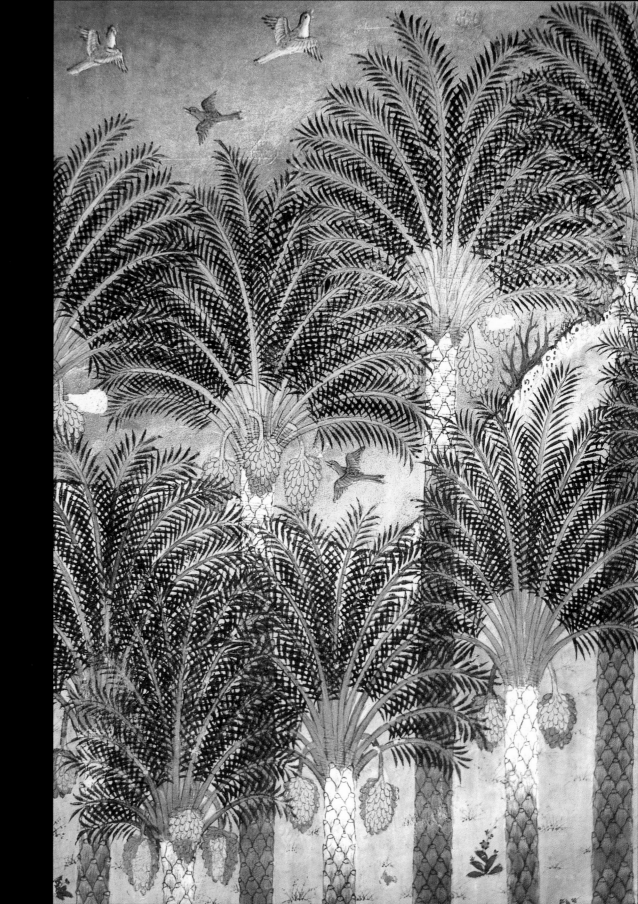

Souks and Bazaars

While in the souks and in the streets they were burning incense,

sublime camphor, aloe, Indian musk, *nadd* and ambergris,

and the inhabitants were staining their hands afresh with henna

and their faces with saffron, and the drums, the flutes, the clarinets,

the fifes, the cymbals and the dulcimers were making the air ring

the way it does on high days and holidays.

The Thousand and One Nights, 1001st night

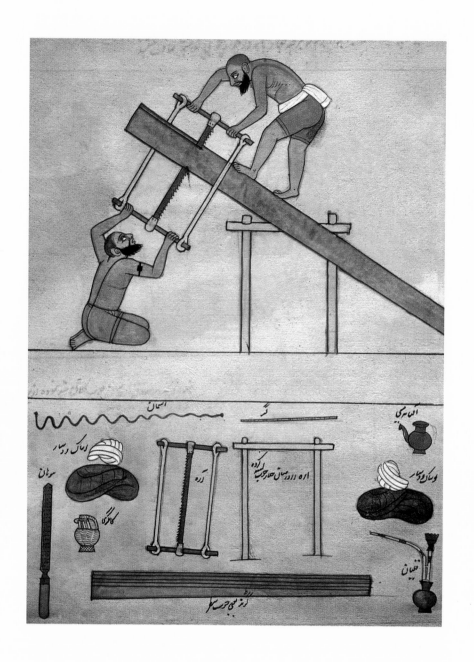

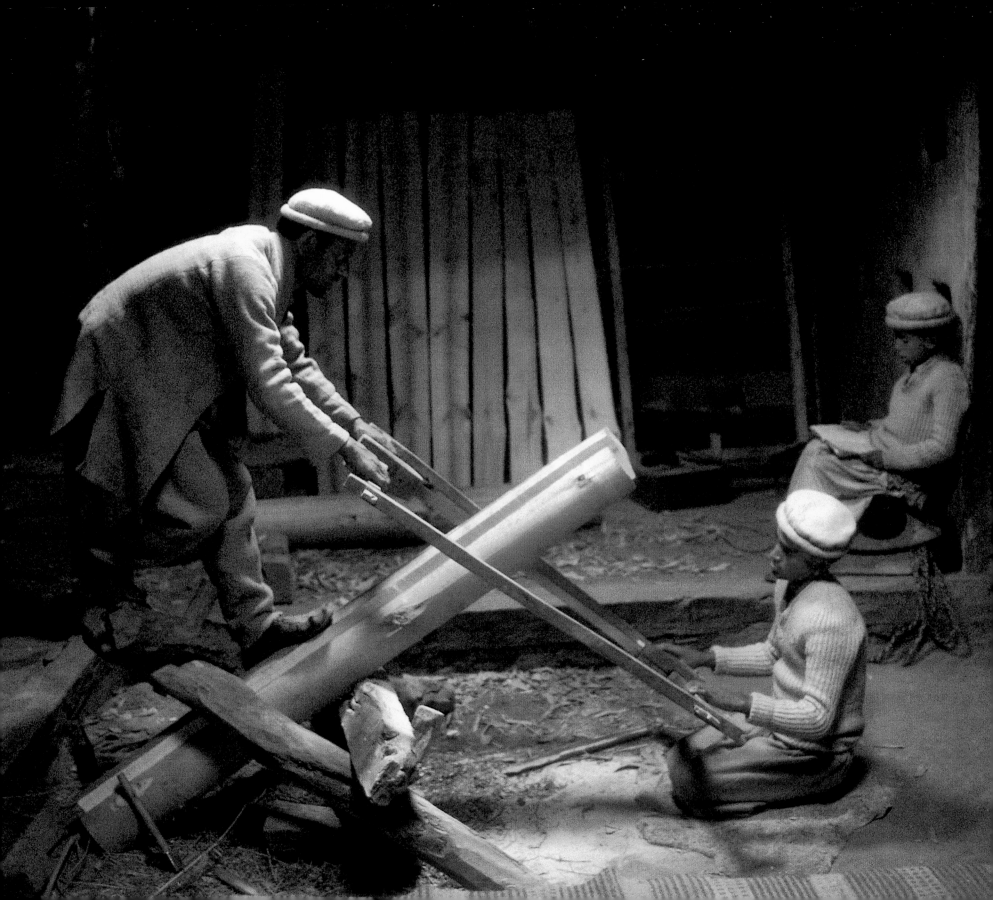

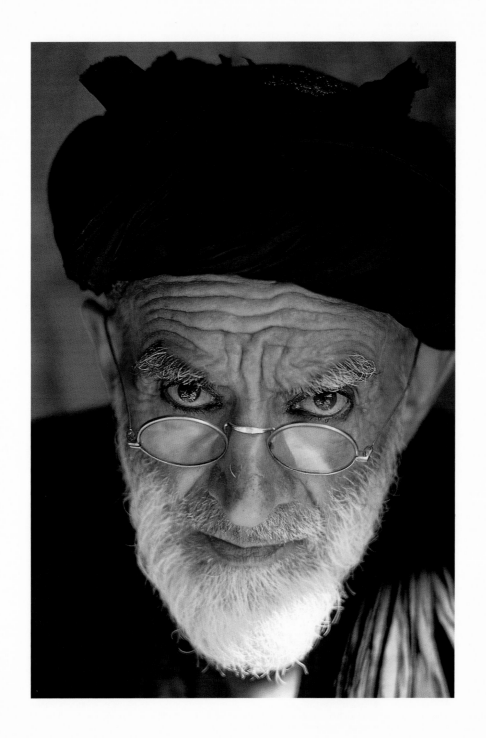

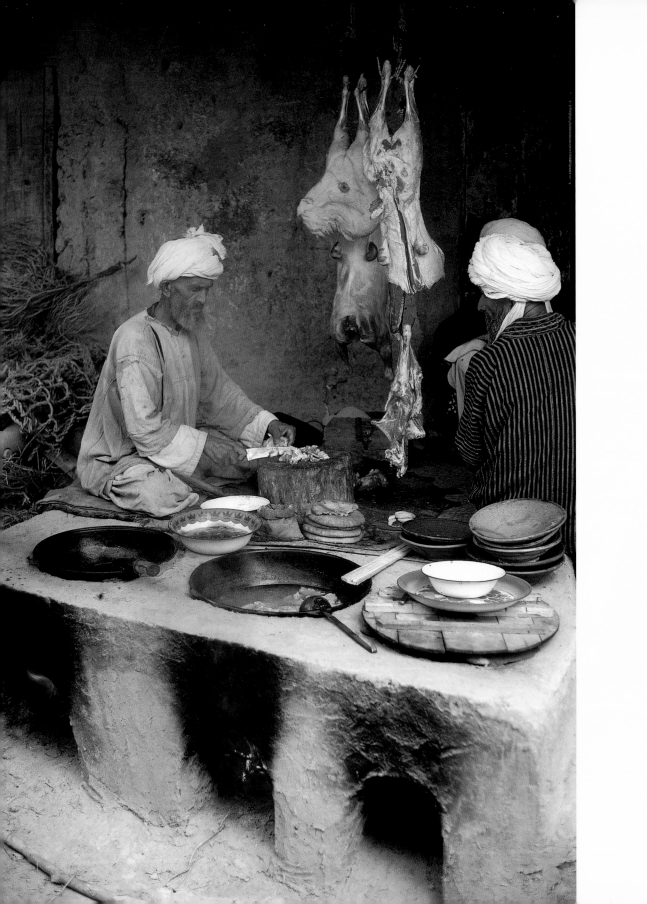

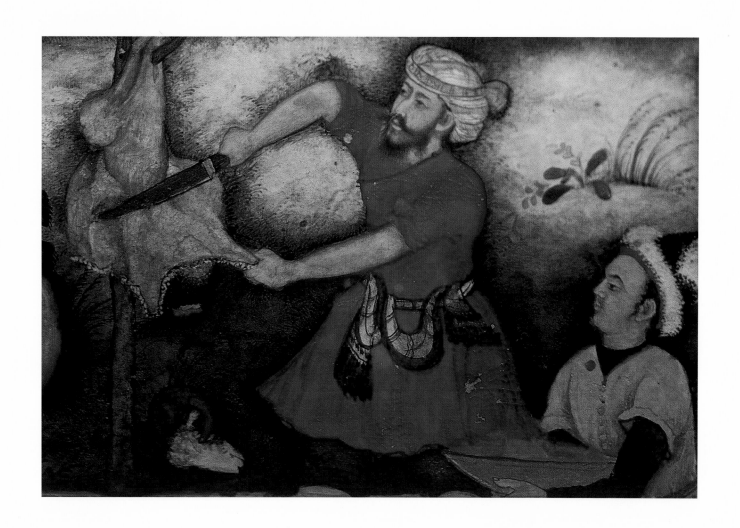

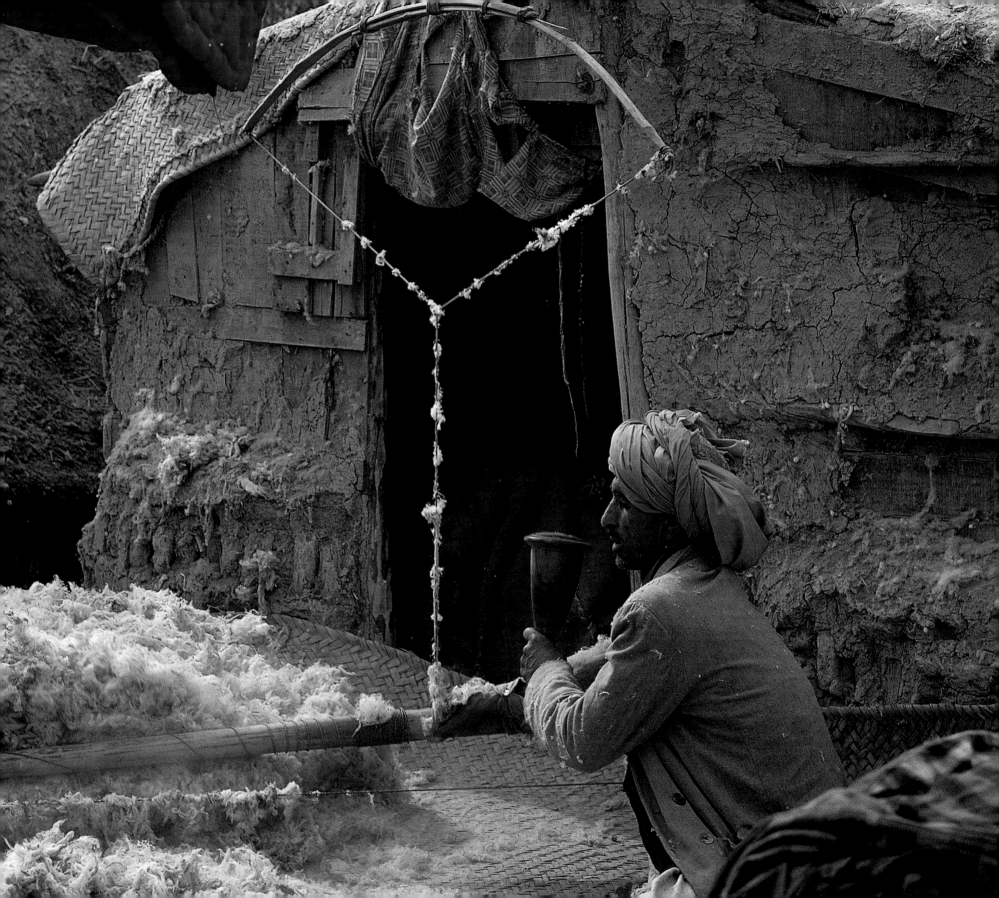

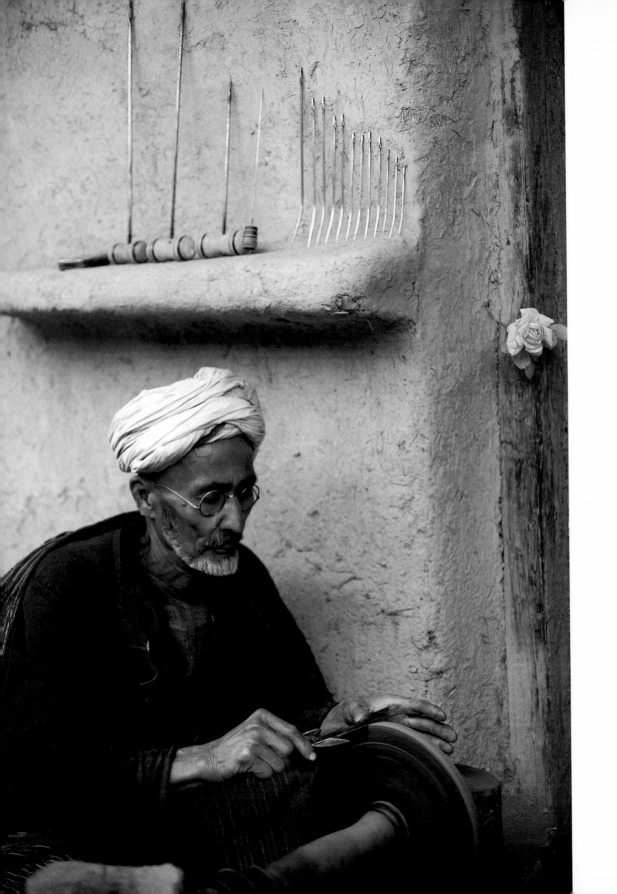

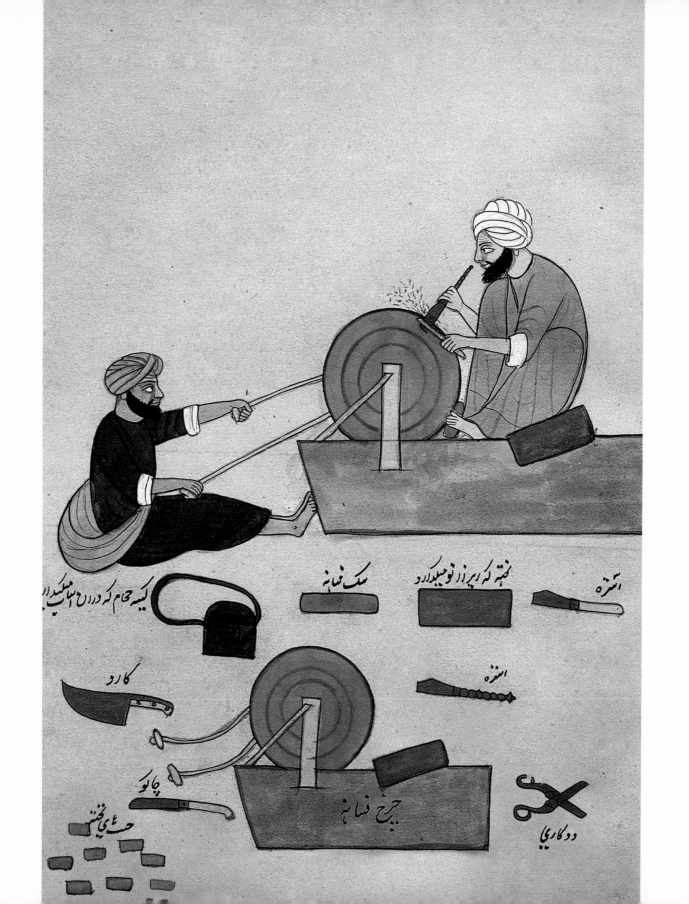

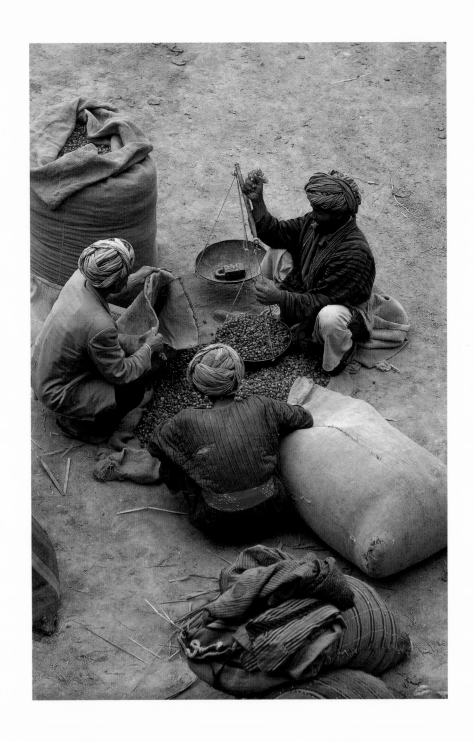

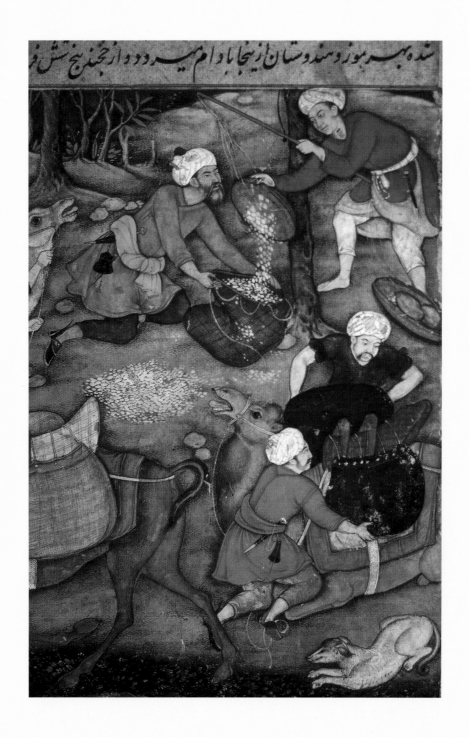

We have made the iron, wherein is great violence and advantages to men.

The Koran, sura LVII, 25

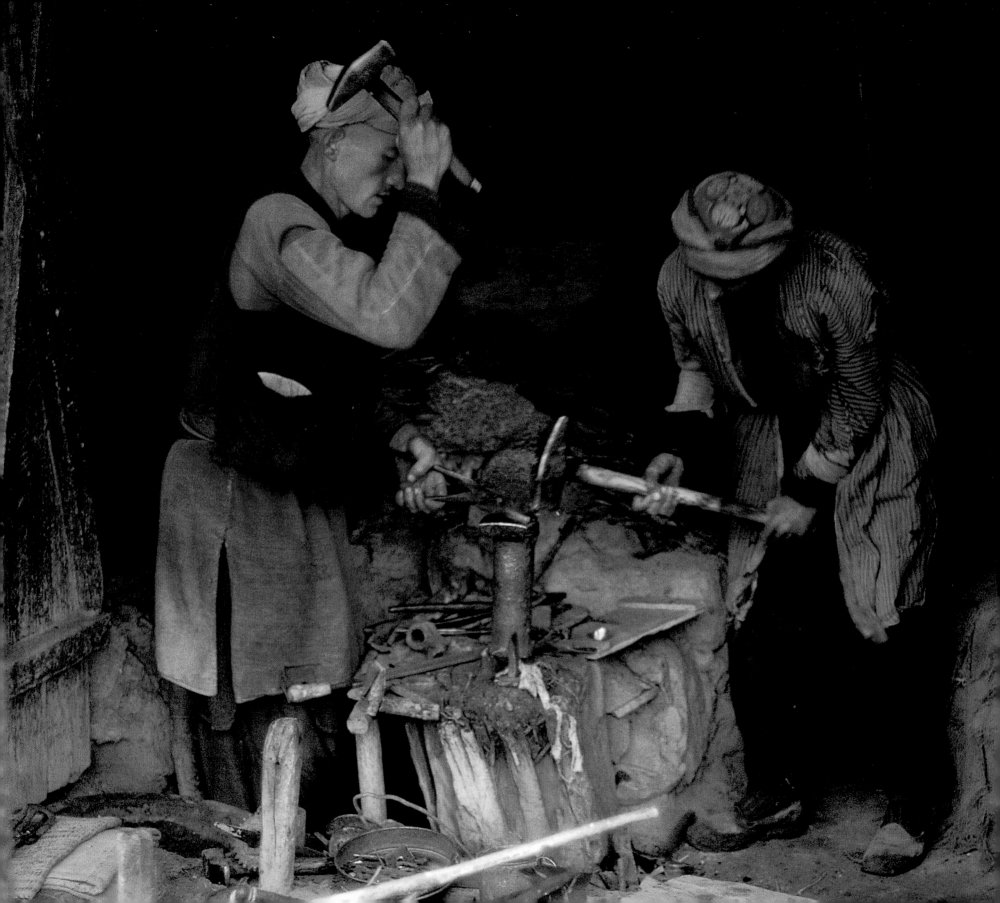

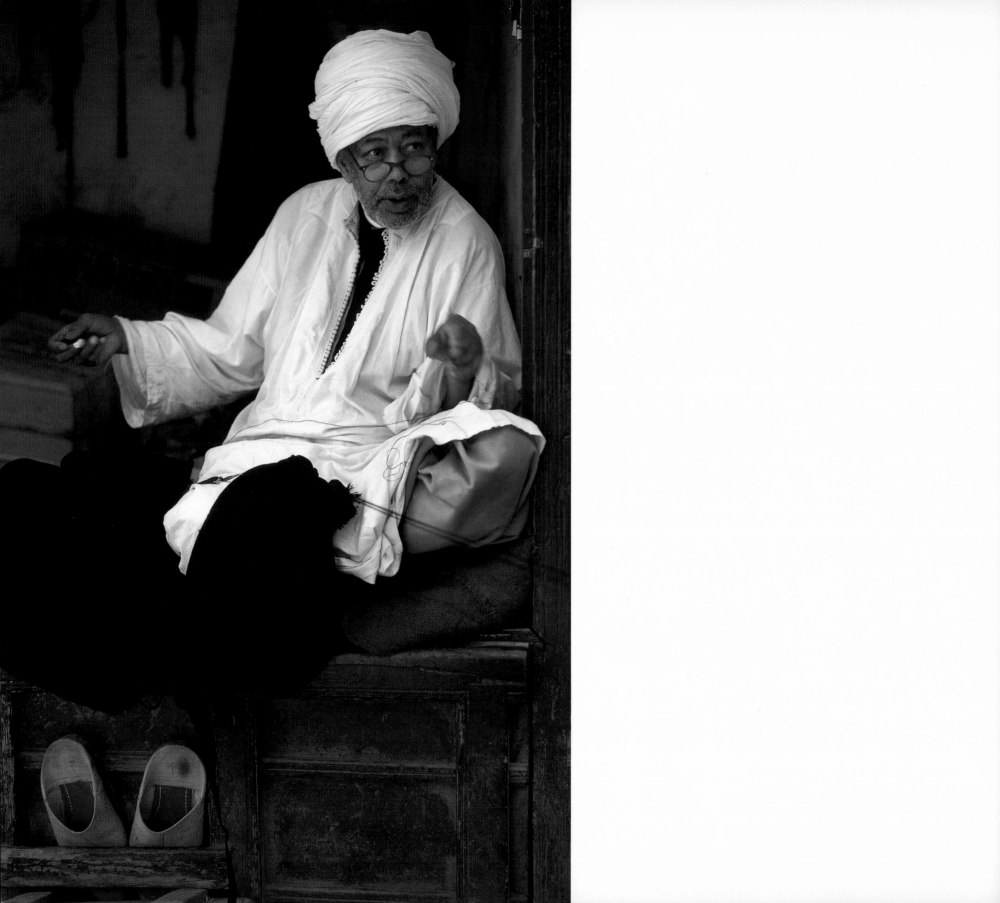

کرفته از دست دیگر در ئوزن نار ئسم کرده کلانون کاری مبار د آیاب کحریر مشود

کلاه مرقالب کرده نشسته

پیچک ها ی ریشم زنگاه

لَا اِلَهَ اِلَّا اللّٰهُ مُحَمَّدٌ رَّسُولُ اللّٰهِ

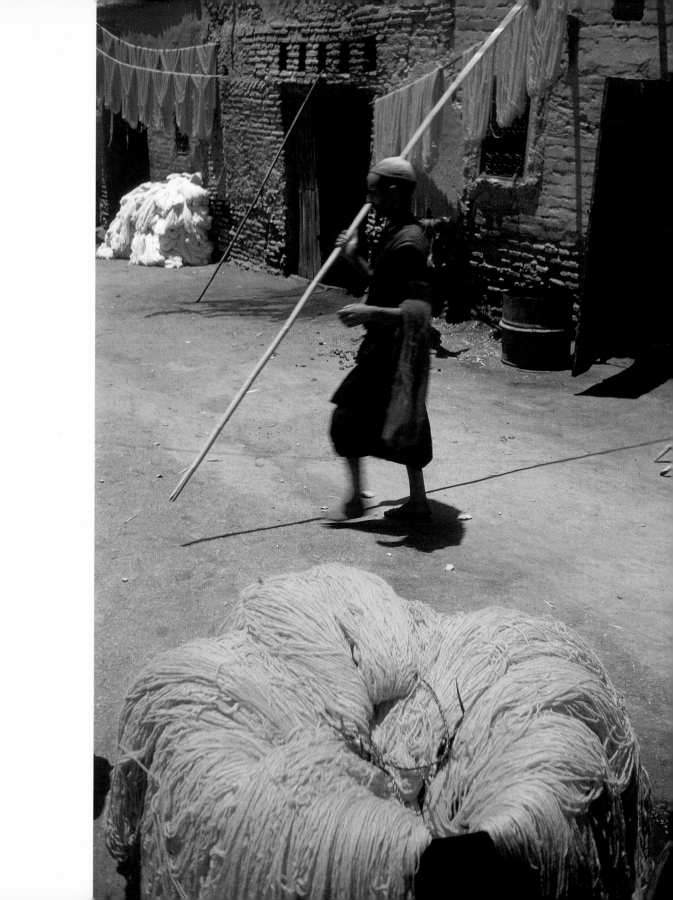

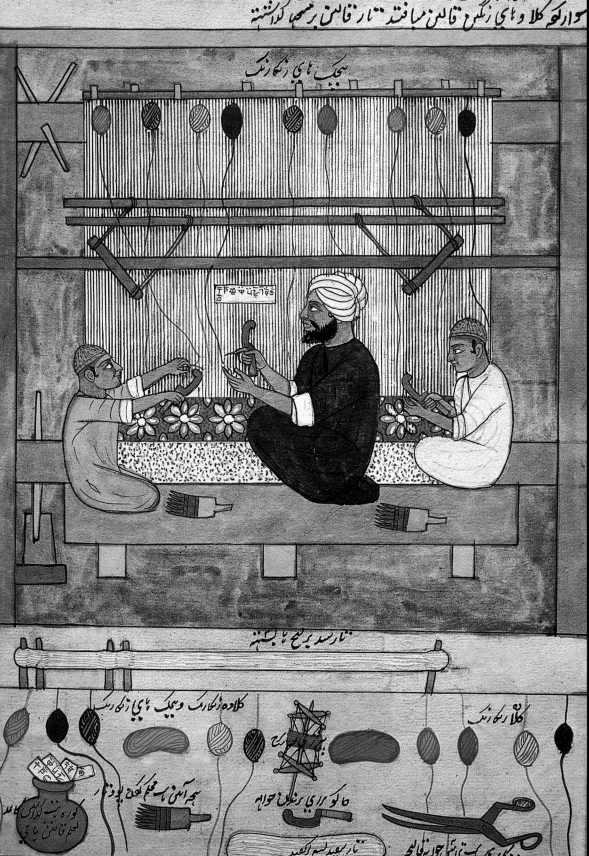

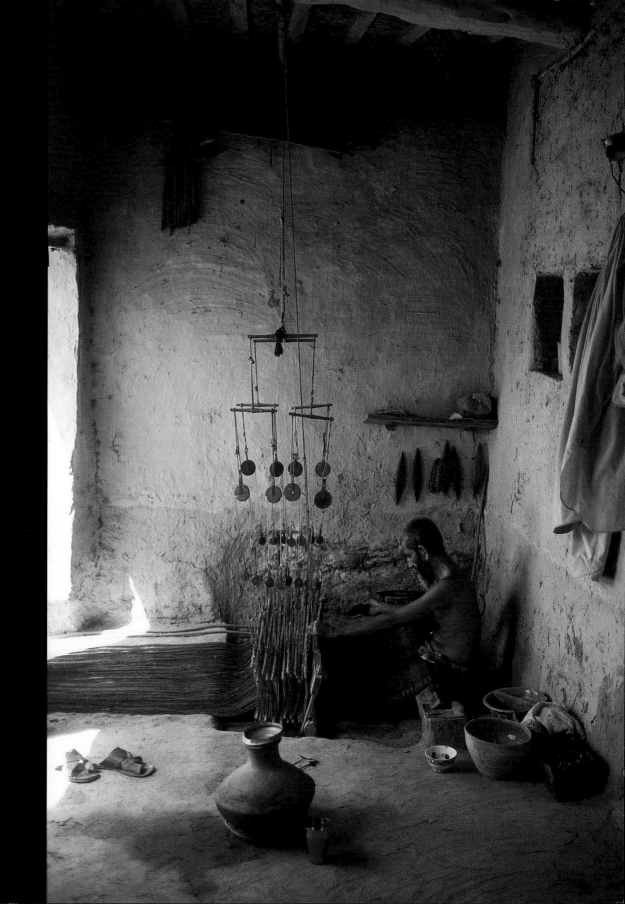

Recreation

And the entertainment began with juggling acts
of extraordinary brilliance and with conjuring tricks
and fakirs' dances.

The Thousand and One Nights, 808th night
Story of Princess Nourennahar and Beautiful Gennia

Dance only when you are mortified:

It is on the field of battle that men dance and whirl…

When they are liberated from the empire of the self, they beat their hands together;

When they escape their own imperfection, they dance.

Rumi, *Mathnawi*

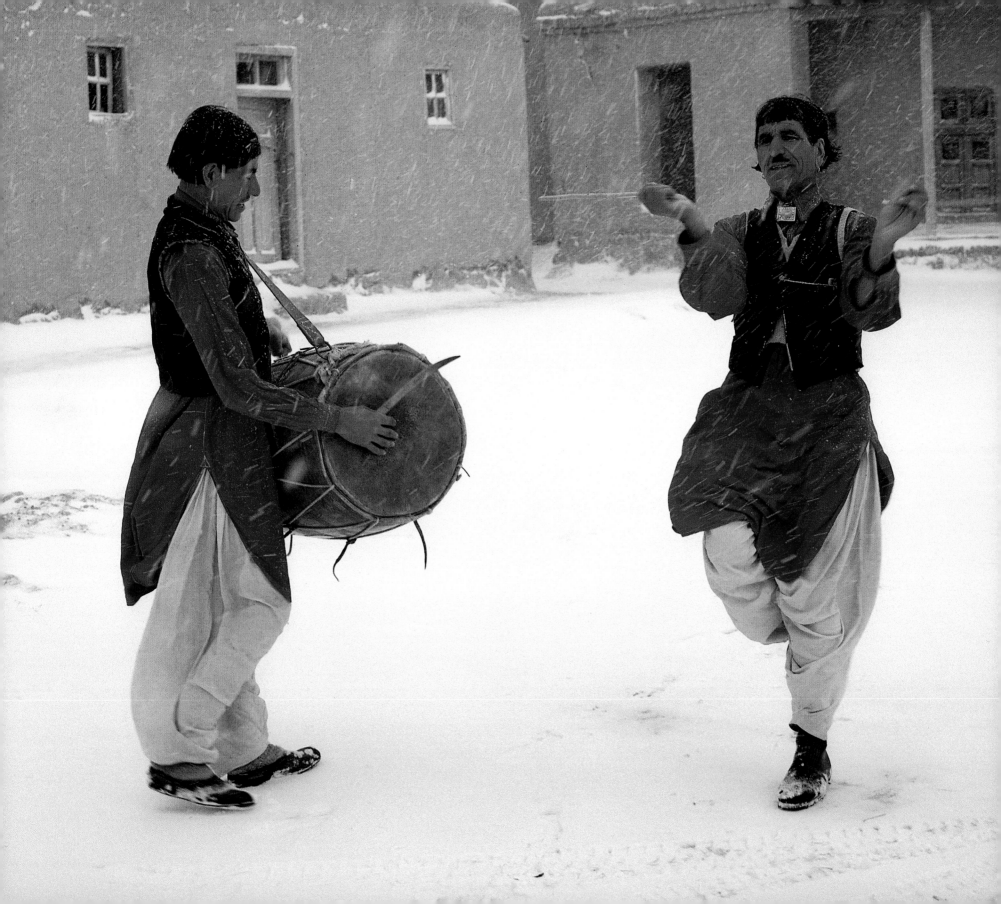

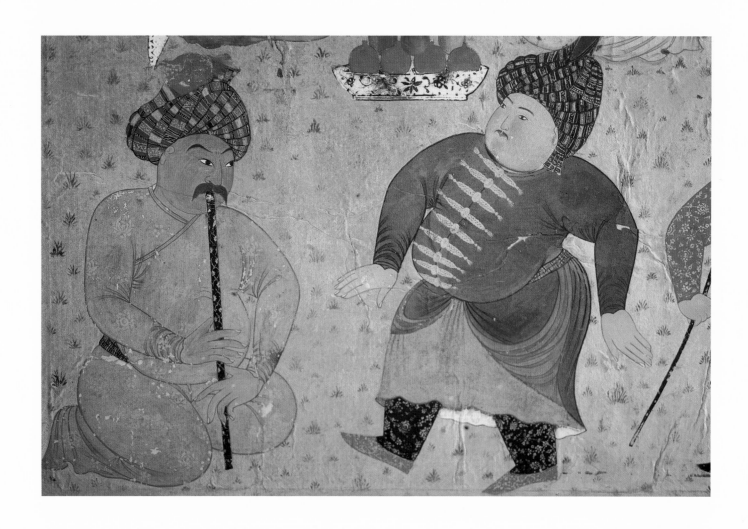

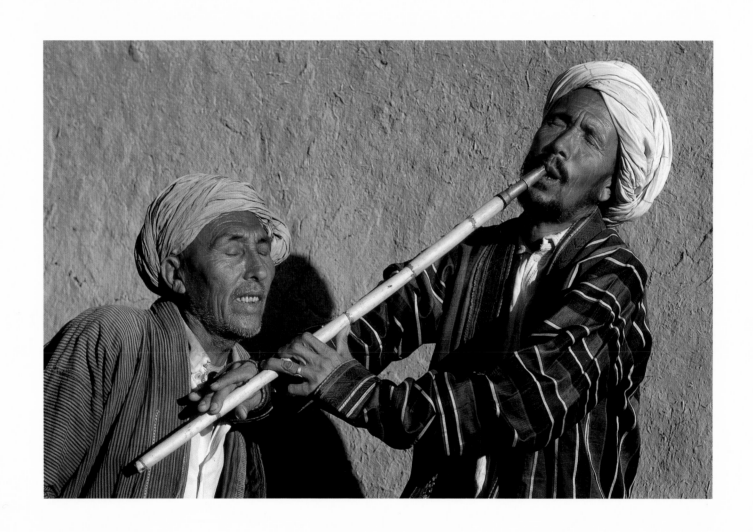

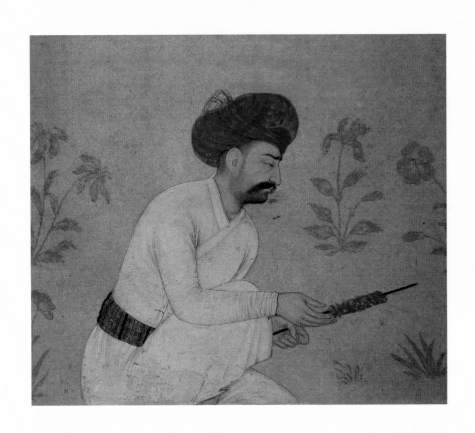

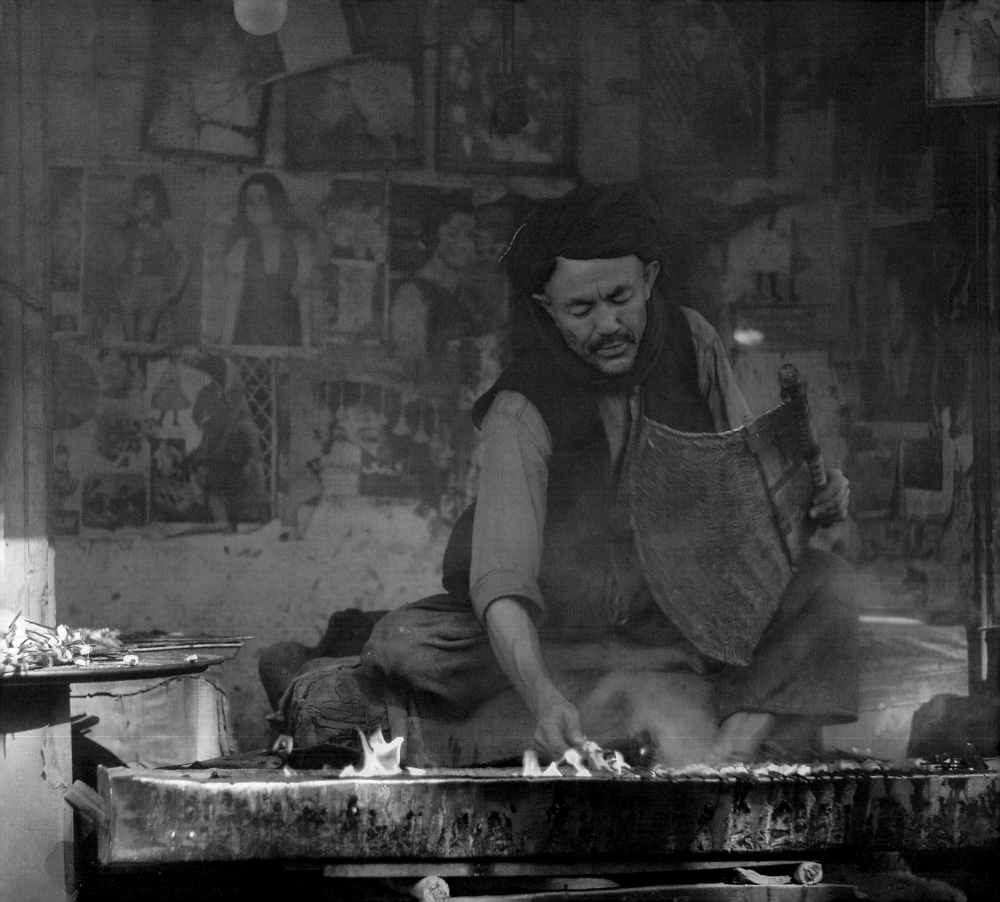

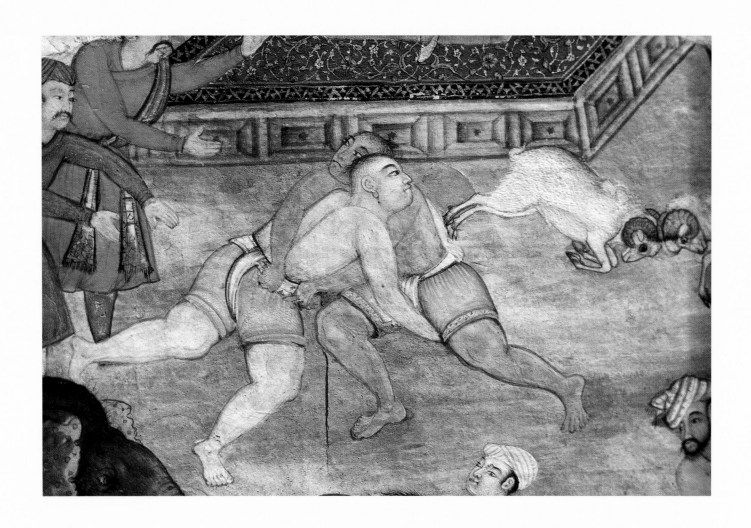

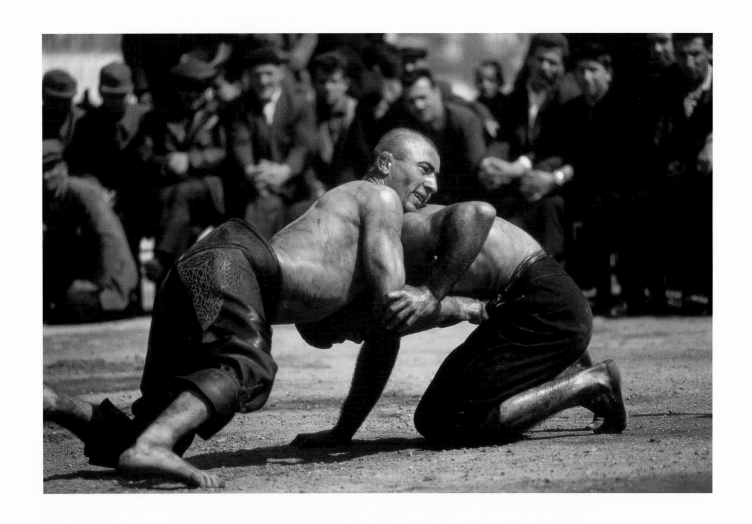

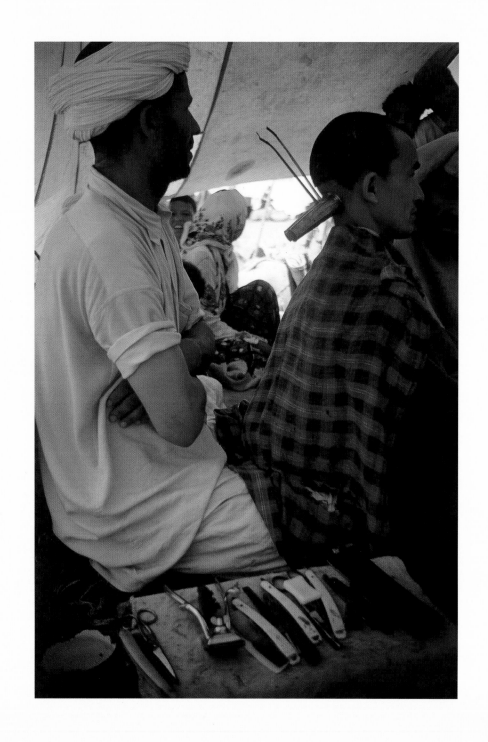

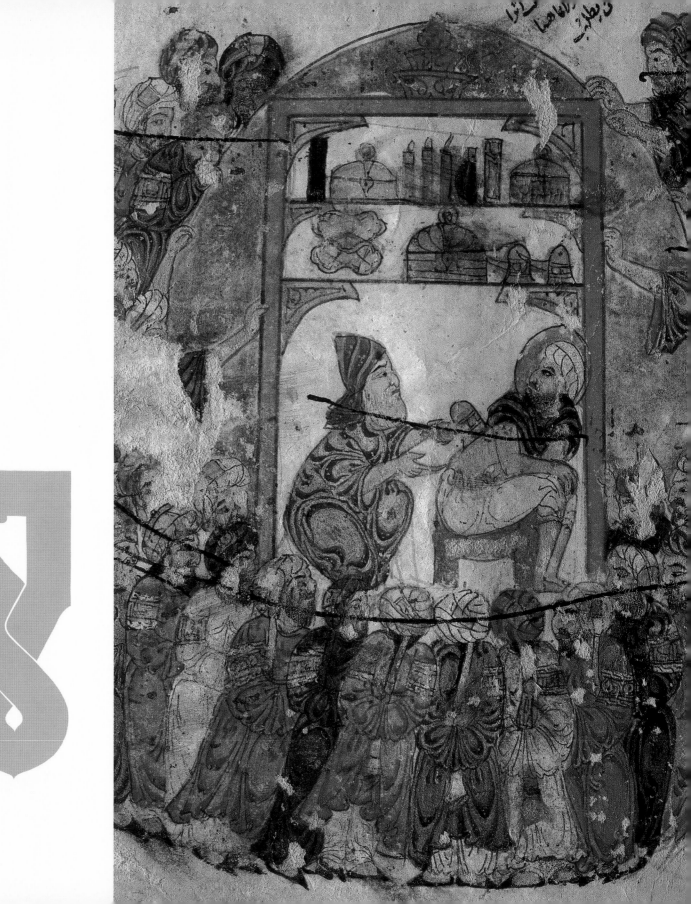

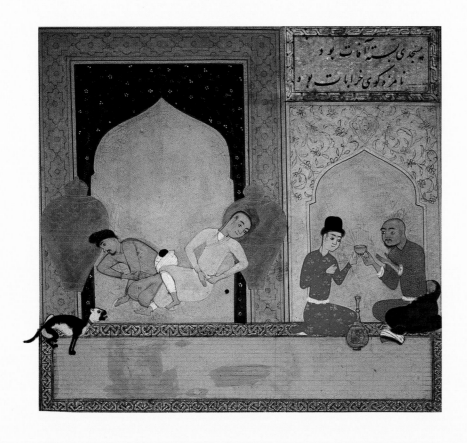

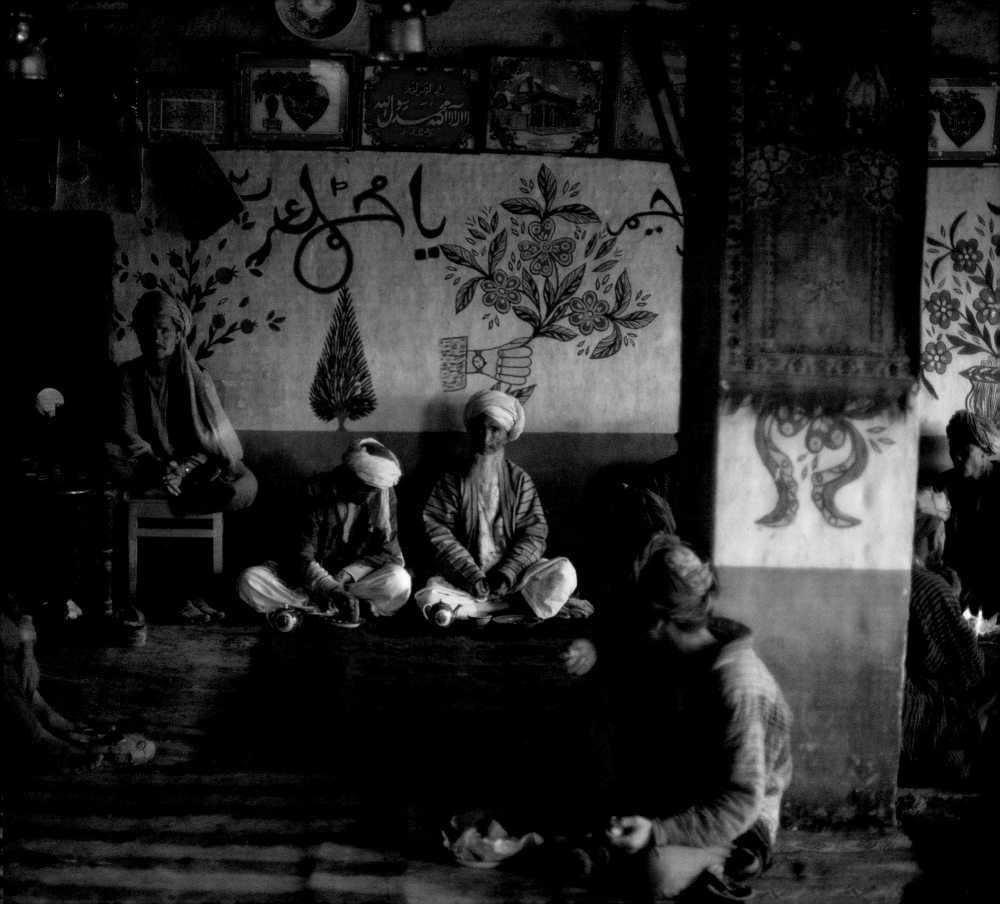

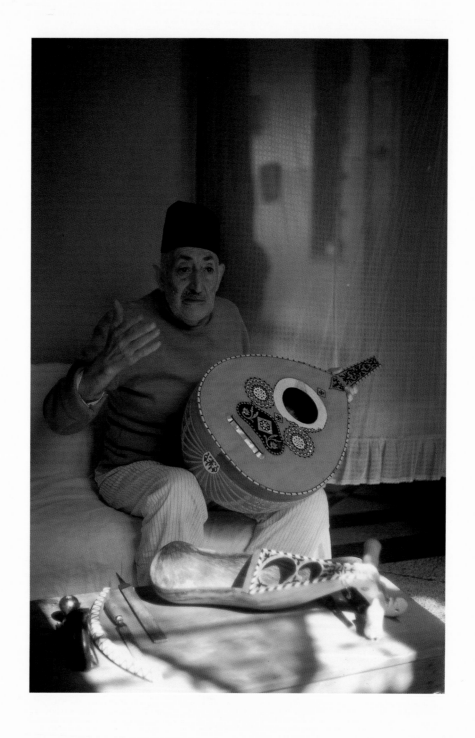

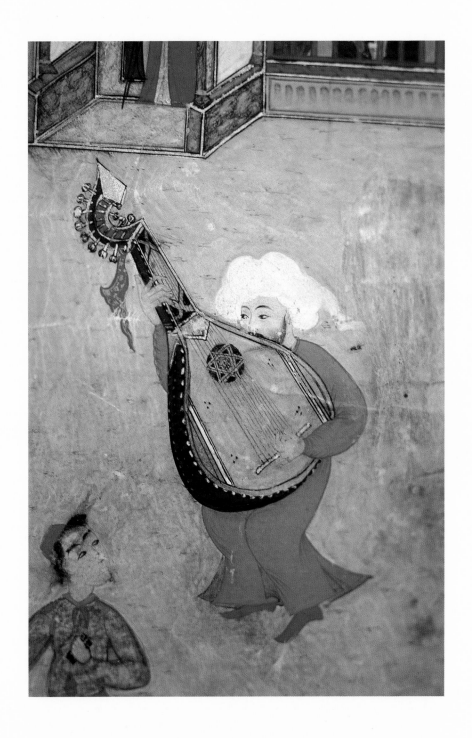

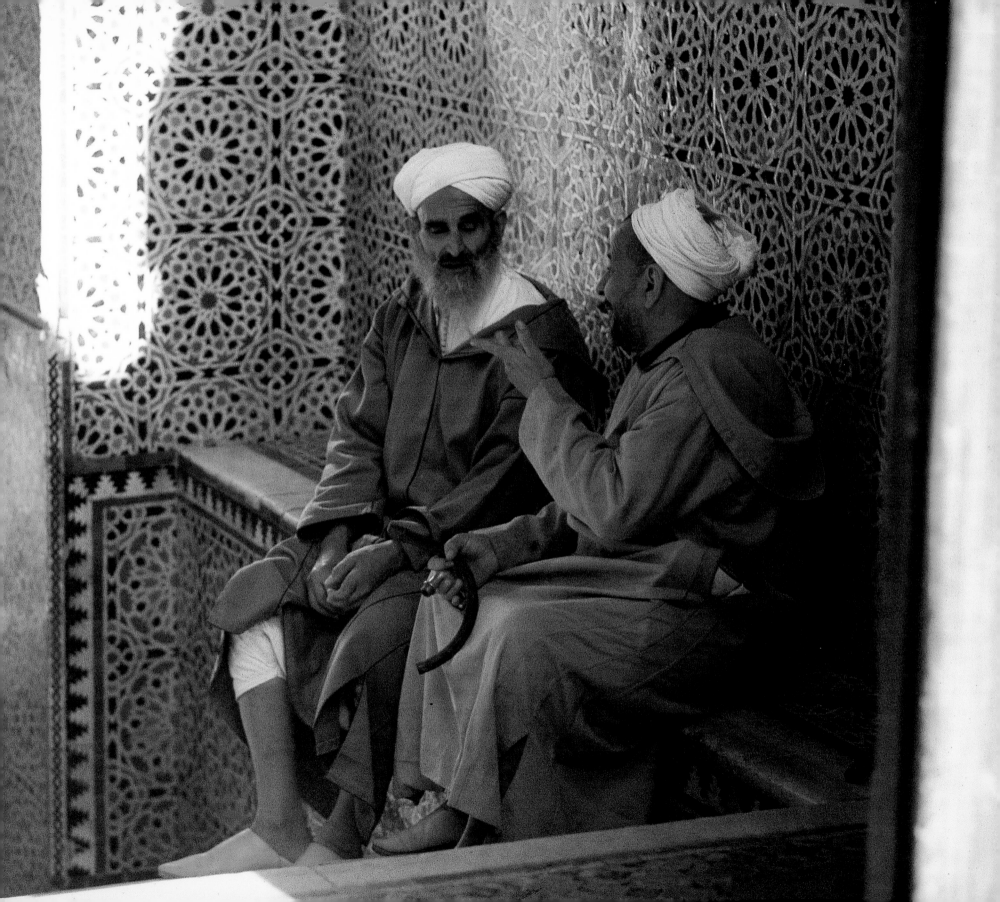

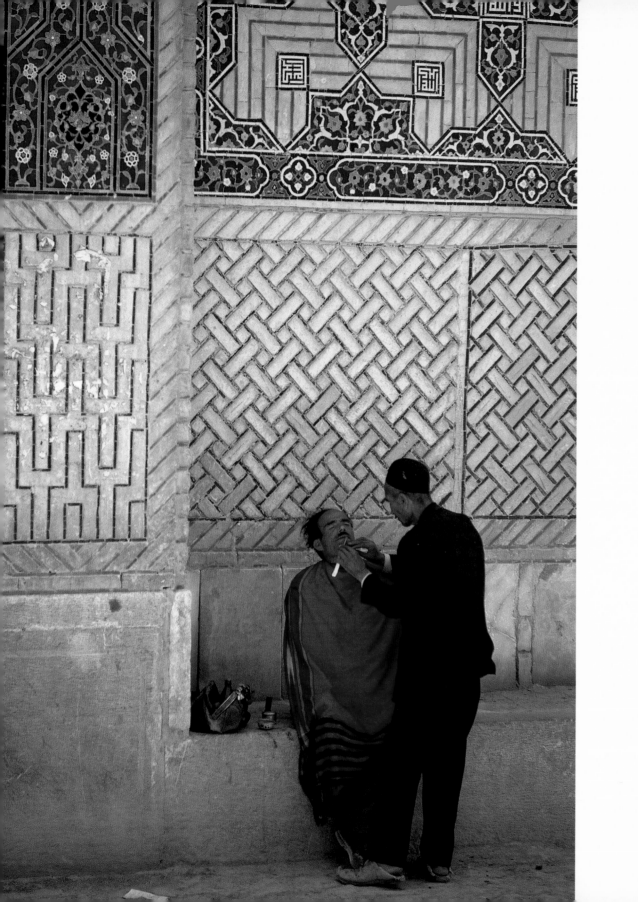

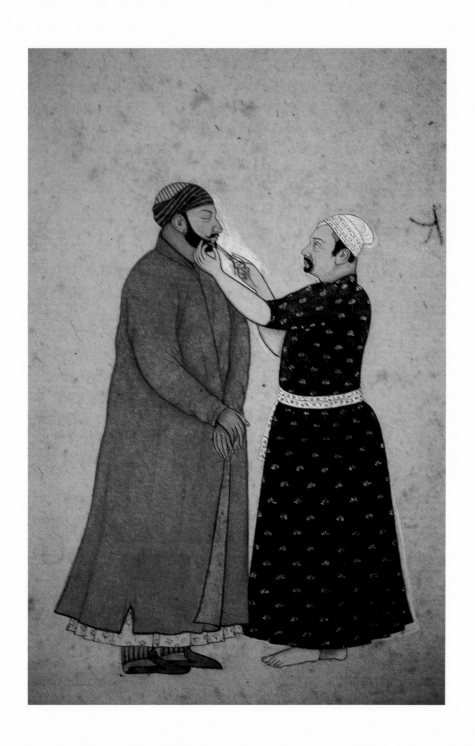

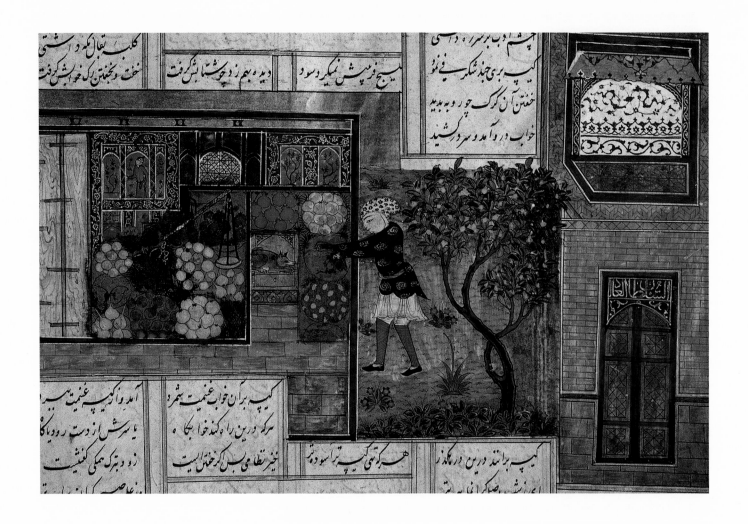

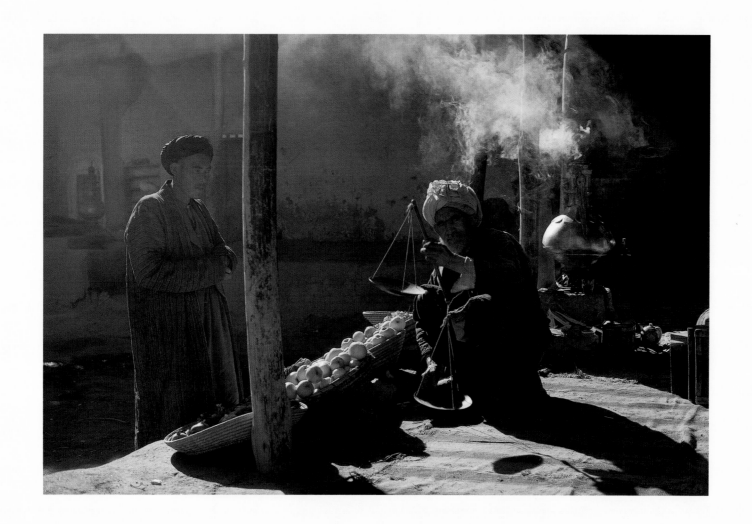

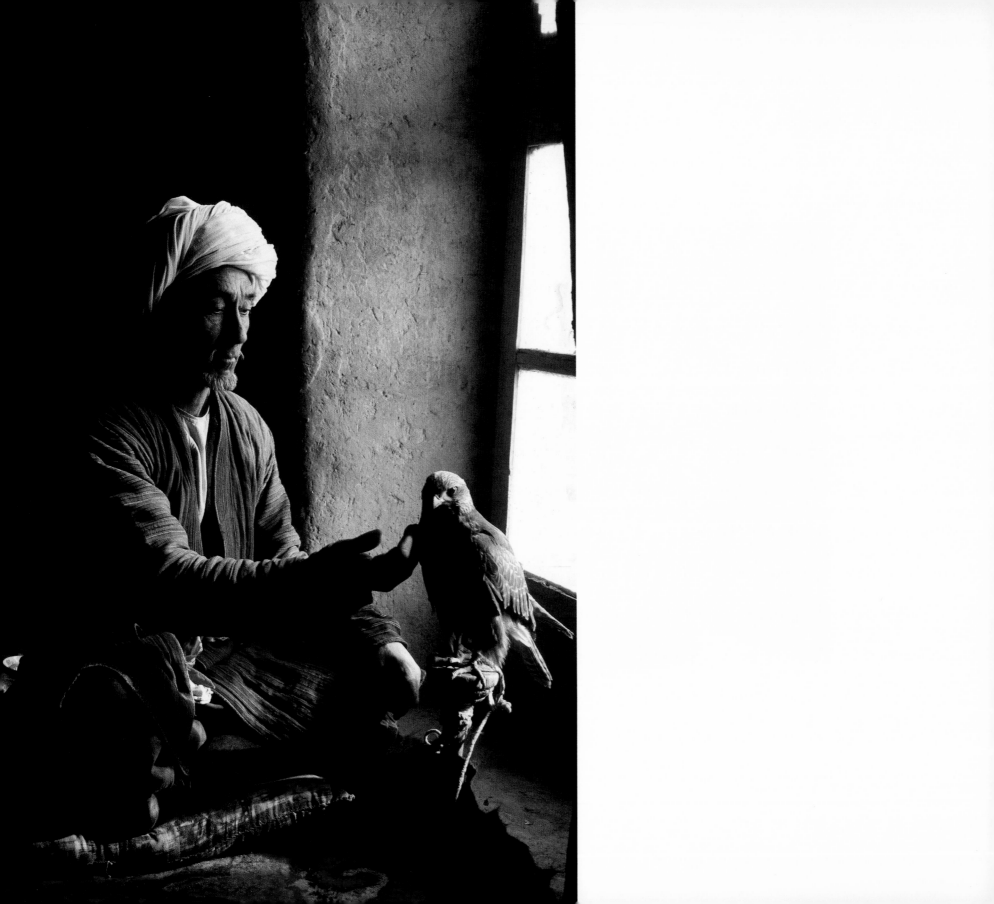

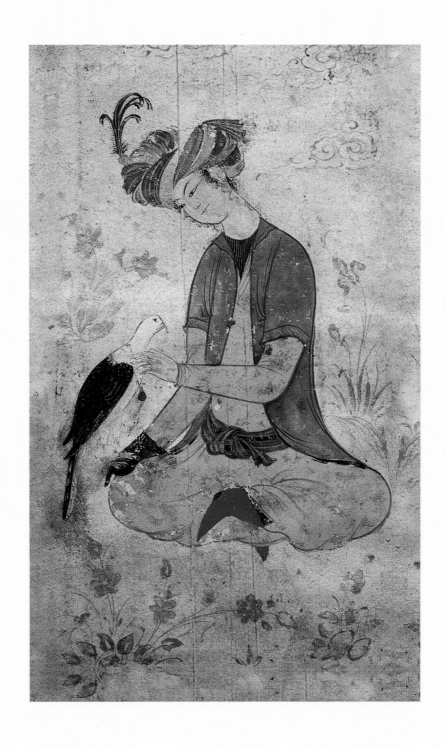

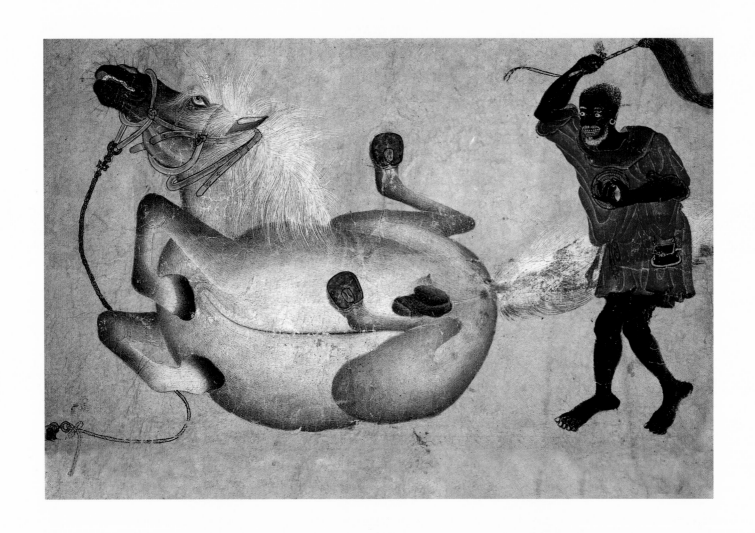

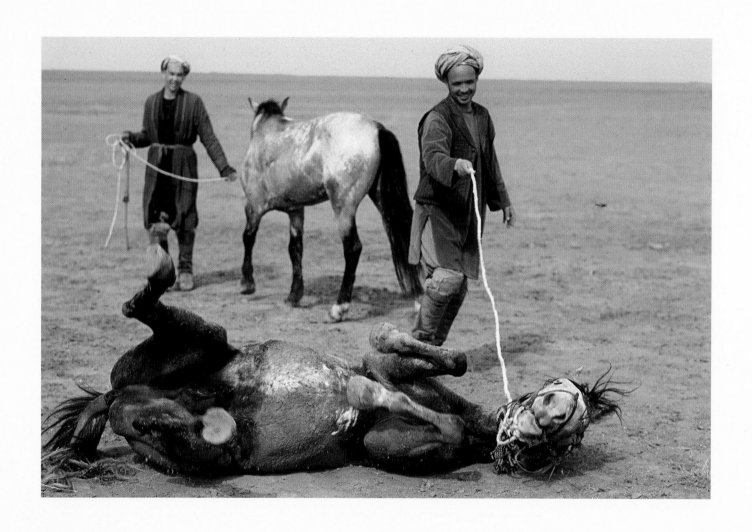

I swear by the runners breathing pantingly!

Then those that produce fire striking,

Then those that make raids at morn,

Then thereby raise dust.

The Koran, sura C, 1–4

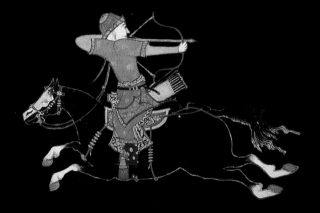

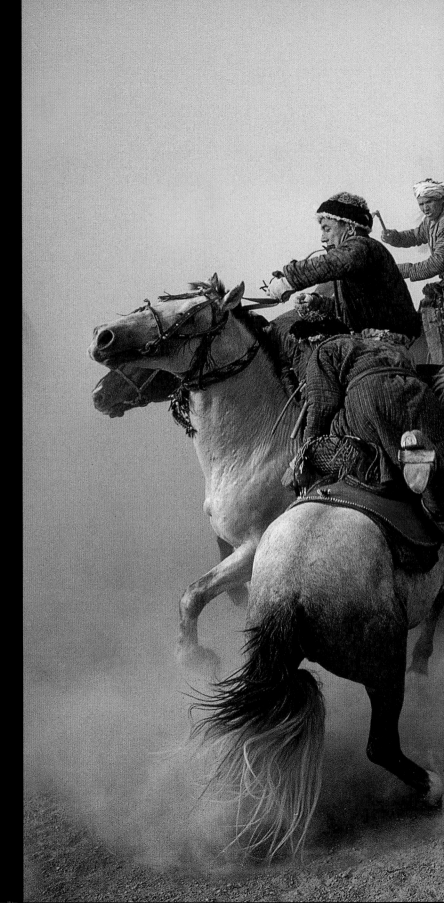

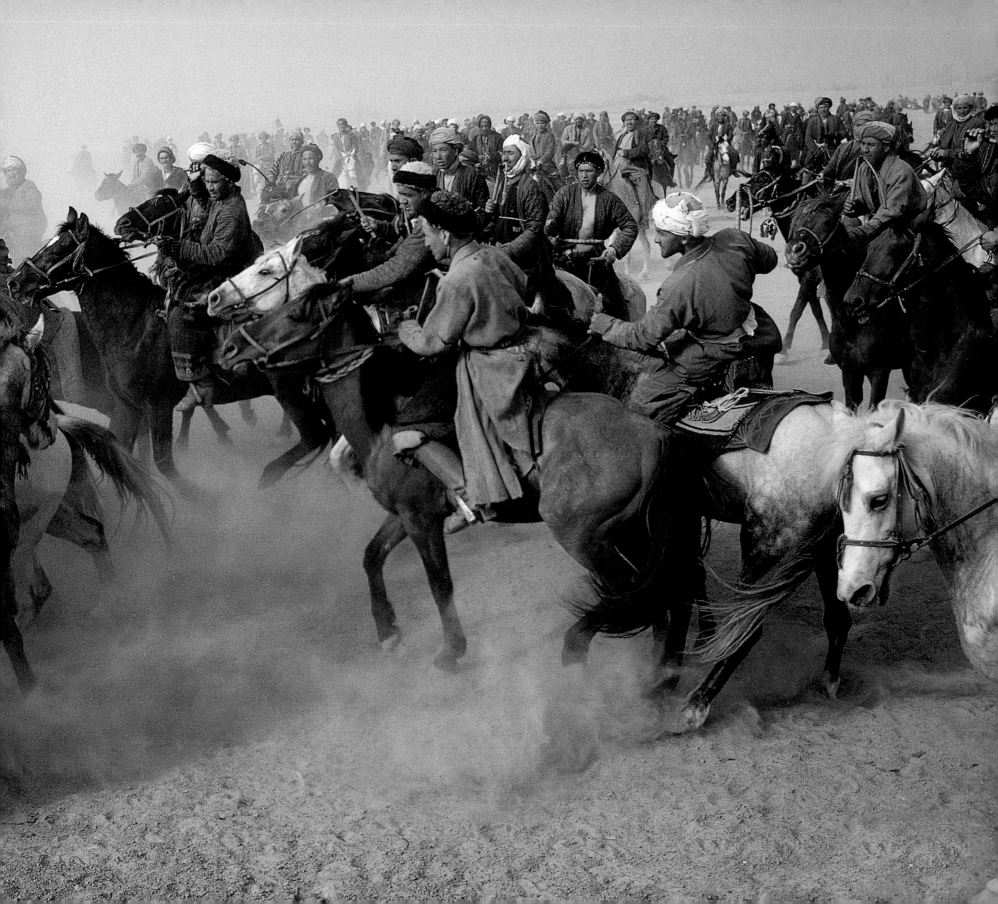

Work and Days

And He created the cattle for you; you have in them
warm clothing and advantages, and of them do you eat.
And there is beauty in them for you when you drive them
back home, and when you send them forth to pasture.

The Koran, sura XVI, 5–6

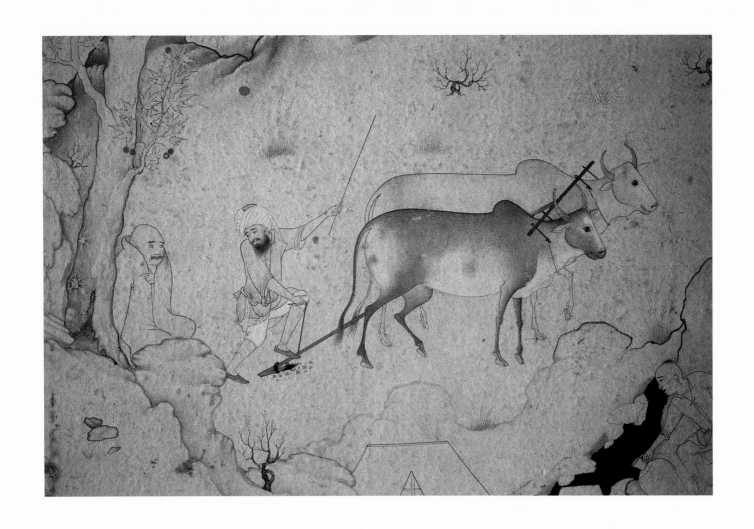

116

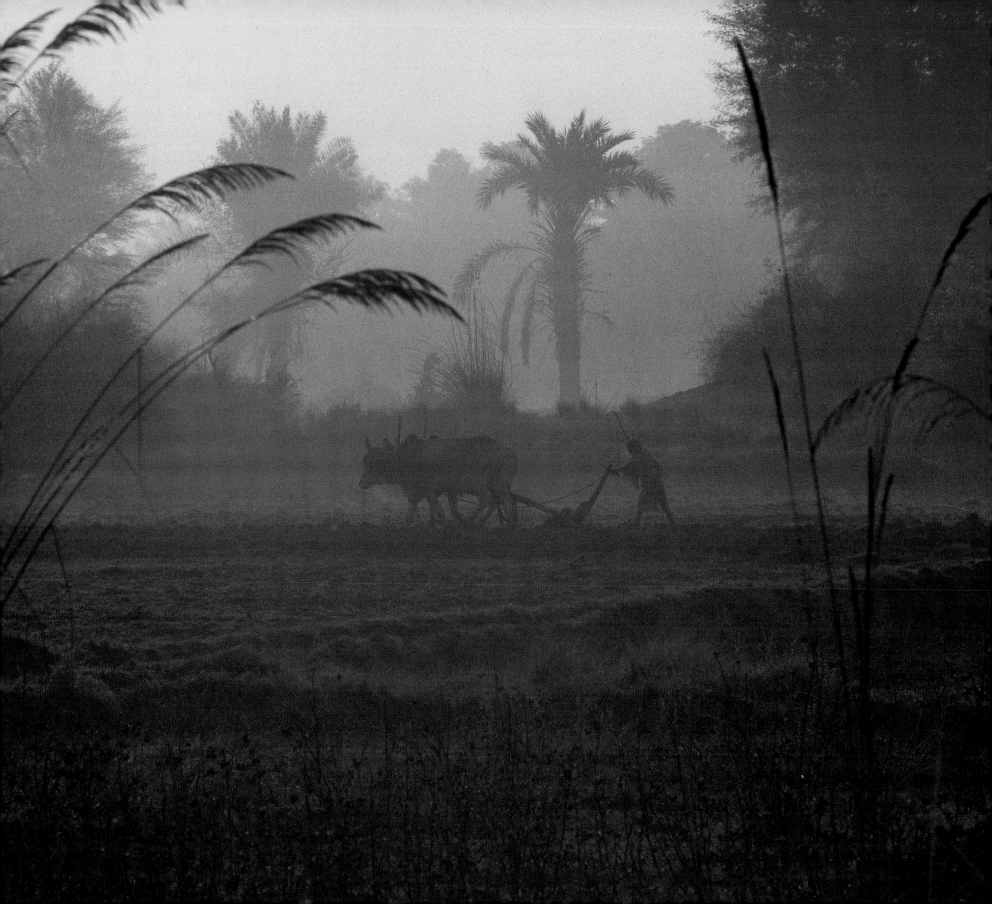

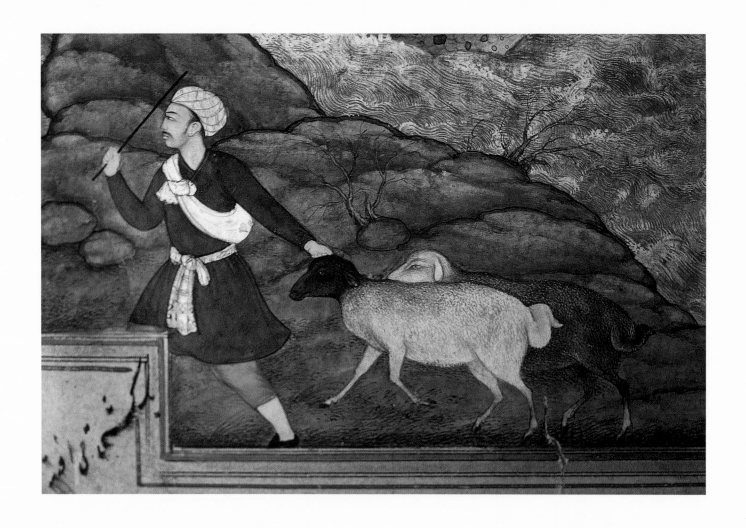

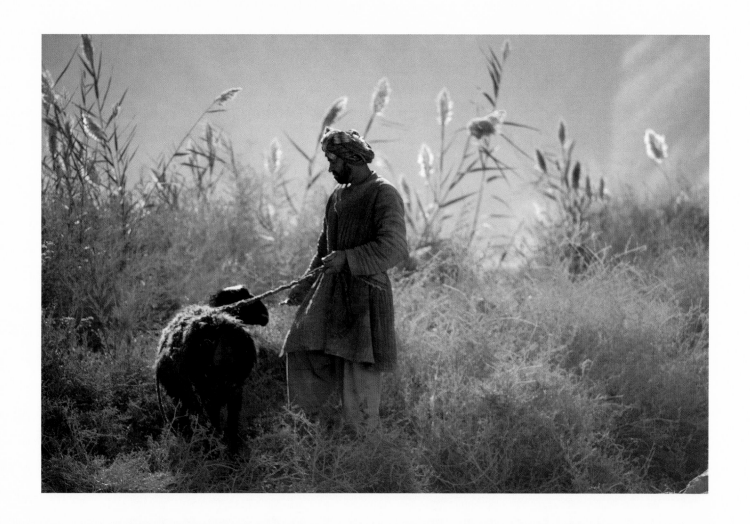

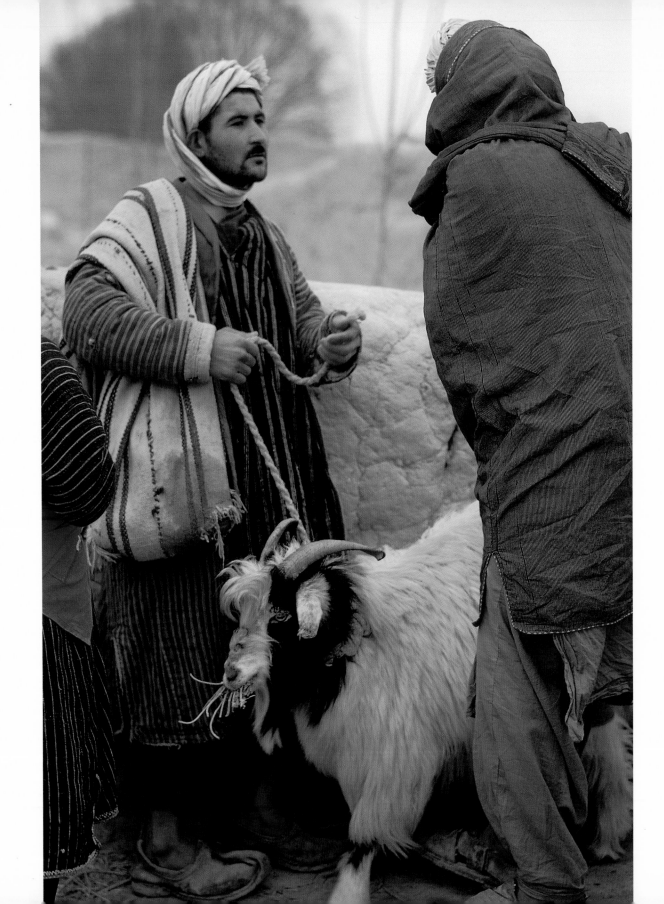

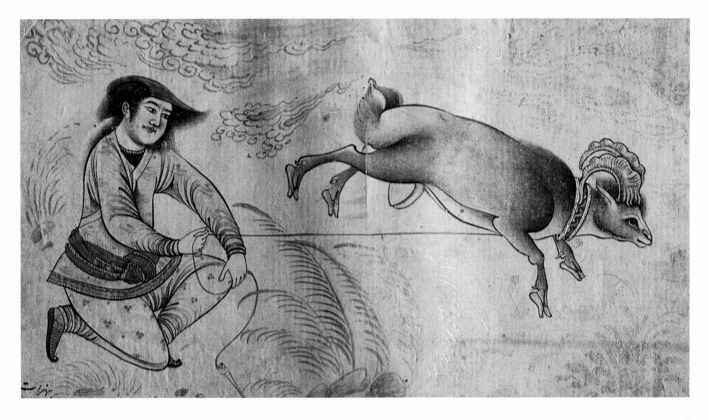

أعوذ بالله العظيم من الشيطان الرجيم

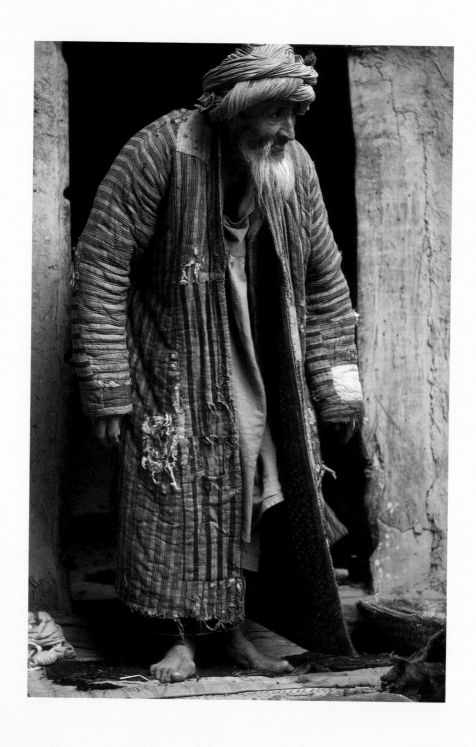

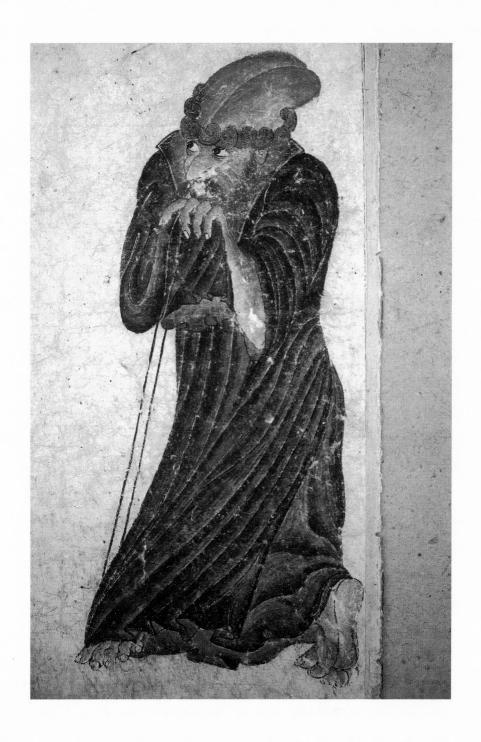

123

Tea is such a valuable commodity that each camel driver
carries it on his person in a small intricately embroidered bag.
Sugar is so precious that tea is drunk with salt instead, and salt
so rare that it is only used in tea.

Roland and Sabrina Michaud, *Caravanes de Tartarie*

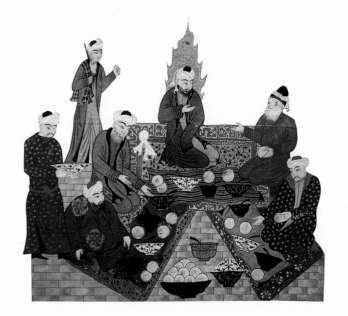

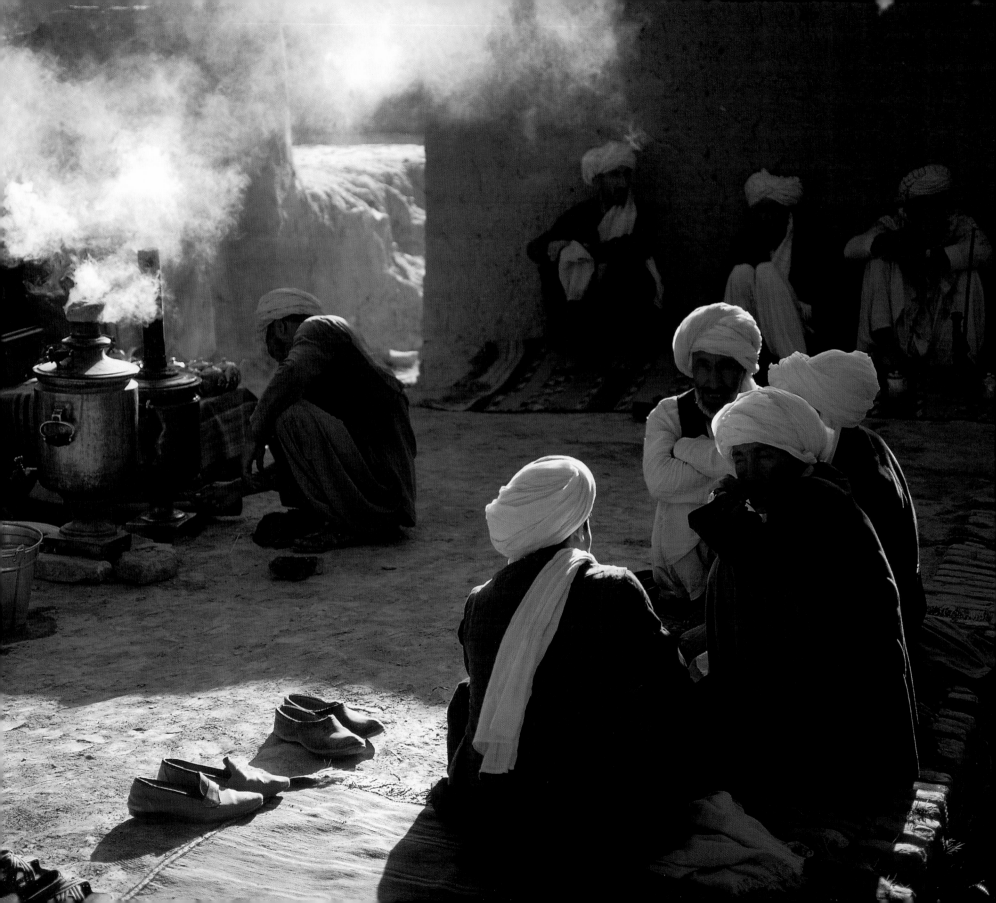

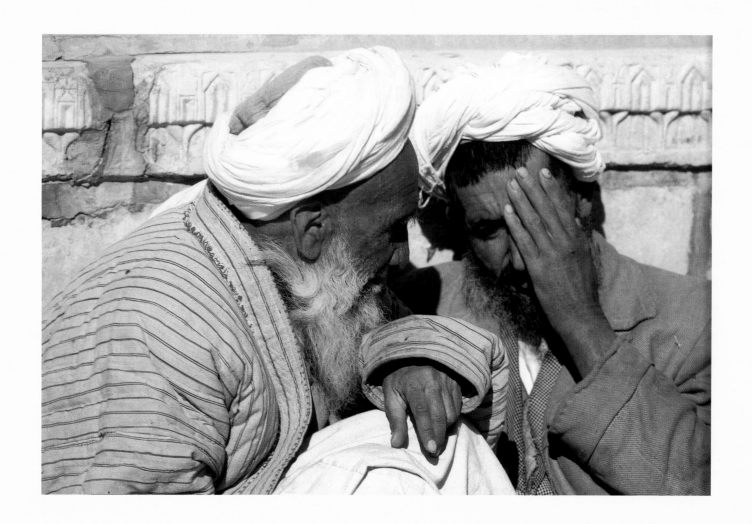

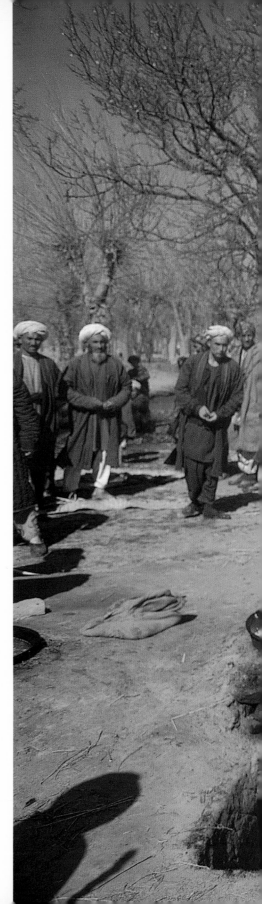

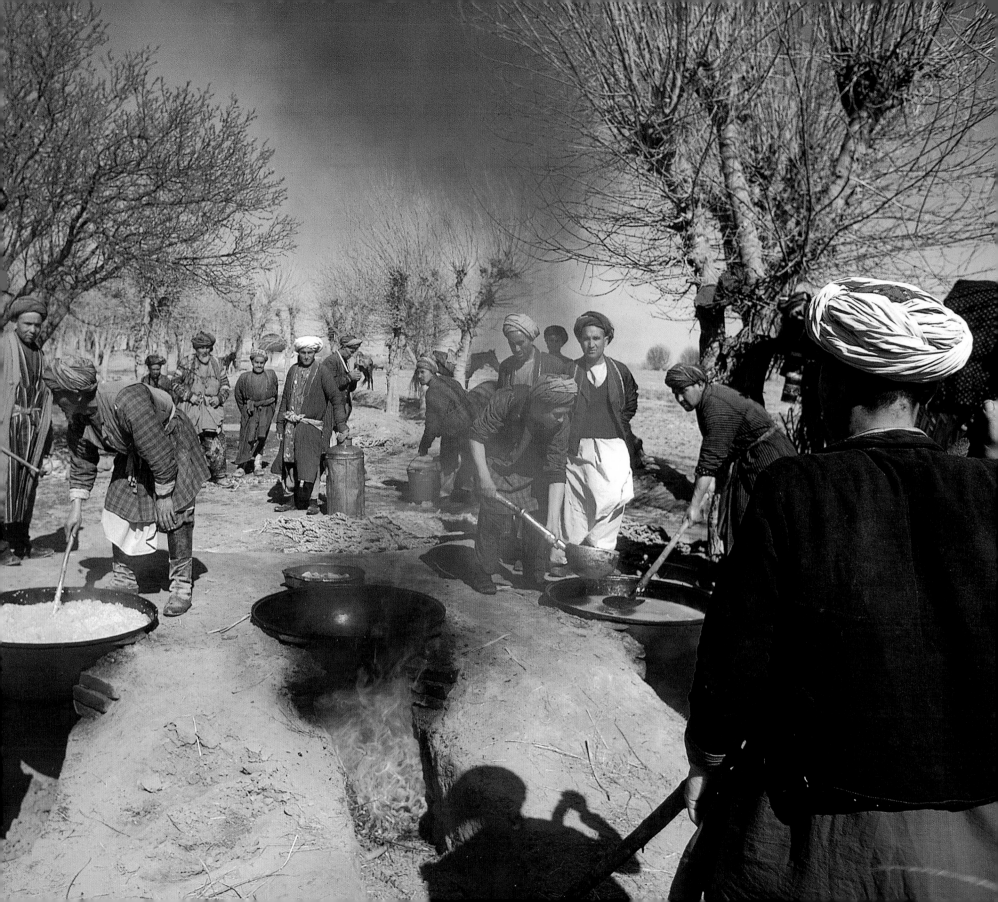

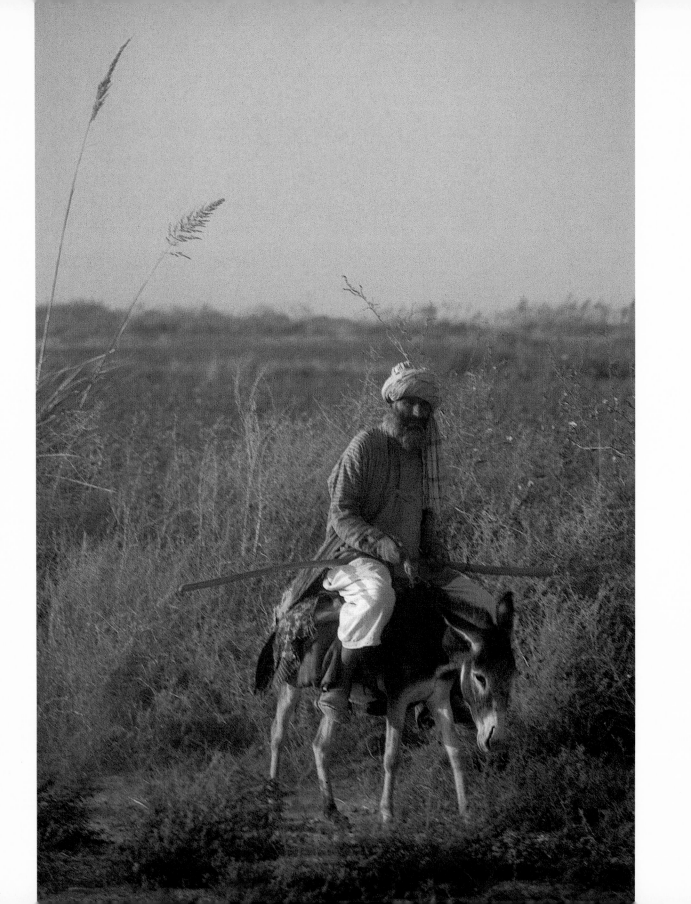

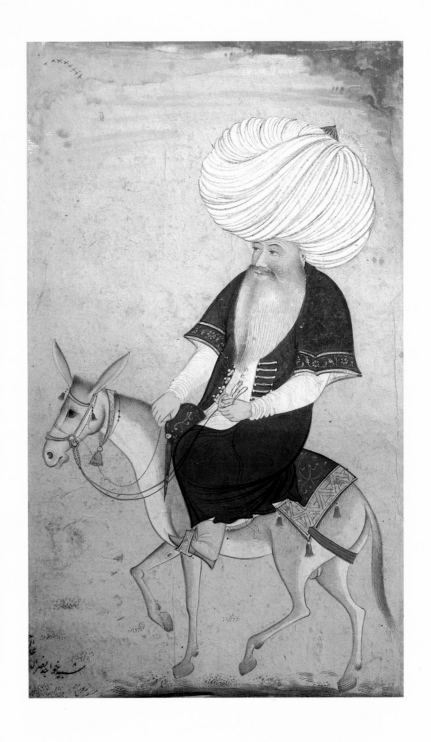

131

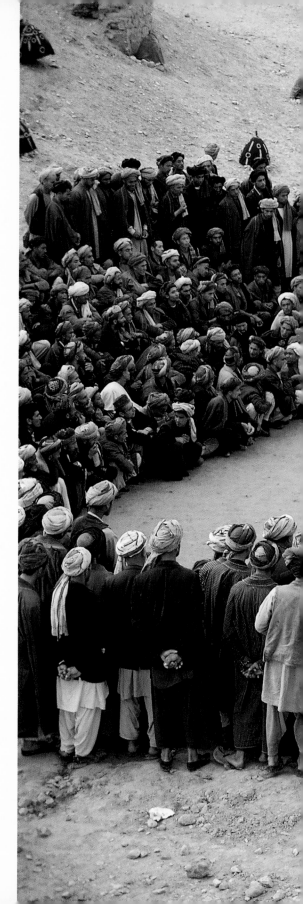

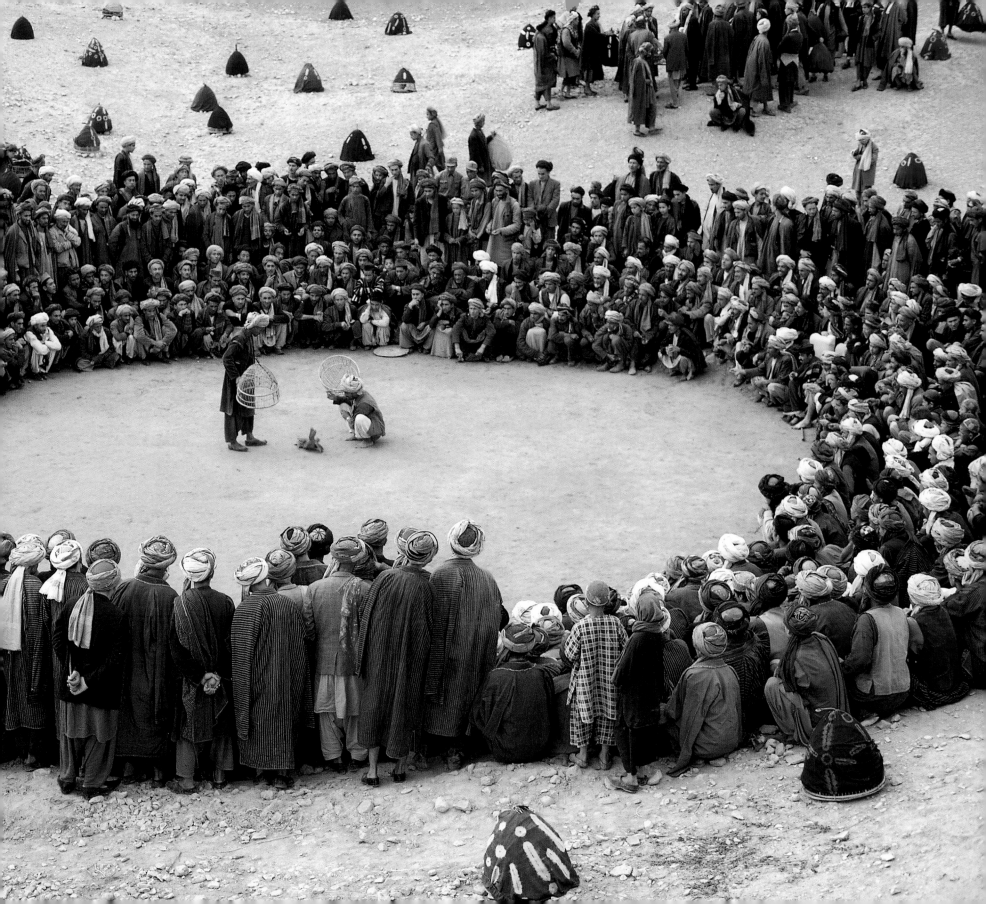

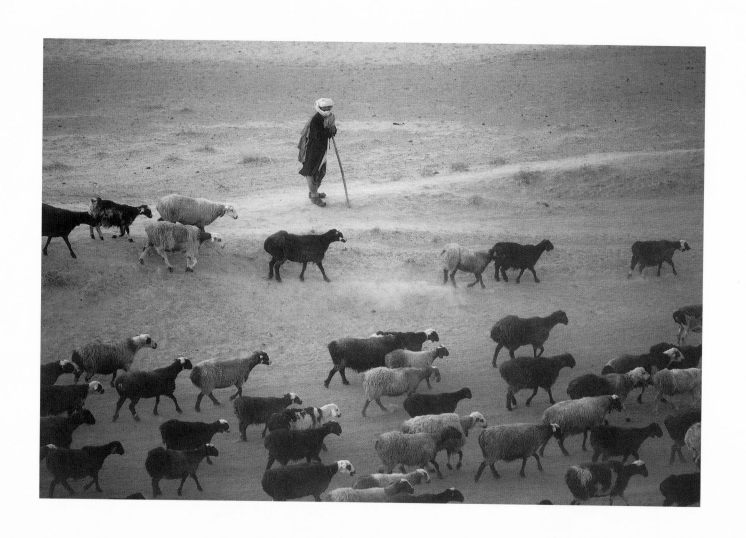

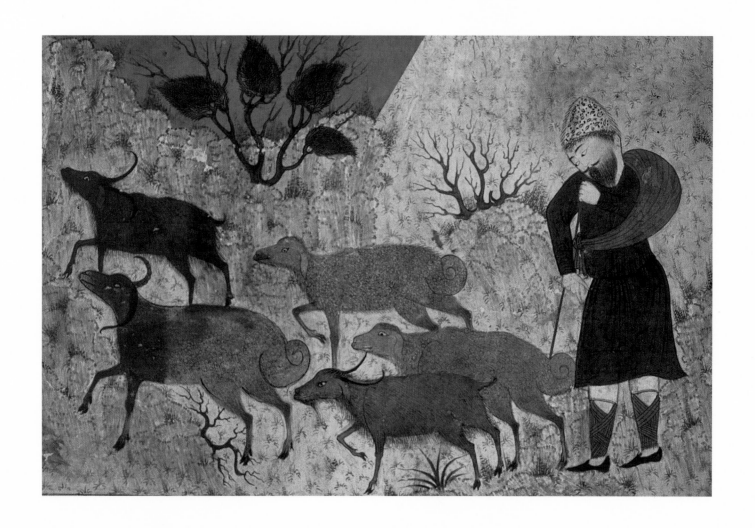

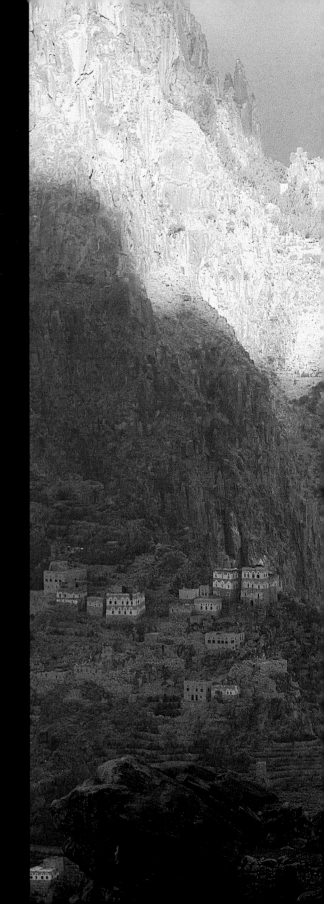

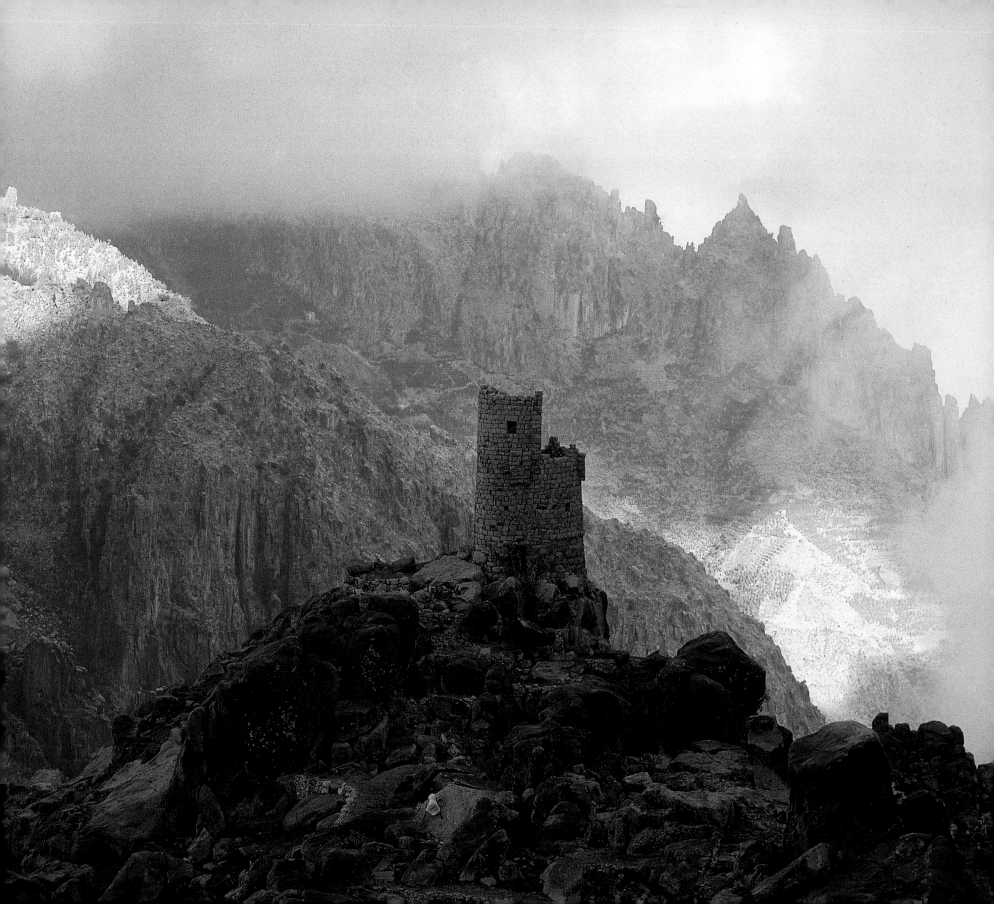

Surrendering to God

Were every tree that is in the earth made into pens and the
sea to supply it with ink, with seven more seas to increase it,
the words of Allah would not come to an end.

The Koran, sura XXXI, 27

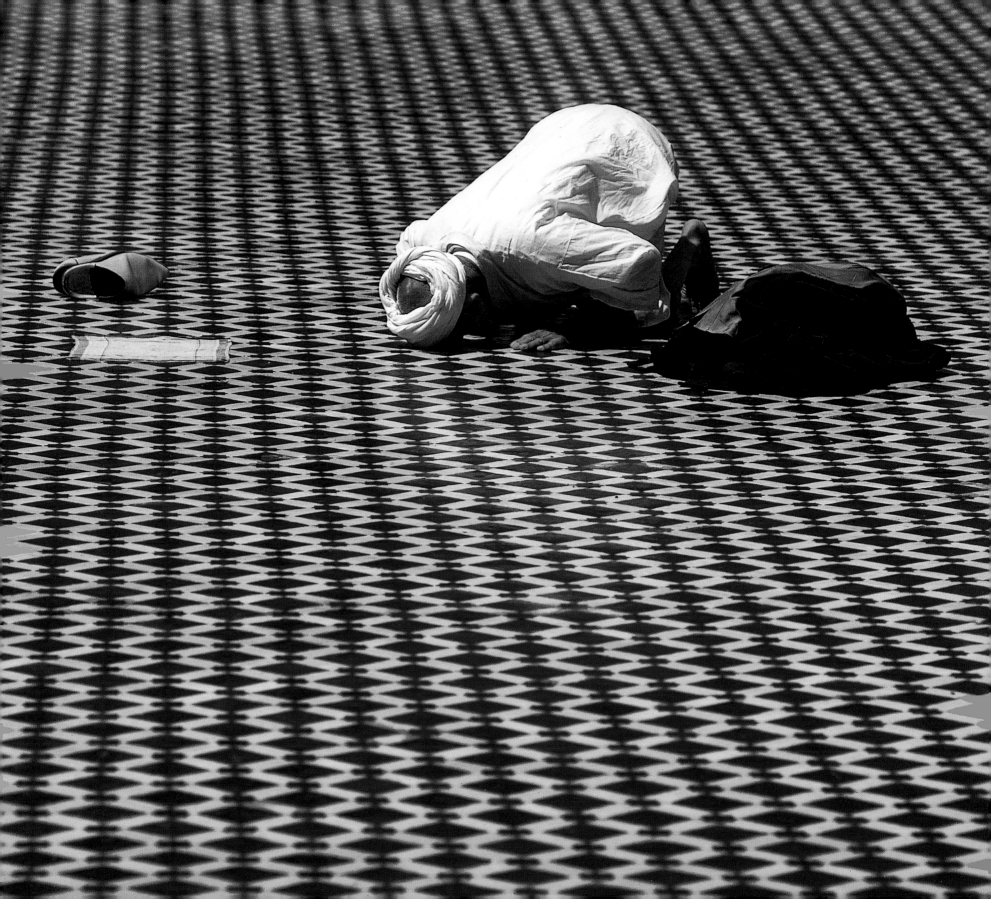

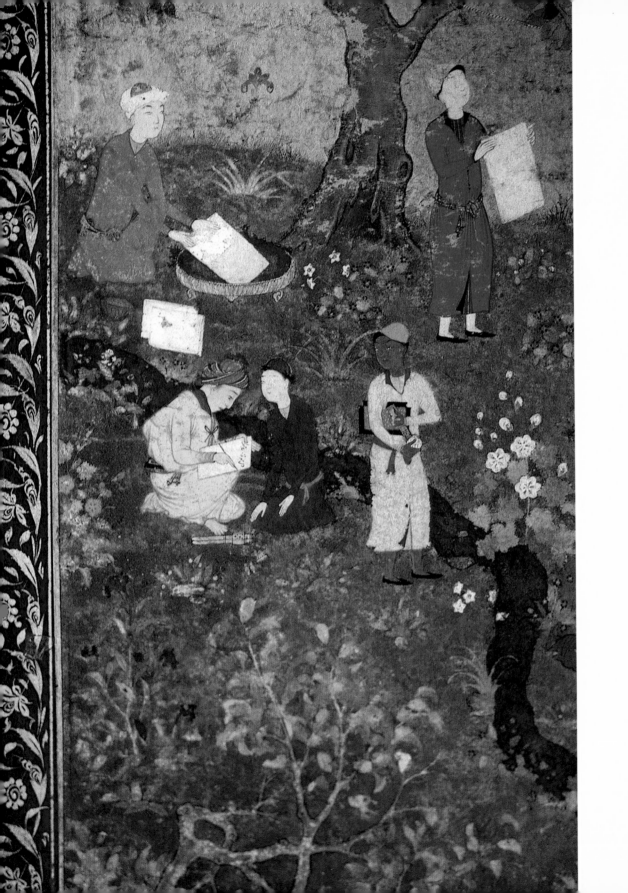

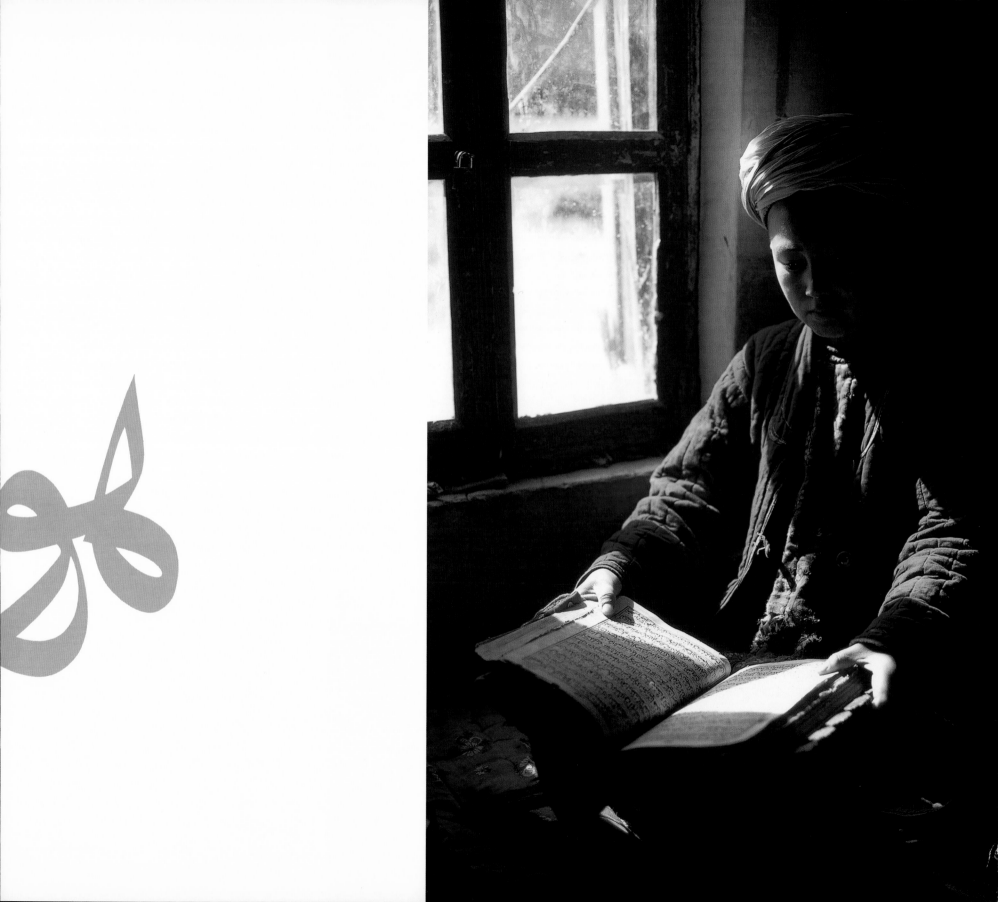

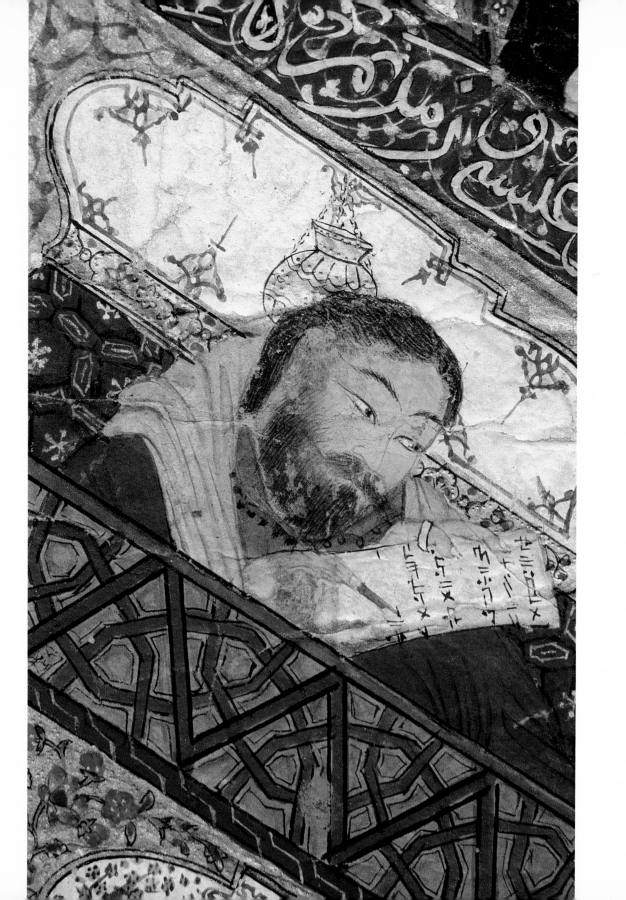

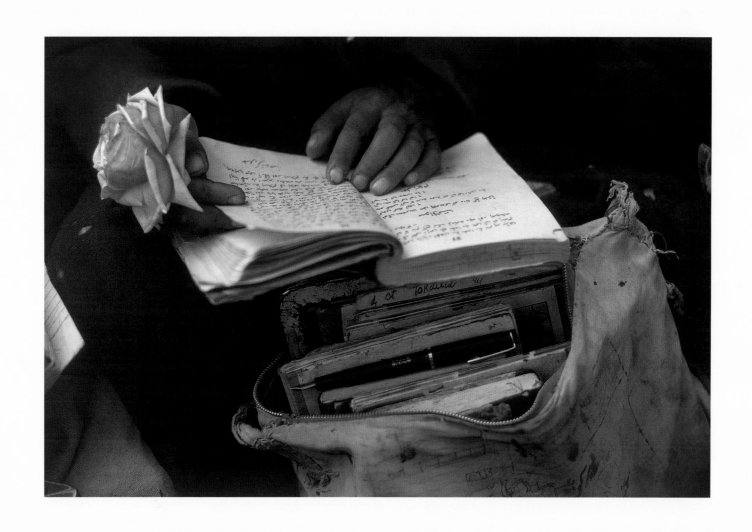

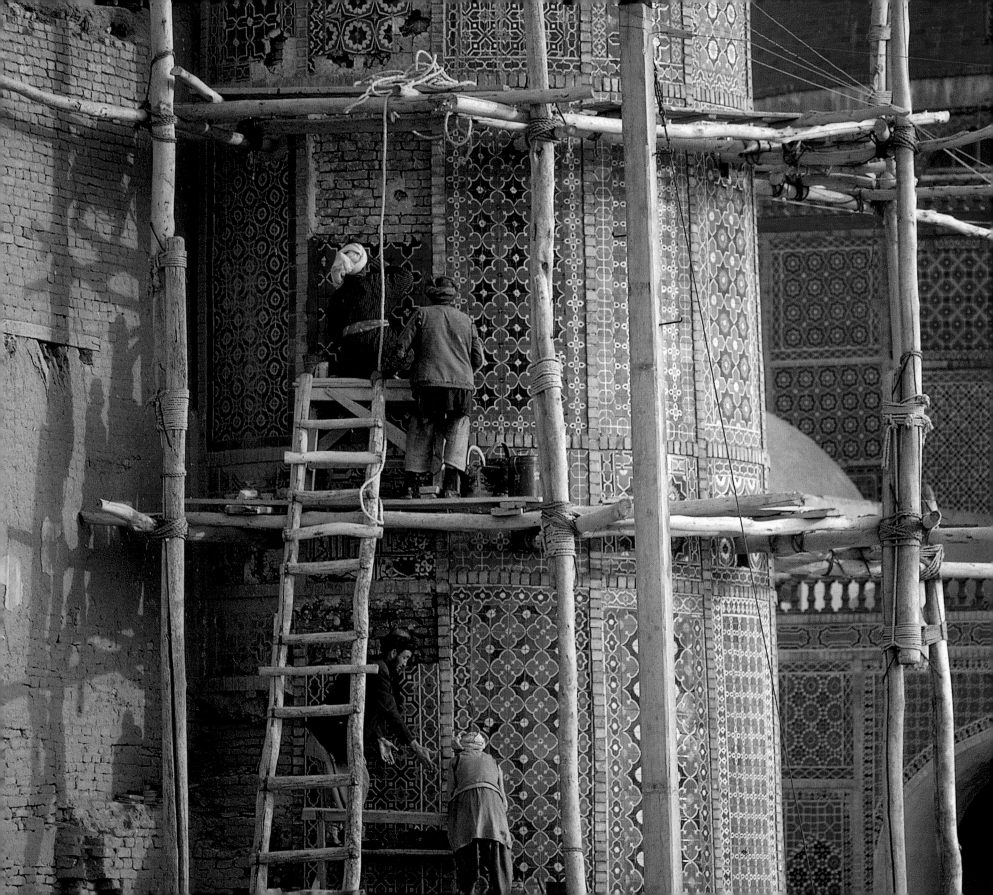

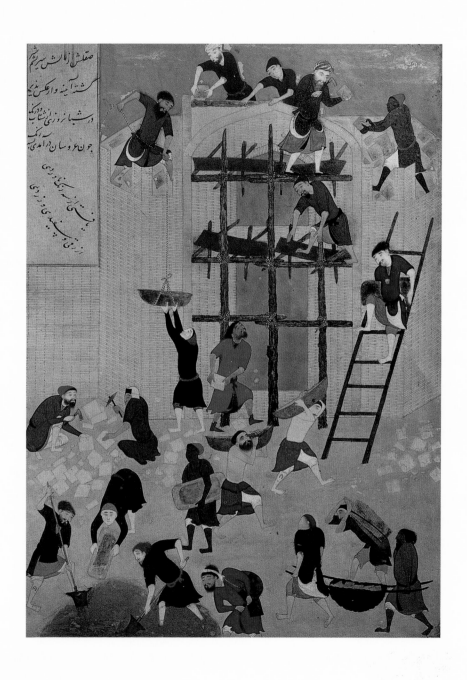

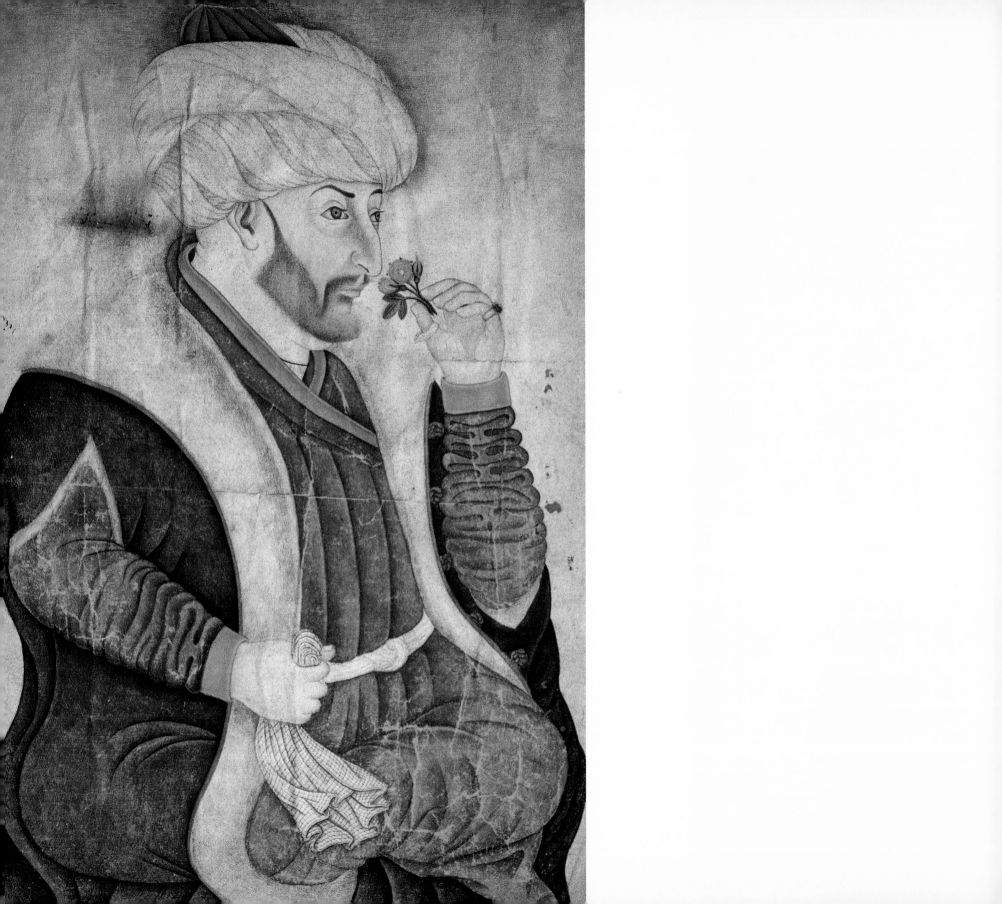

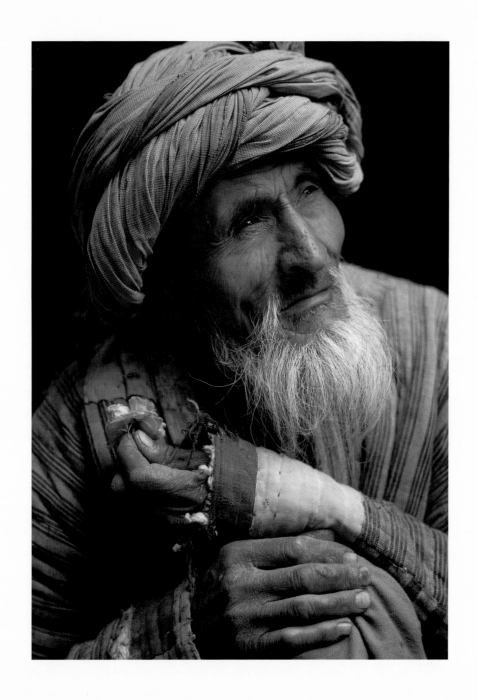

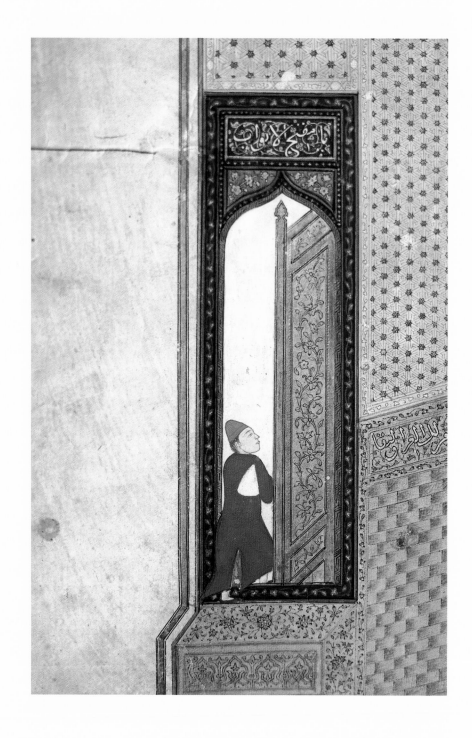

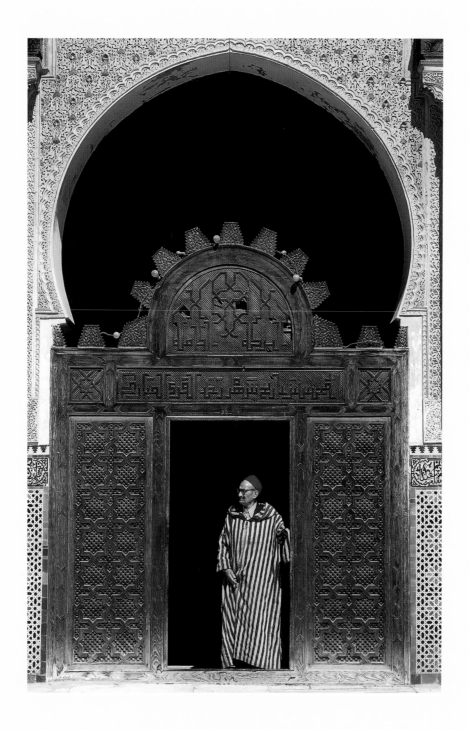

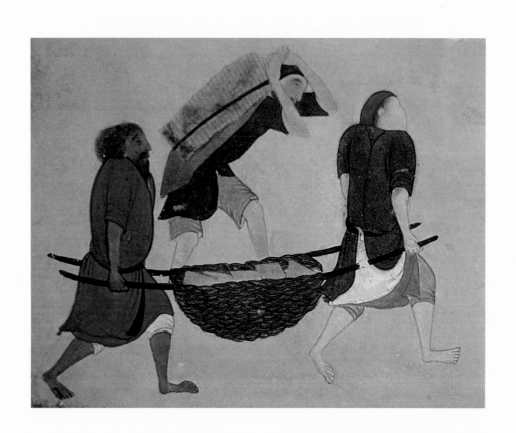

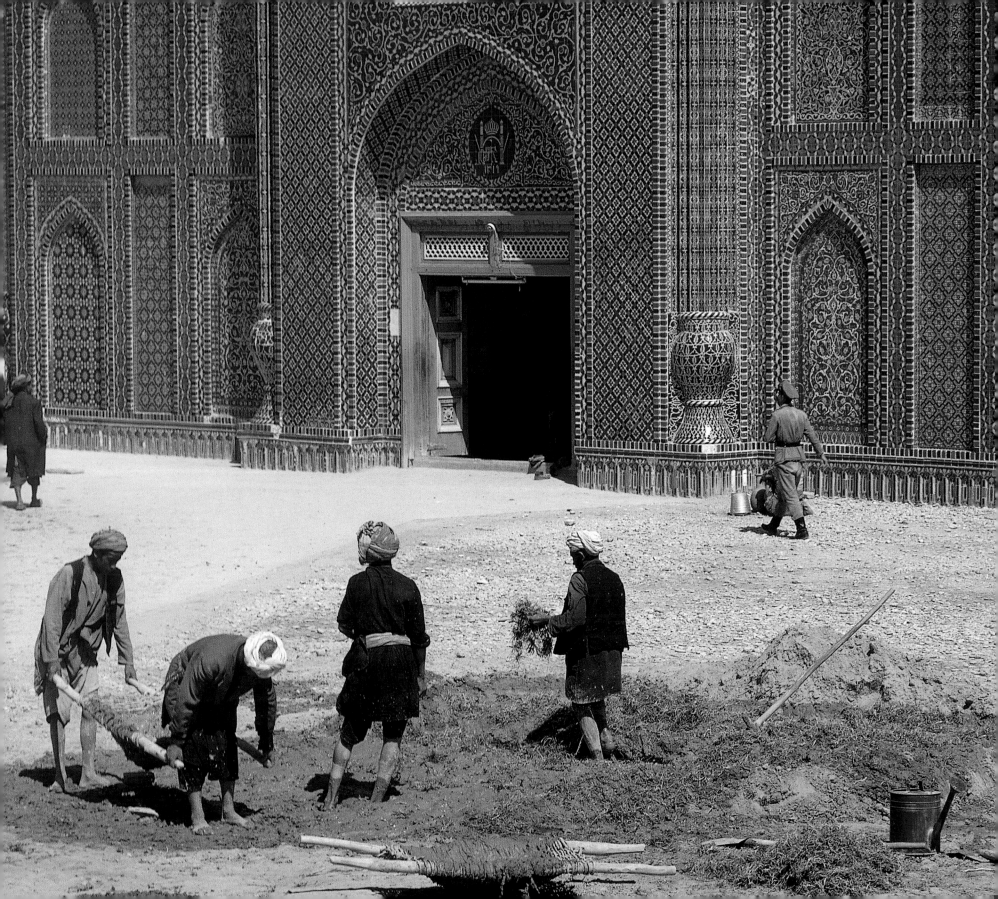

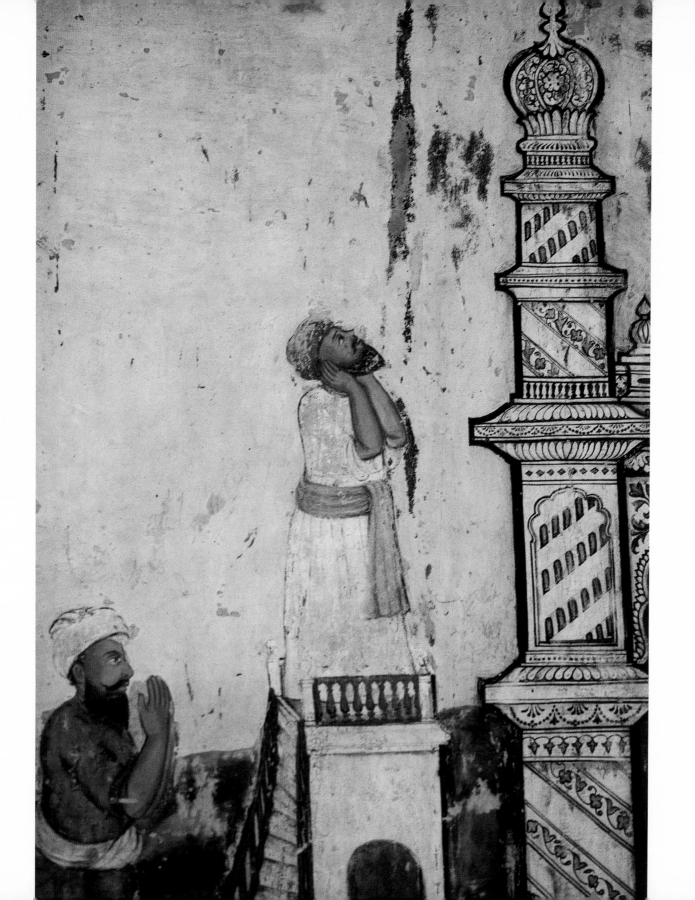

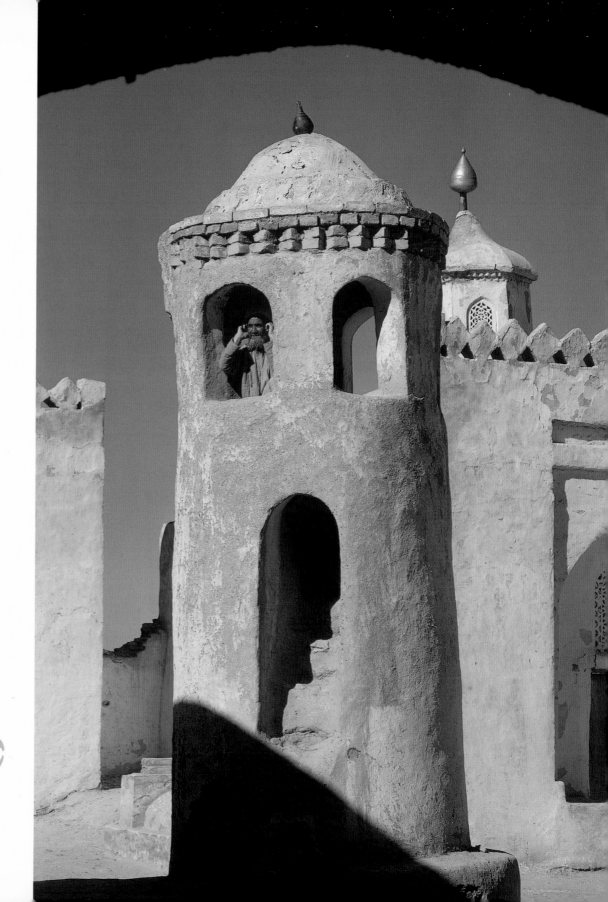

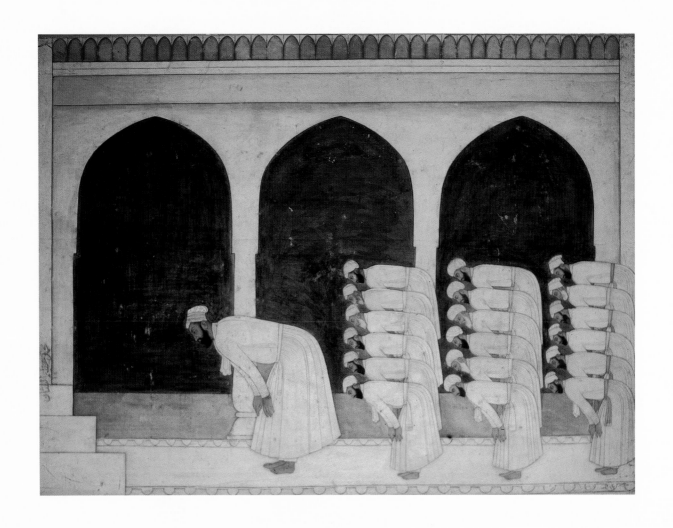

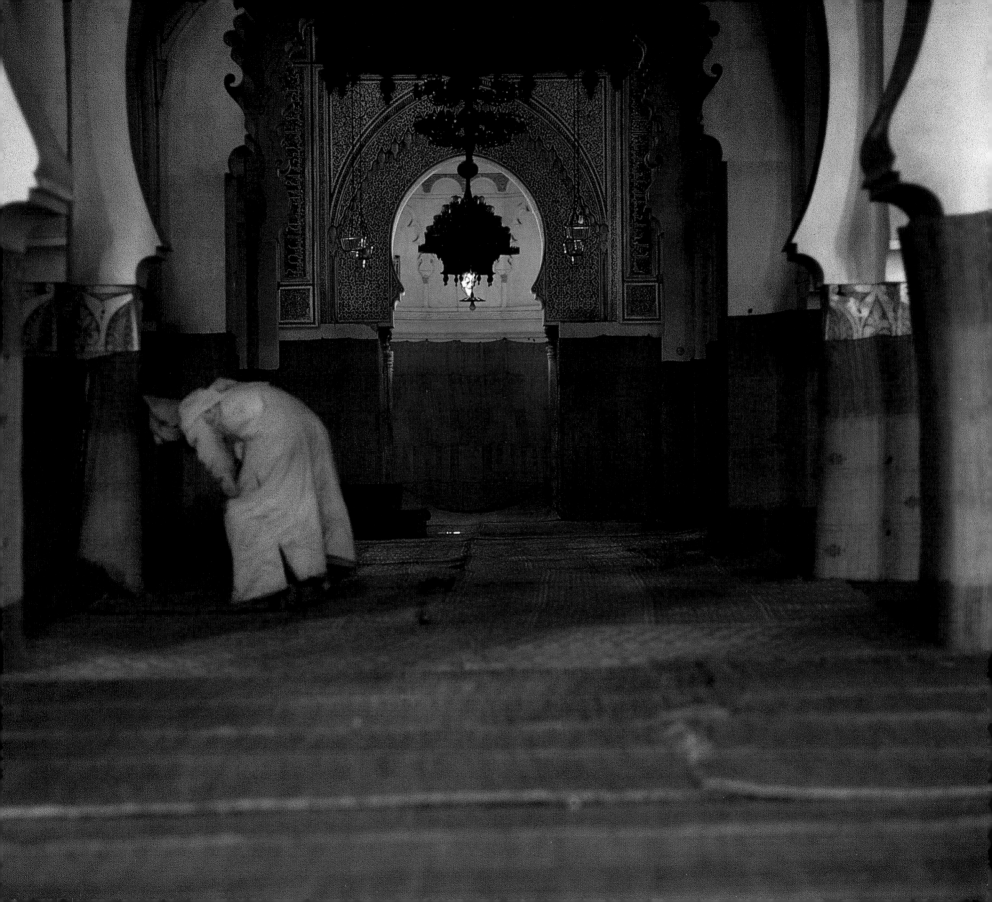

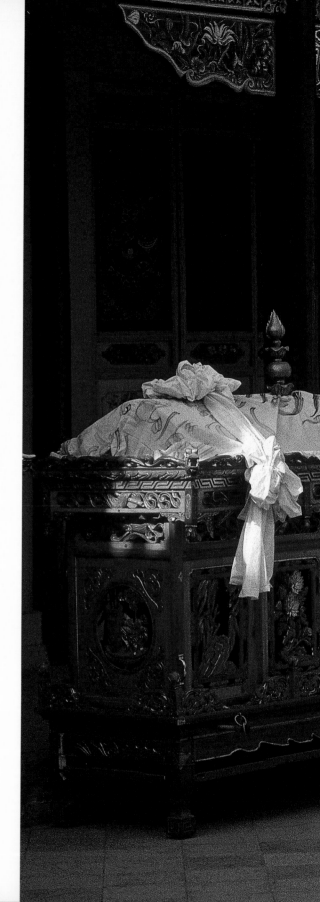

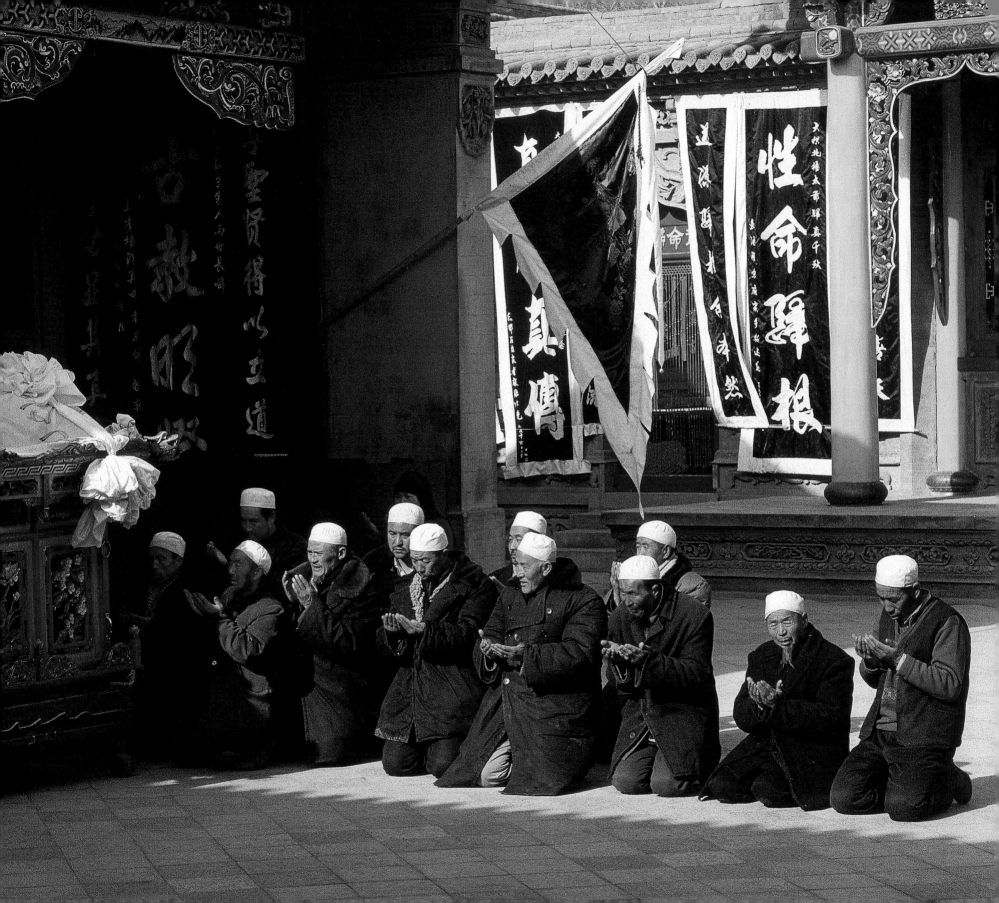

There is nothing greater than praying to Allah.

Allah knows exactly what you do.

The Koran, sura XXIX, 45

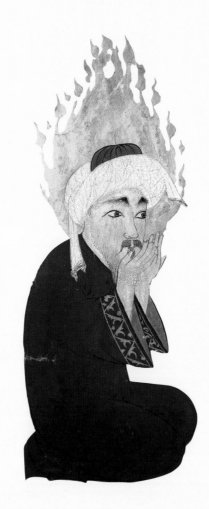

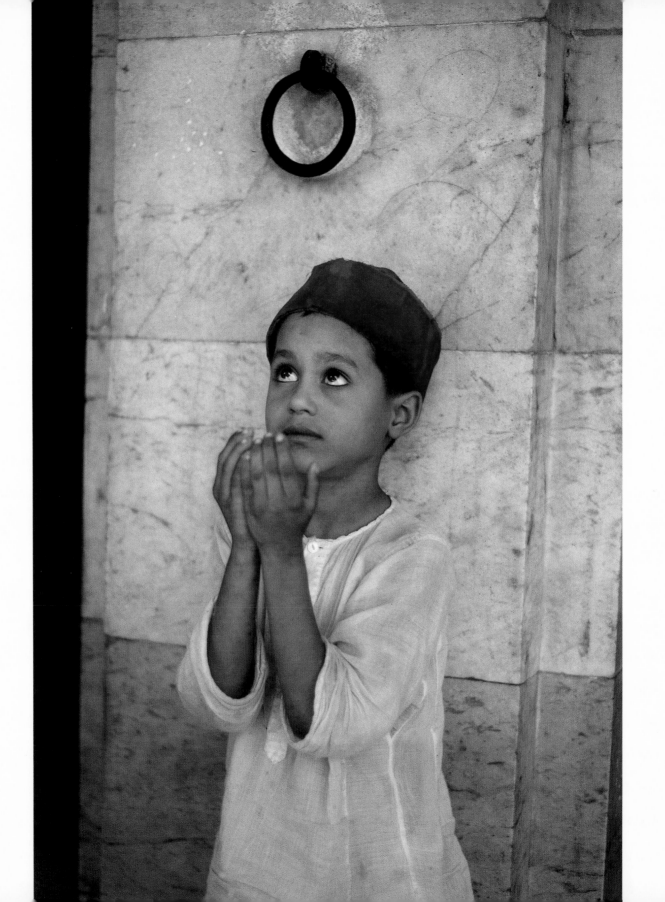

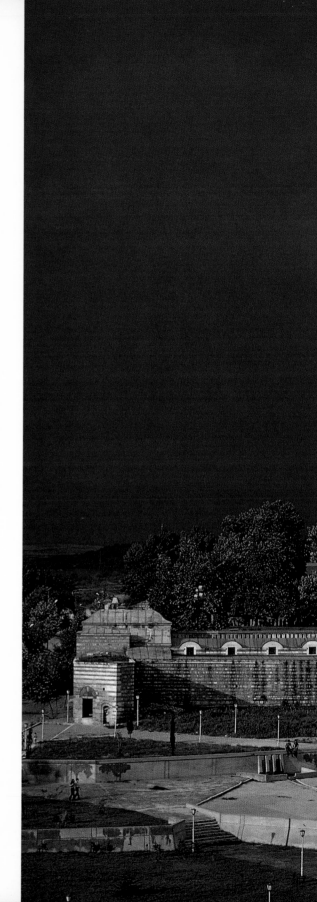

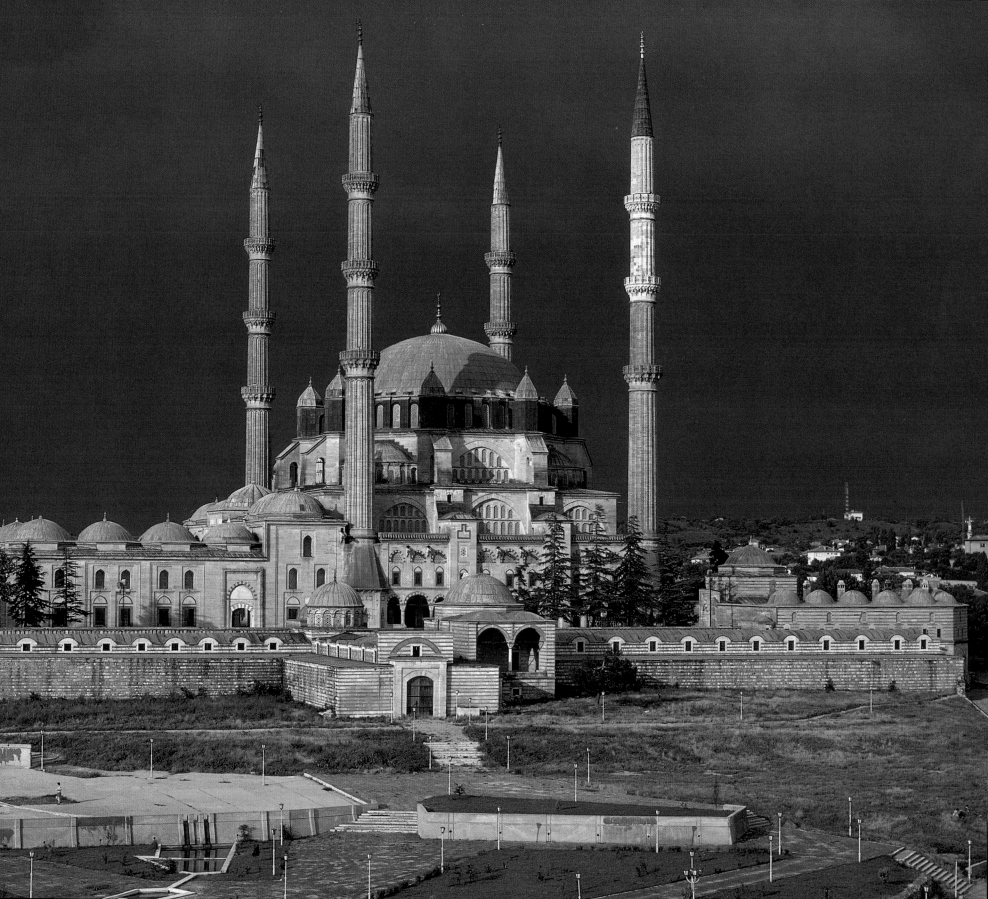

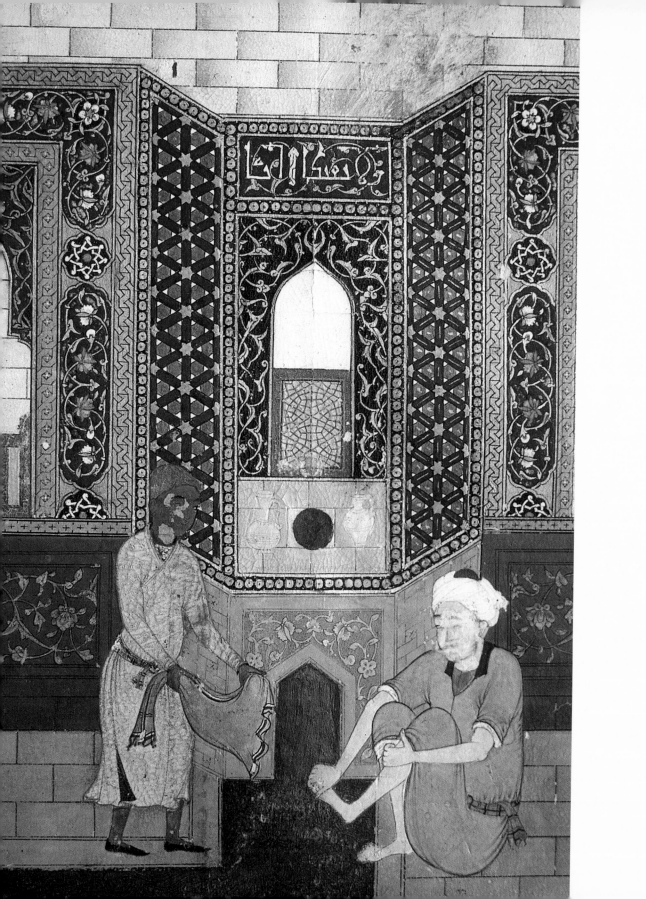

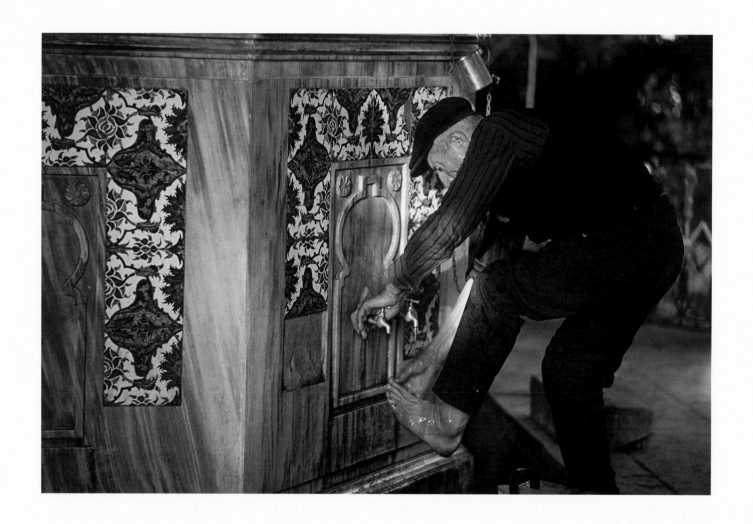

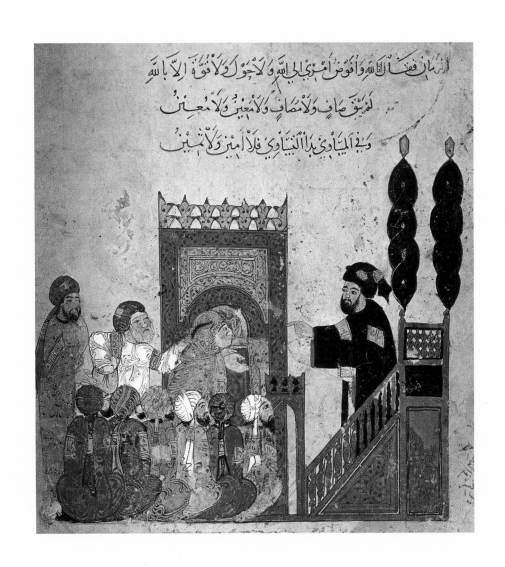

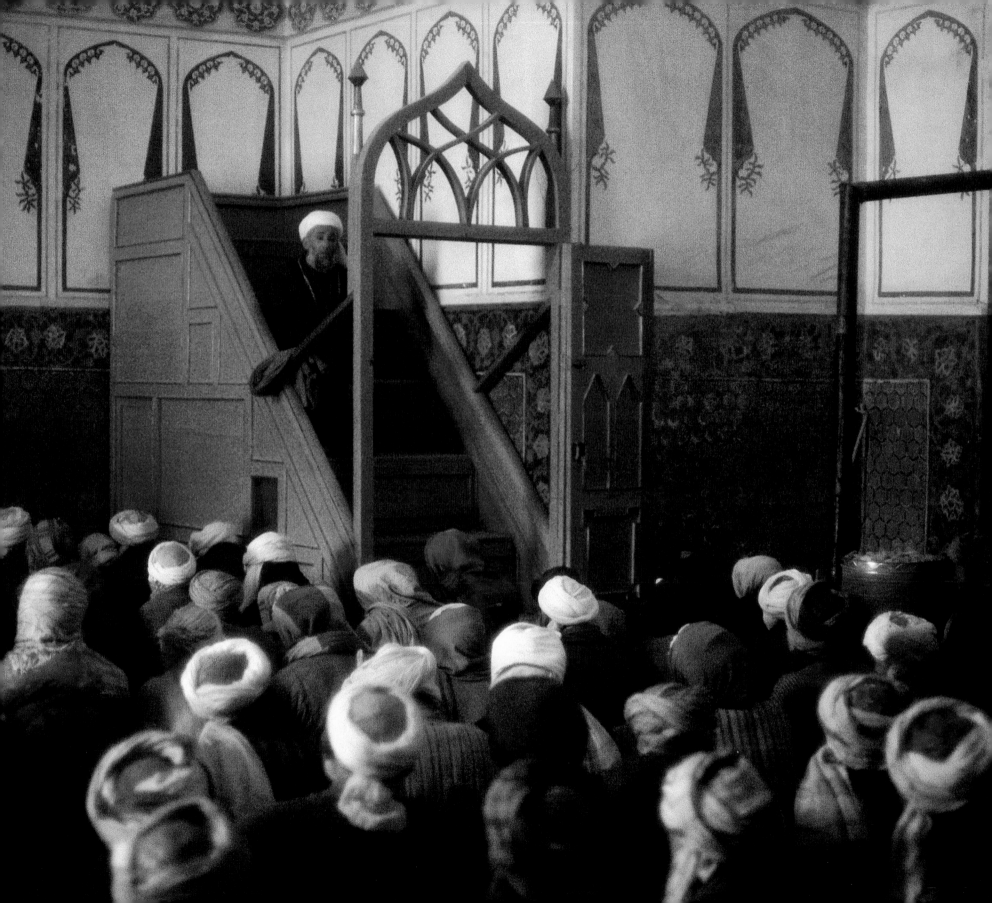

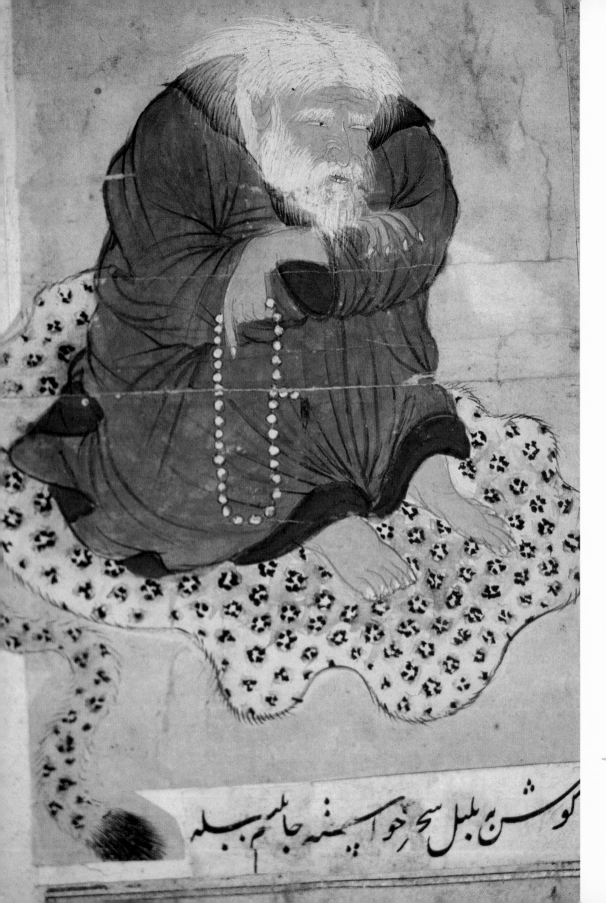

<div dir="rtl">

الله اكبر

</div>

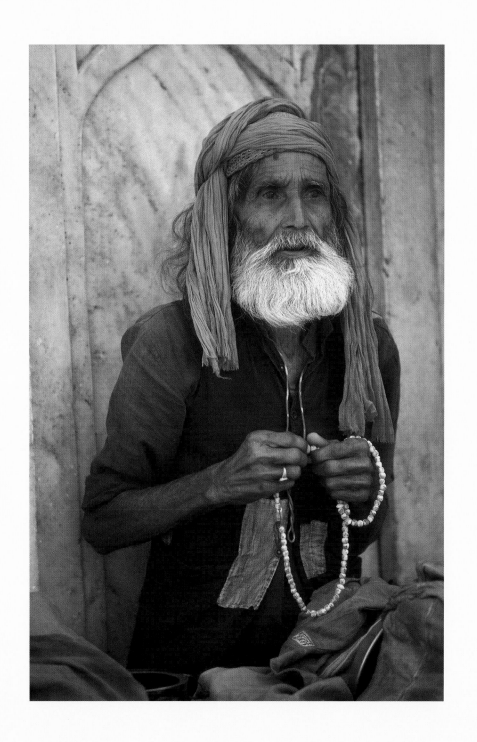

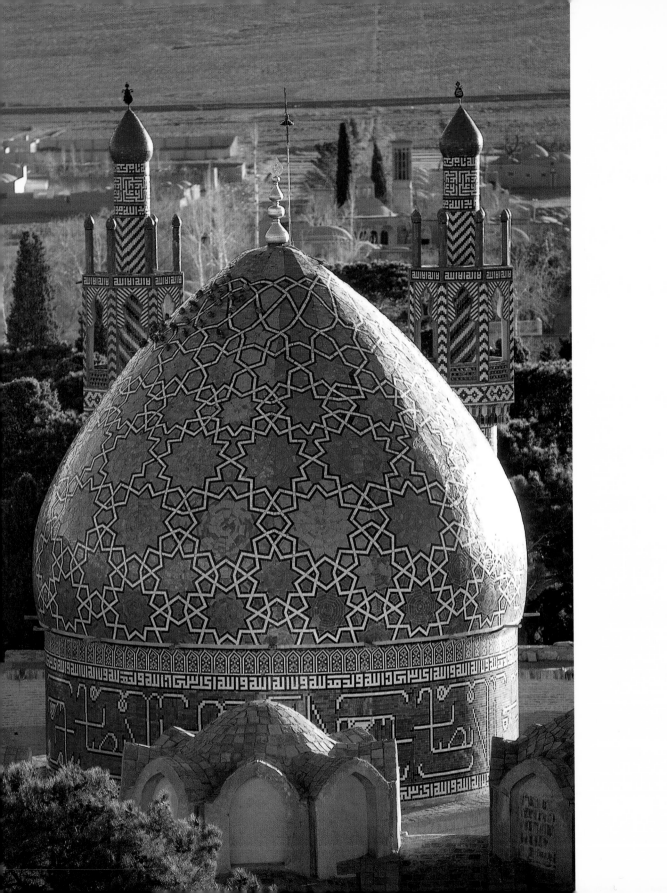

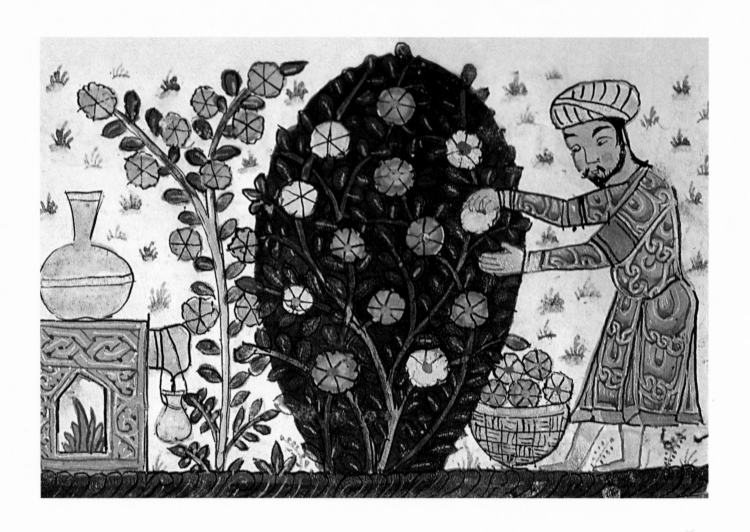

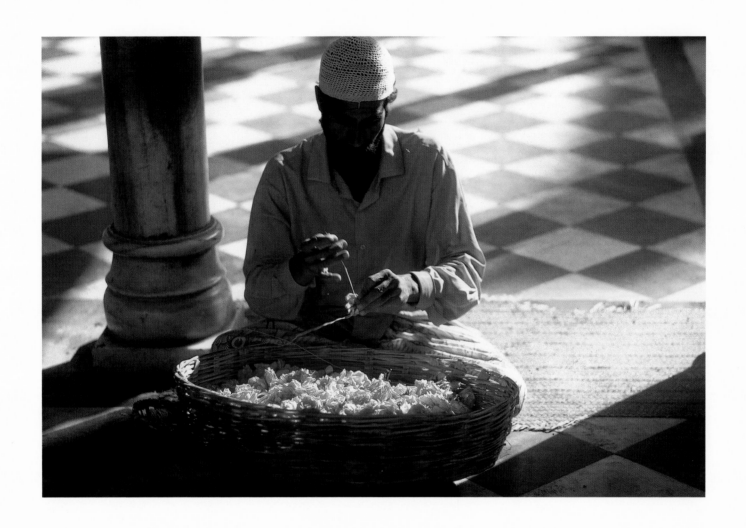

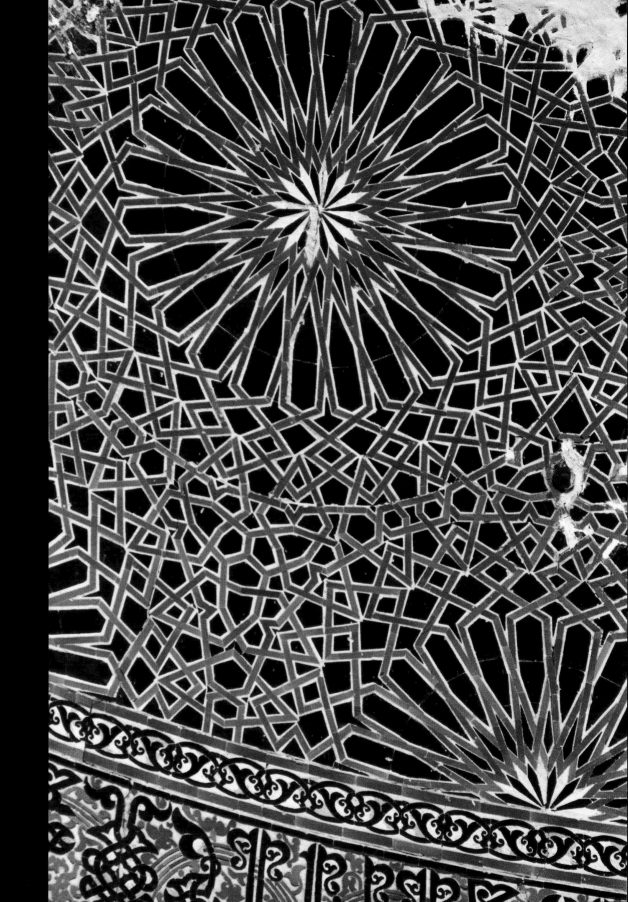

The Memory of God

Allah is the light of the heavens and the earth!

His light is comparable to a niche in which there is a lamp,

The lamp is in a glass,

And the glass resembles a brightly shining star,

Lit from a blessed olive tree, neither eastern nor western,

The oil whereof almost gives light though fire touch it not

– Light upon light –

Allah guides to His light whom He pleases.

The Koran, sura XXXIV, 35

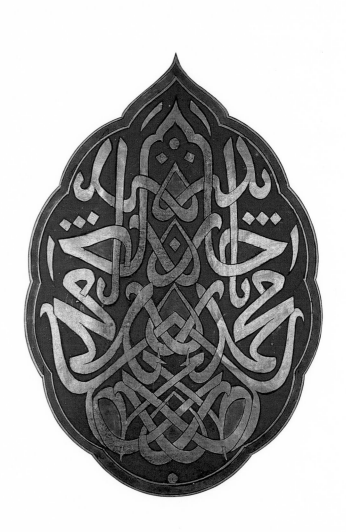

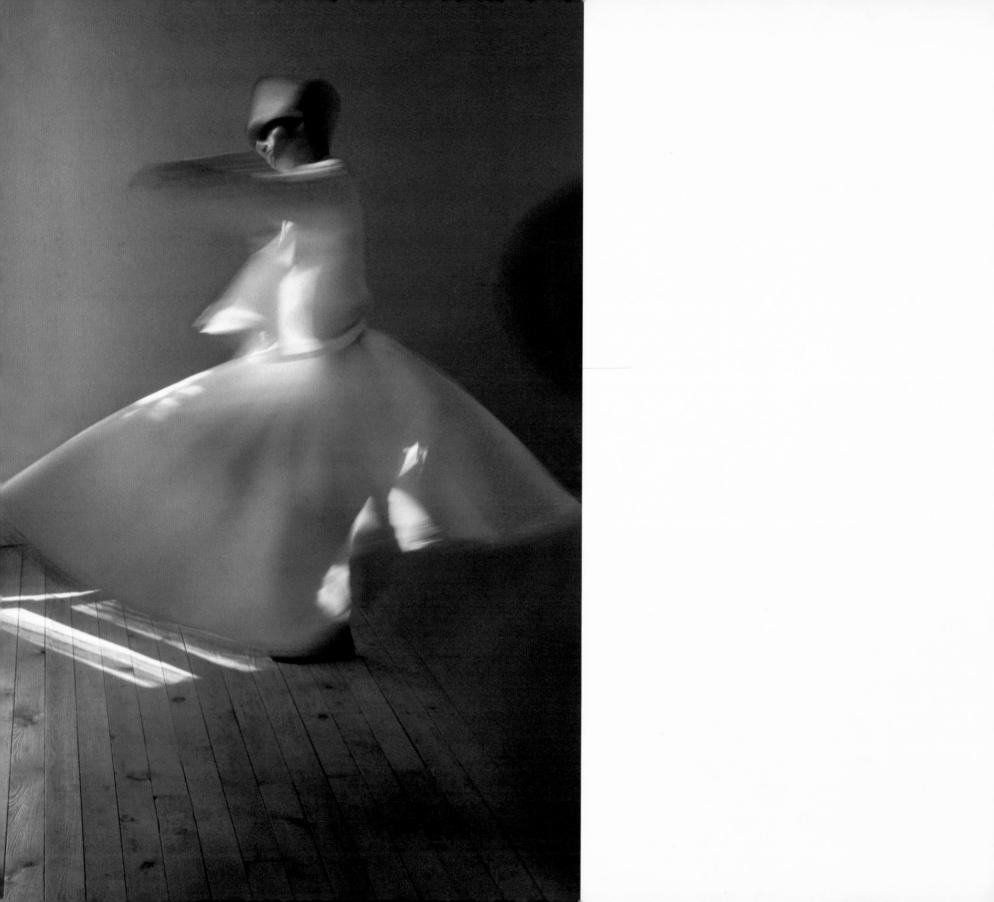

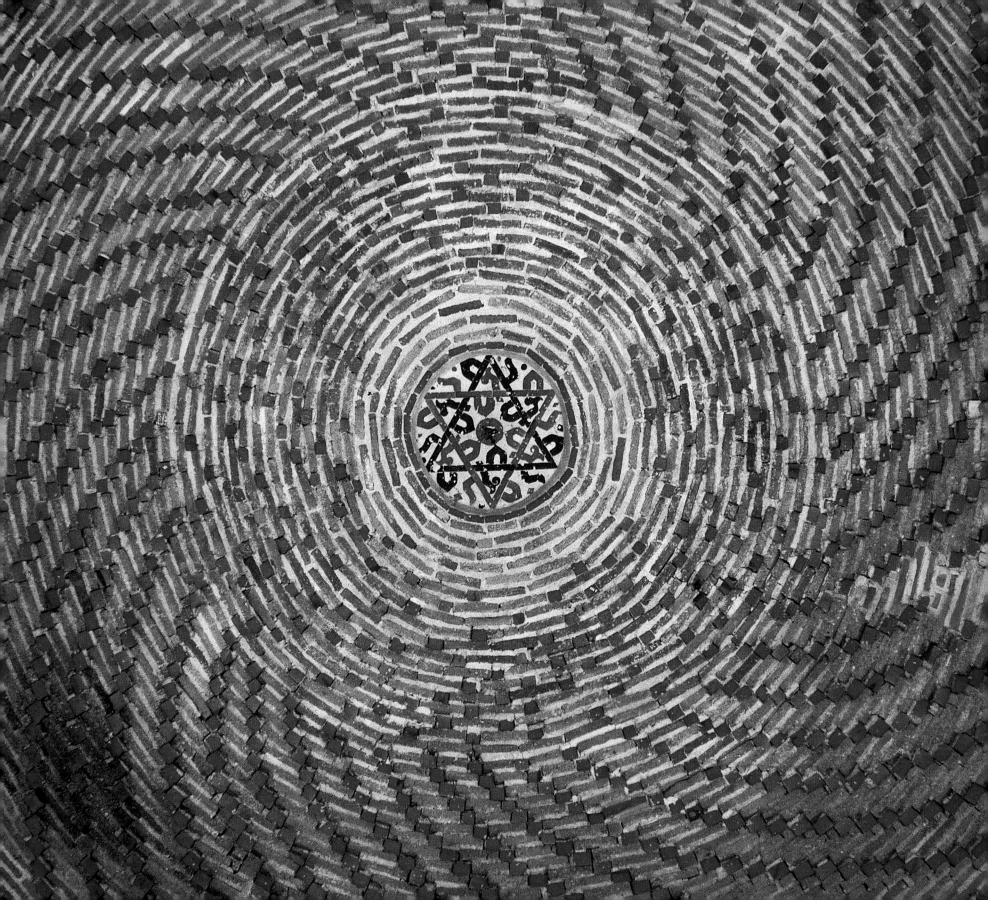

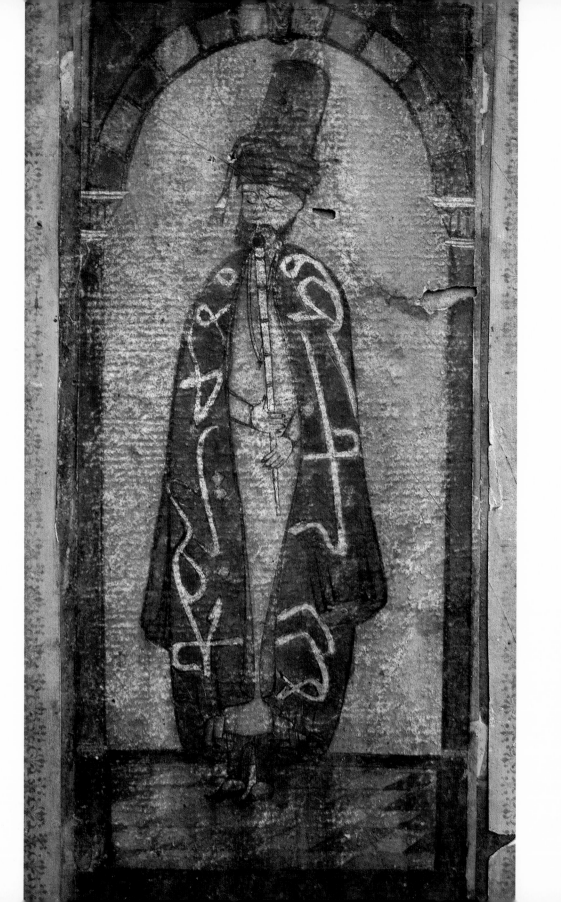

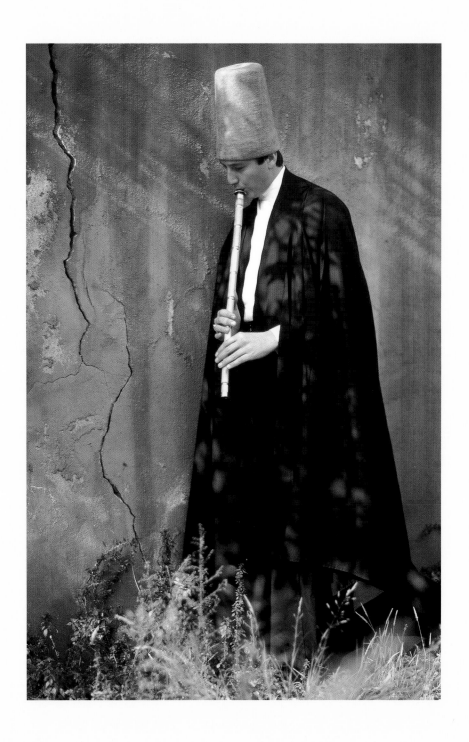

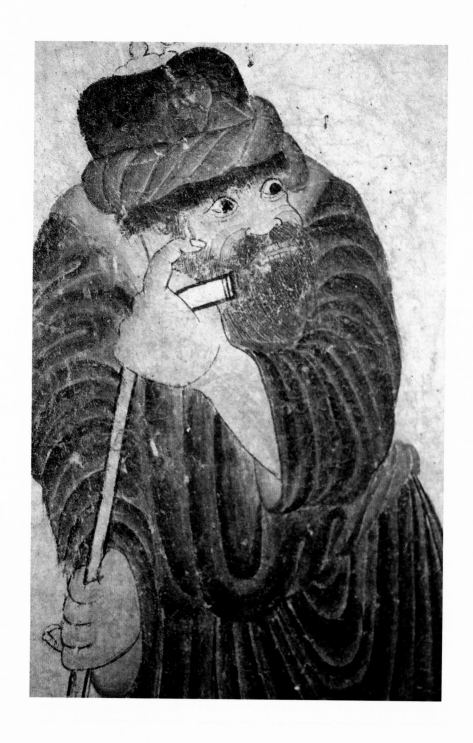

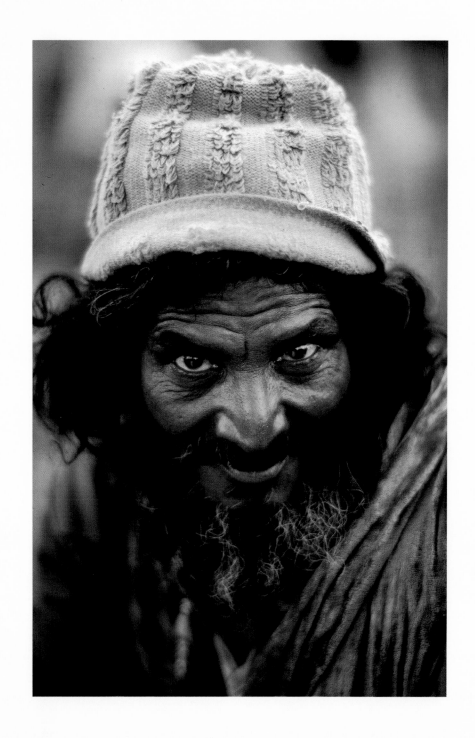

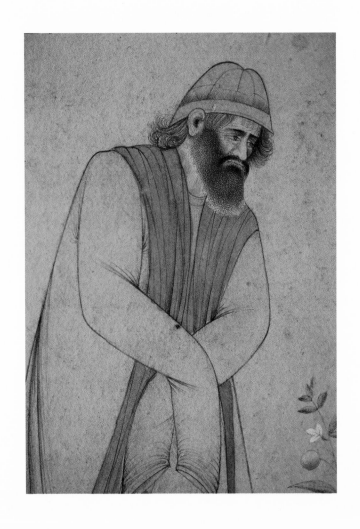

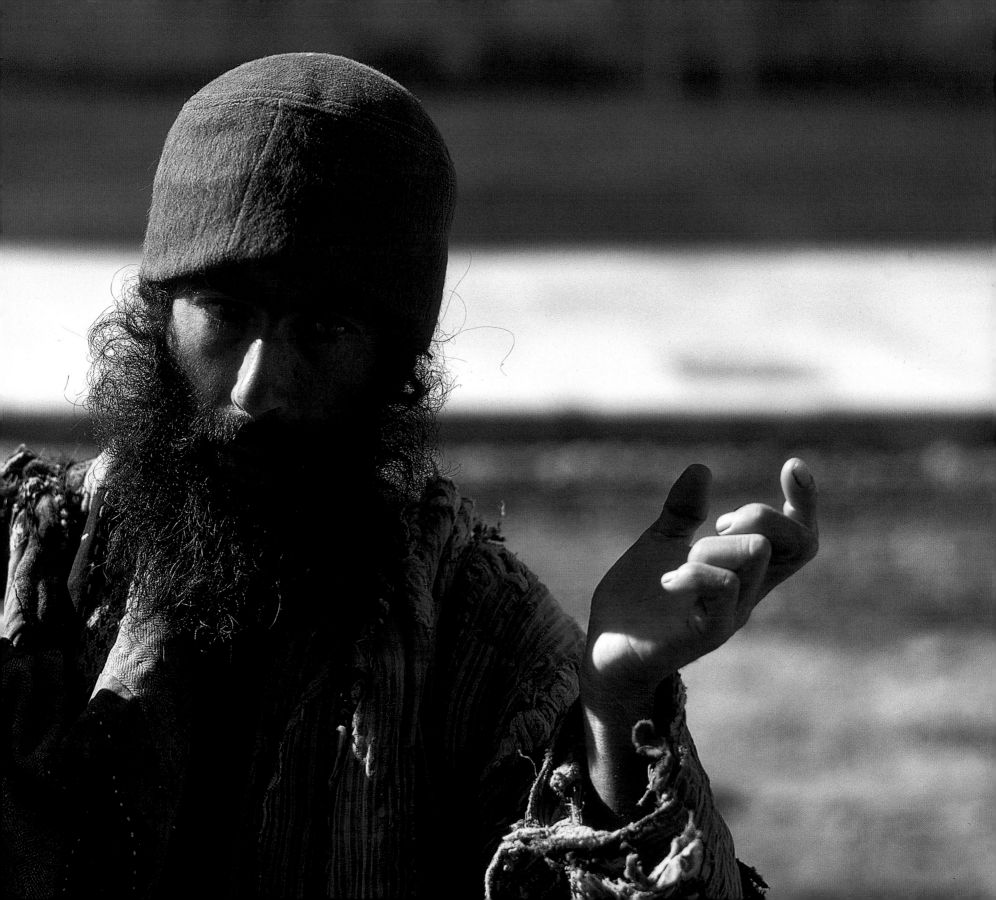

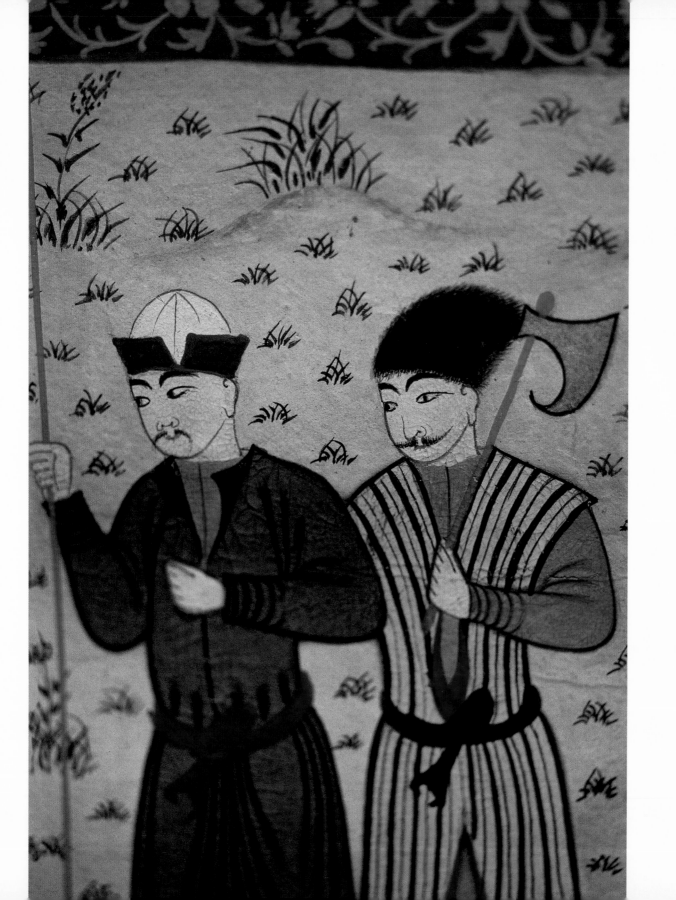

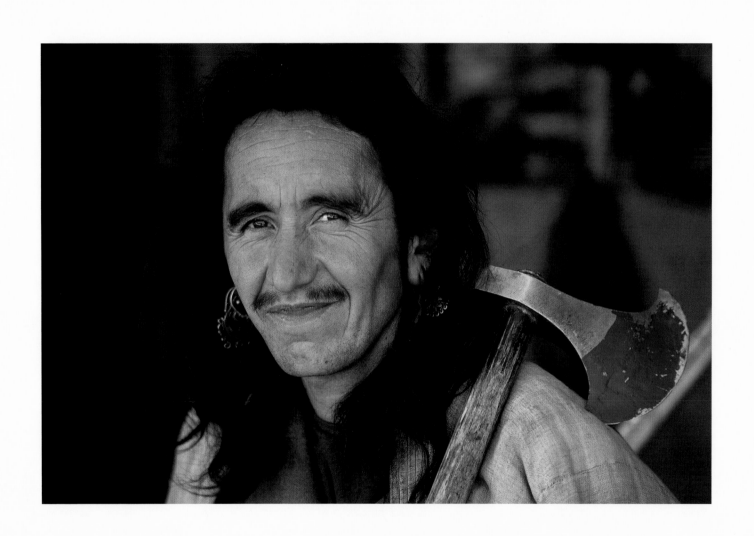

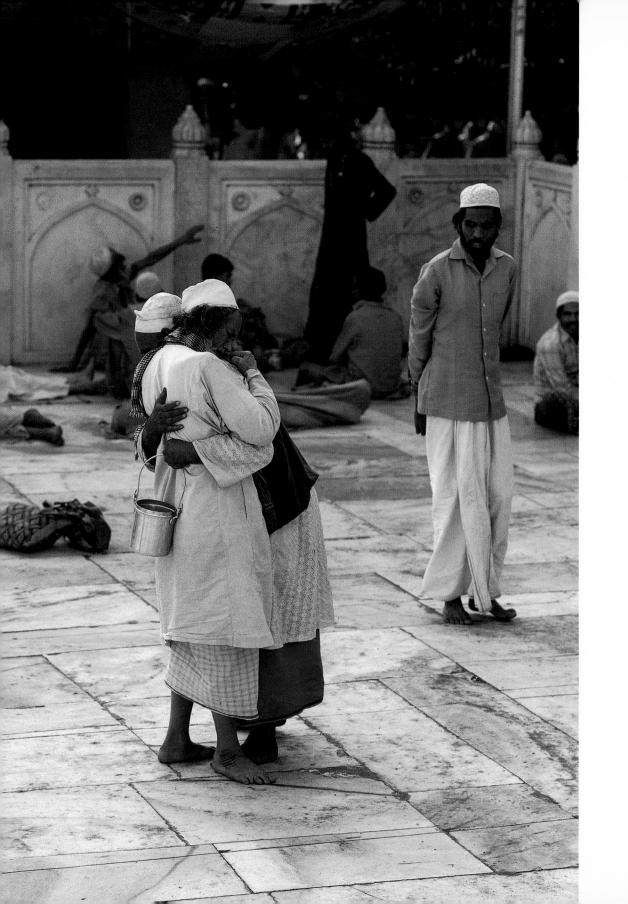

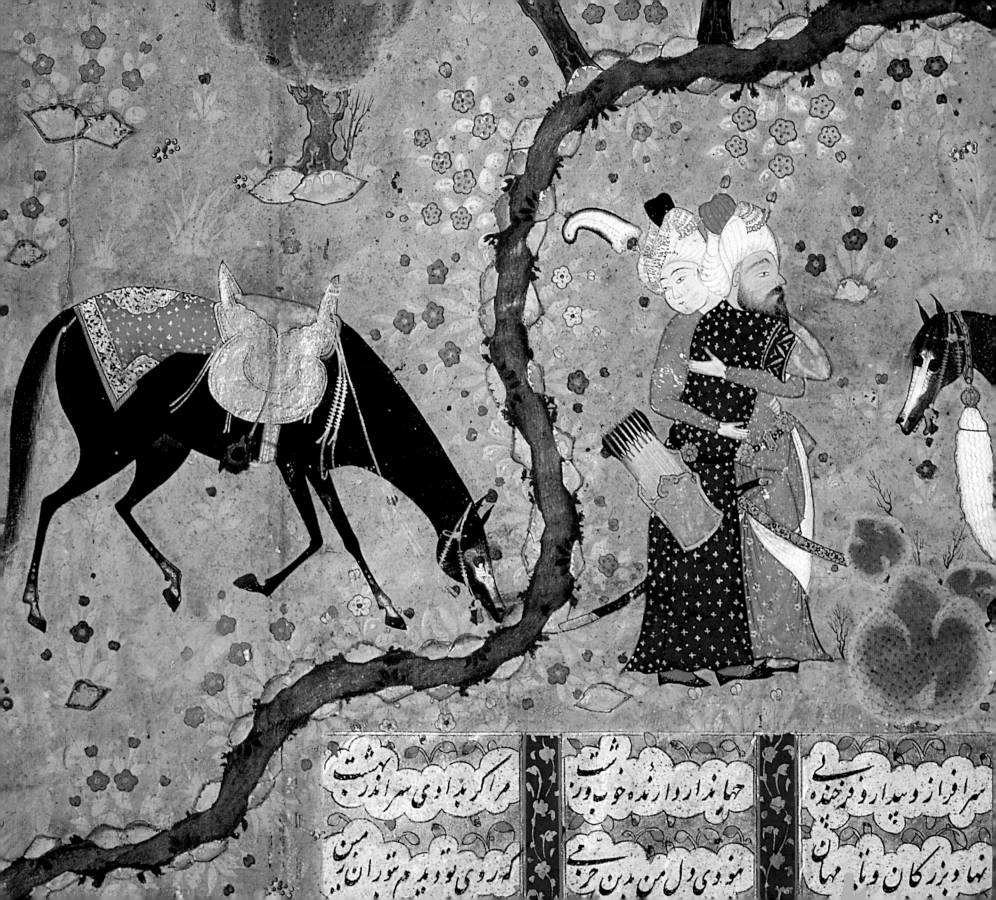

سر افراز و بیدار و فرخنده پی

جهاندار دارندهٔ خوب پور

چرا کرد باید سر اندر بهشت

هنوز دل من در من حرب

کر دی بودید هم توران بر من

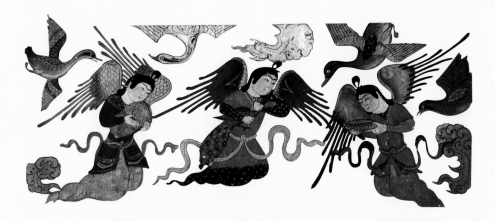

You are the gate to the city of Knowledge,

for you are the rays of the Sun of compassion.

Be open, oh Gate! for the one who seeks the gate…

Be open until eternity, oh Gate of Mercy…

God's vision encompasses all things; but as long as the gate

is not open, who will say, 'Over there is a gate'?

Unless the Watcher opens the gate,

this idea does not take shape in him.

Rumi, *Mathnawi*

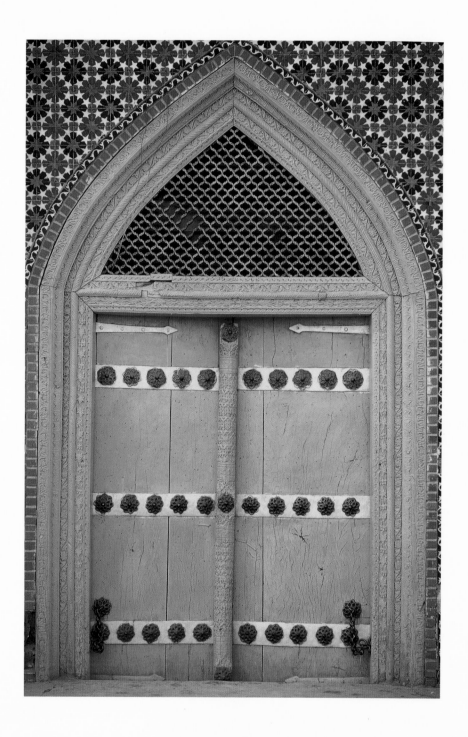

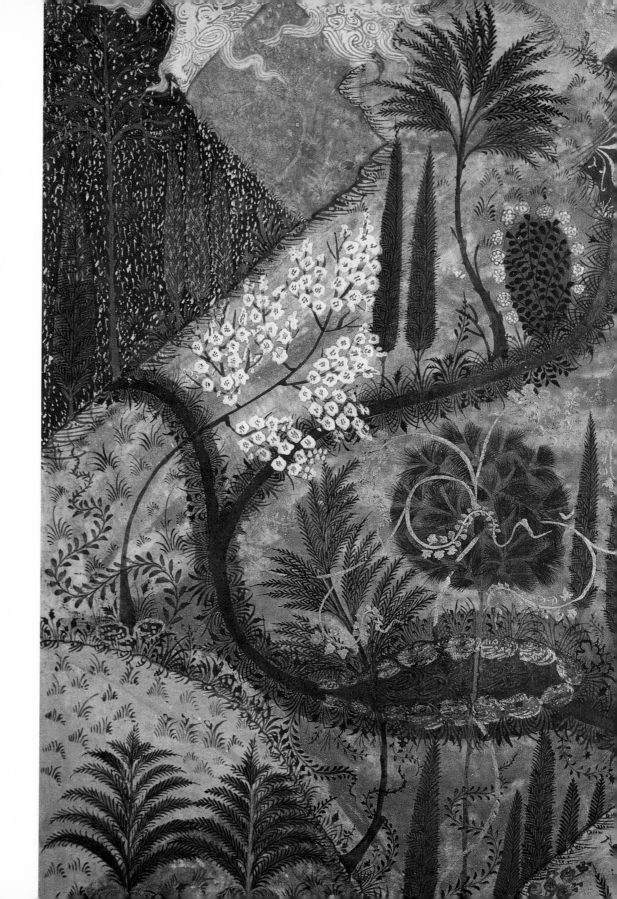

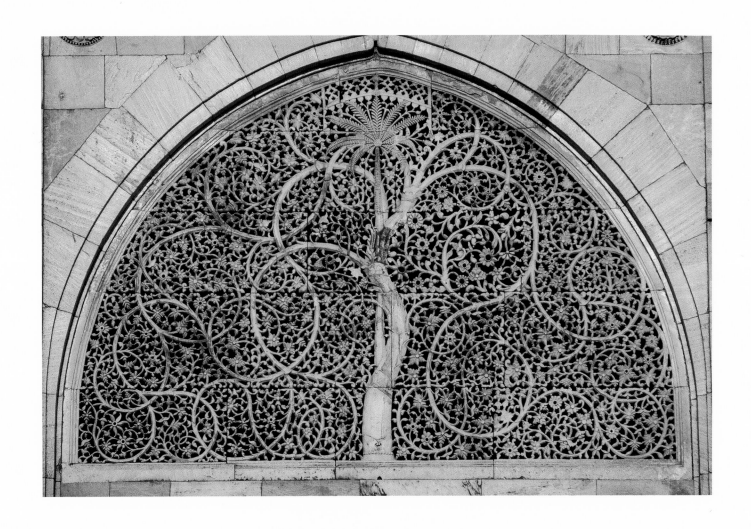

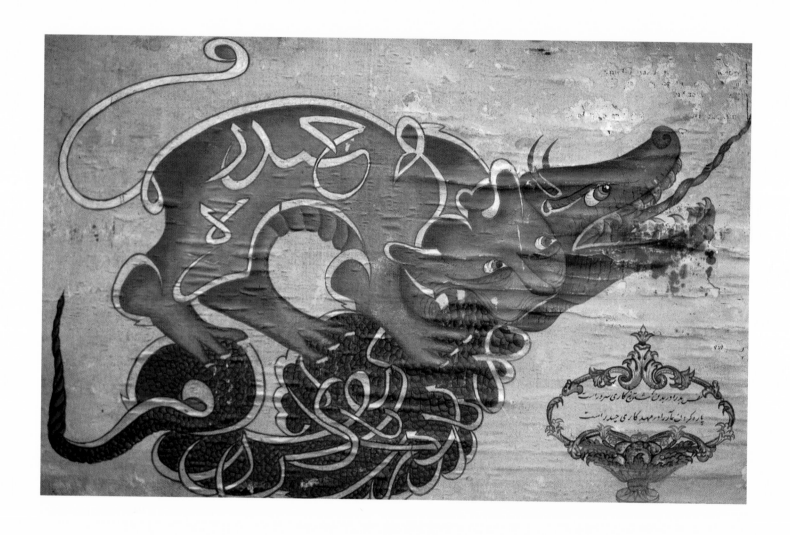

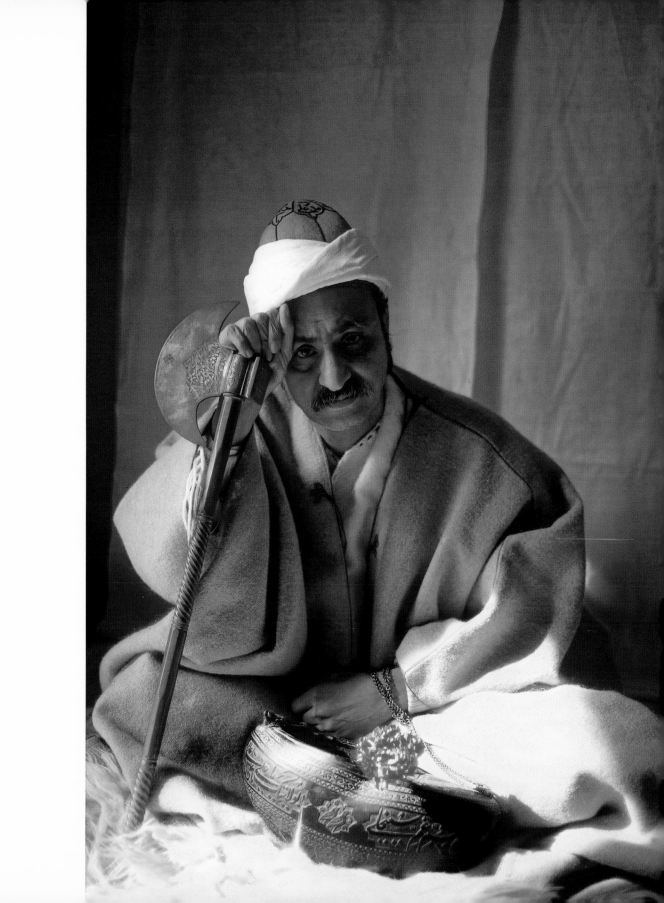

Do you not see that Allah sends down water from the cloud, then makes it go along in the earth in springs, then brings forth therewith herbage of various colours, then it withers so that you see it becoming yellow, then He makes it a thing crushed and broken into pieces.

The Koran, sura XXXIX, 21

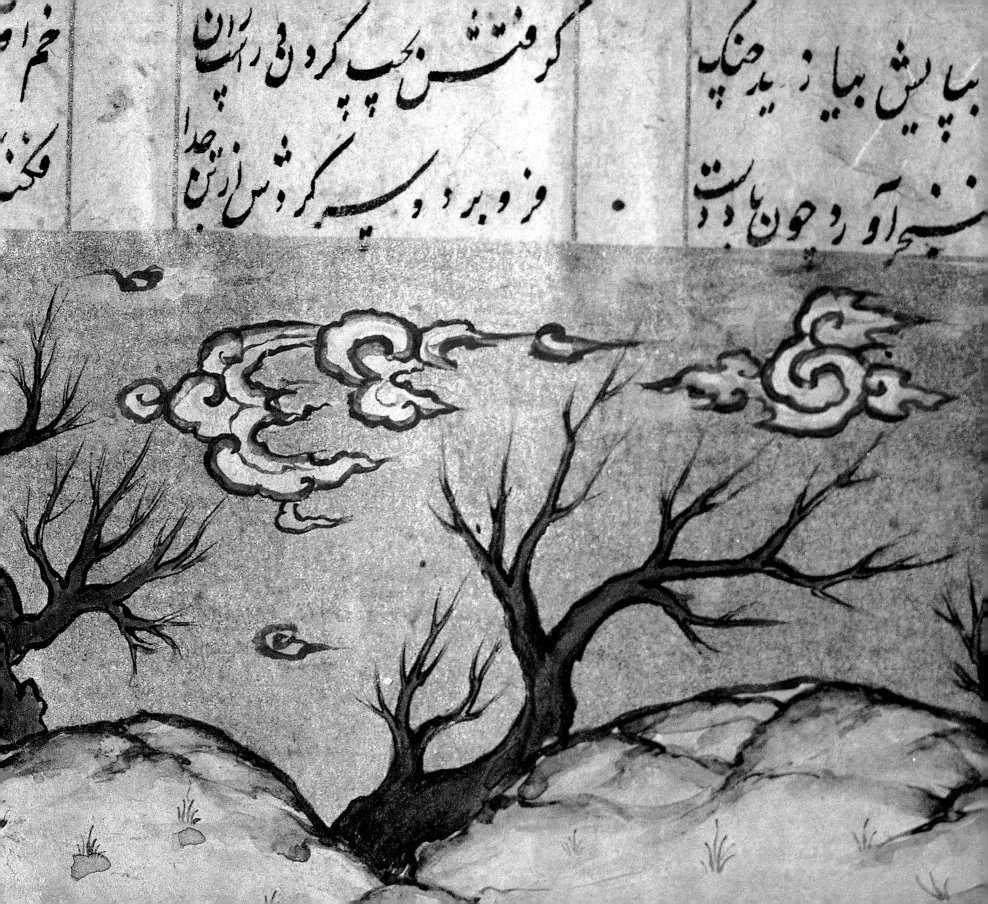

Muslim Women

Now, she was a slender Egyptian girl whose body was admirably formed, as upright as the letter aleph. She had Babylonian eyes, hair black as the shades of night and skin white as mined silver or as an almond freed of its shell. And she was so beautiful and so brilliant, in her dark dress, that she could have been mistaken for the summer moon shining in the midst of a winter night. How, then, could her breasts have been other than palest ivory, her belly not perfectly curved; how could she have failed to have glorious thighs and buttocks padded like cushions.

The Thousand and One Nights, 669th night
Story of the Young Nour

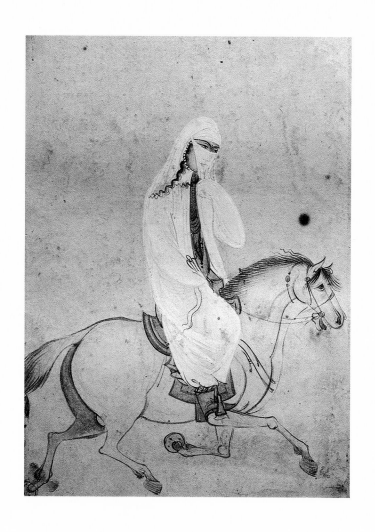

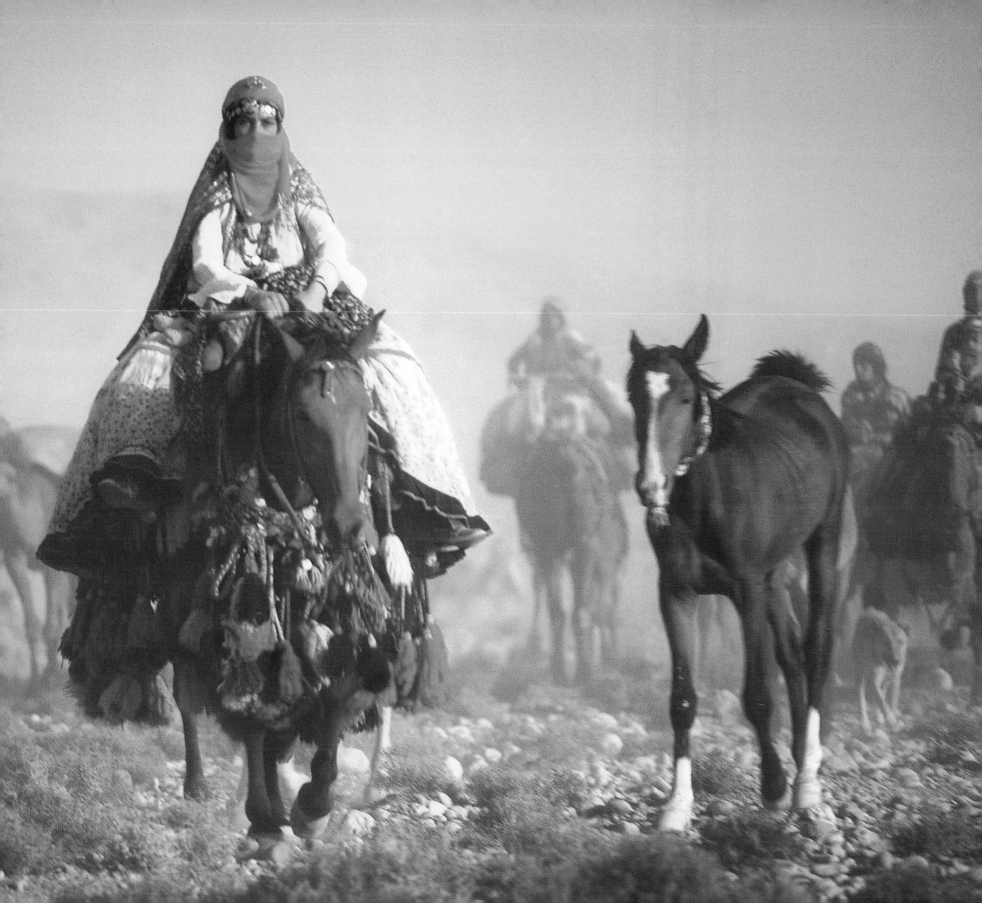

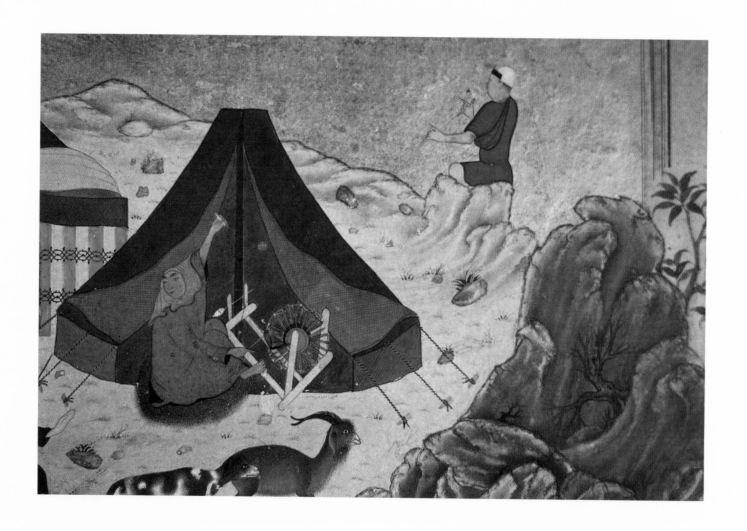

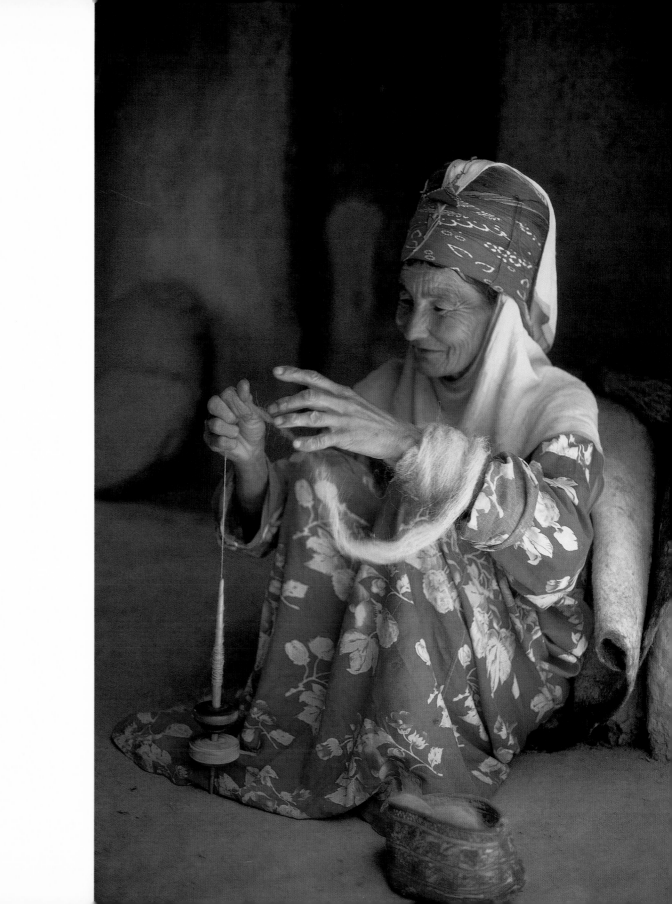

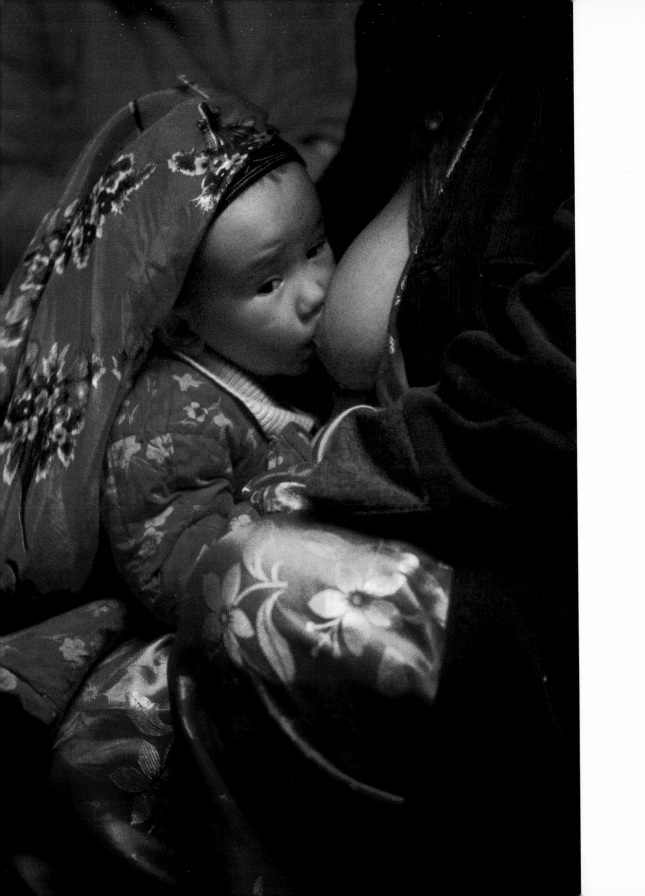

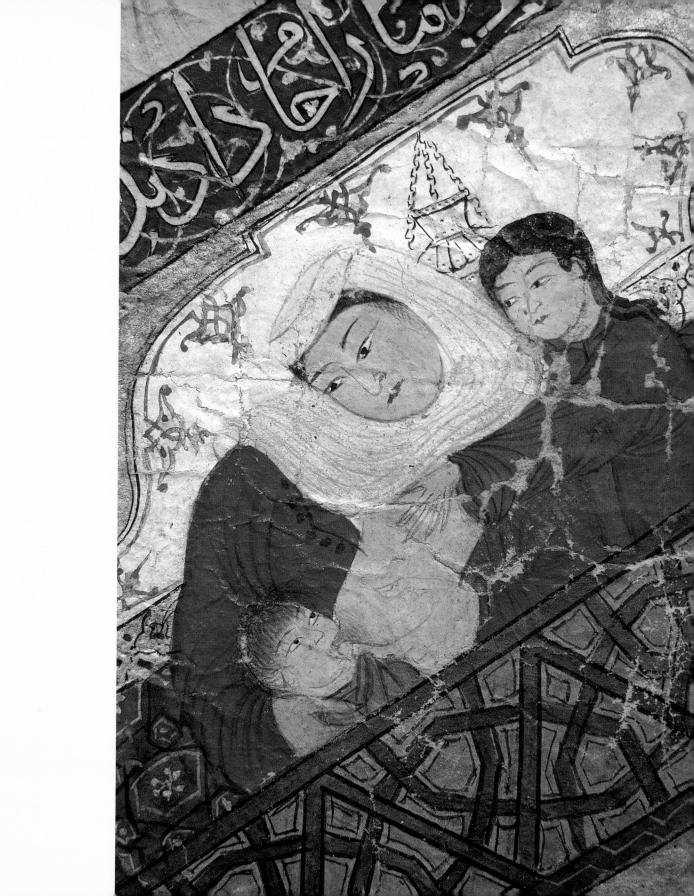

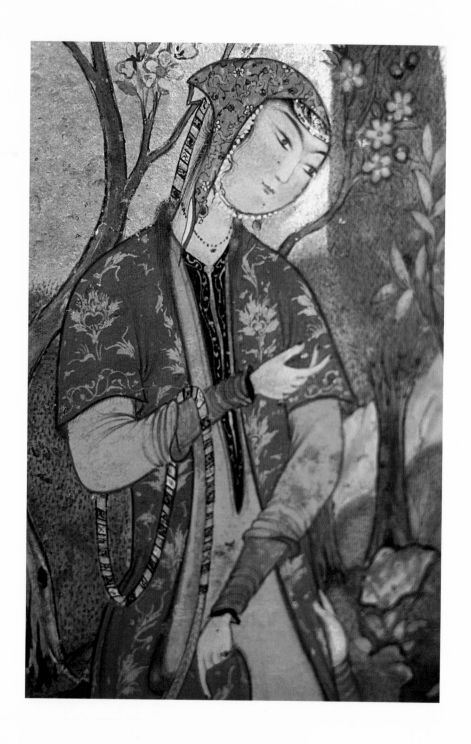

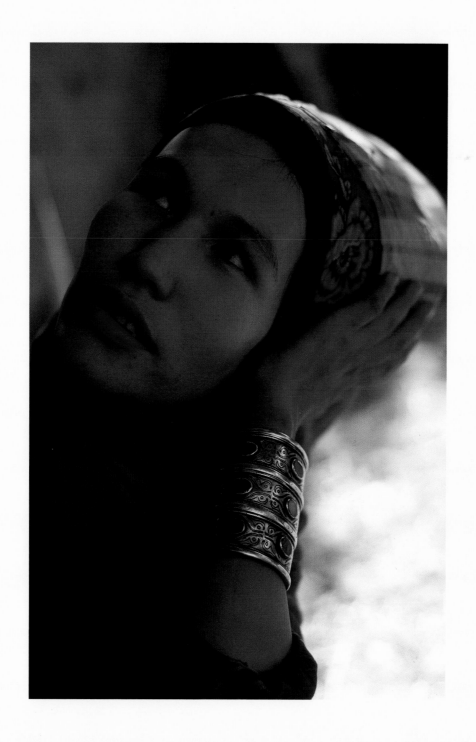

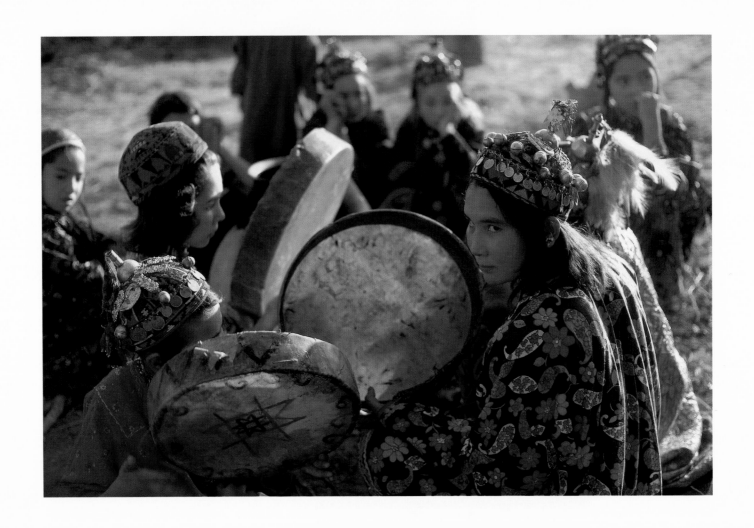

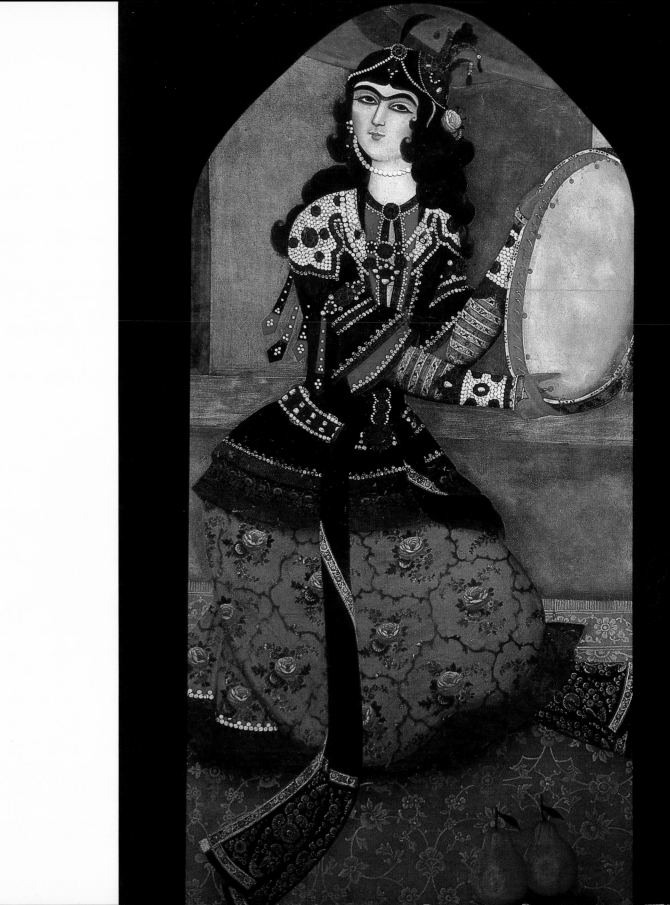

Now it happened that one day a poor old woman came into the Turkish baths. She was shaking under the blast of approaching death and could only walk with the help of a stick. She went up to the king's daughter and said to her, 'My misfortunes exceed the number of my years, and my tongue would wither before I had finished recounting them all to you'.

The Thousand and One Nights, 885th night
Story of the Billy Goat and the King's Daughter

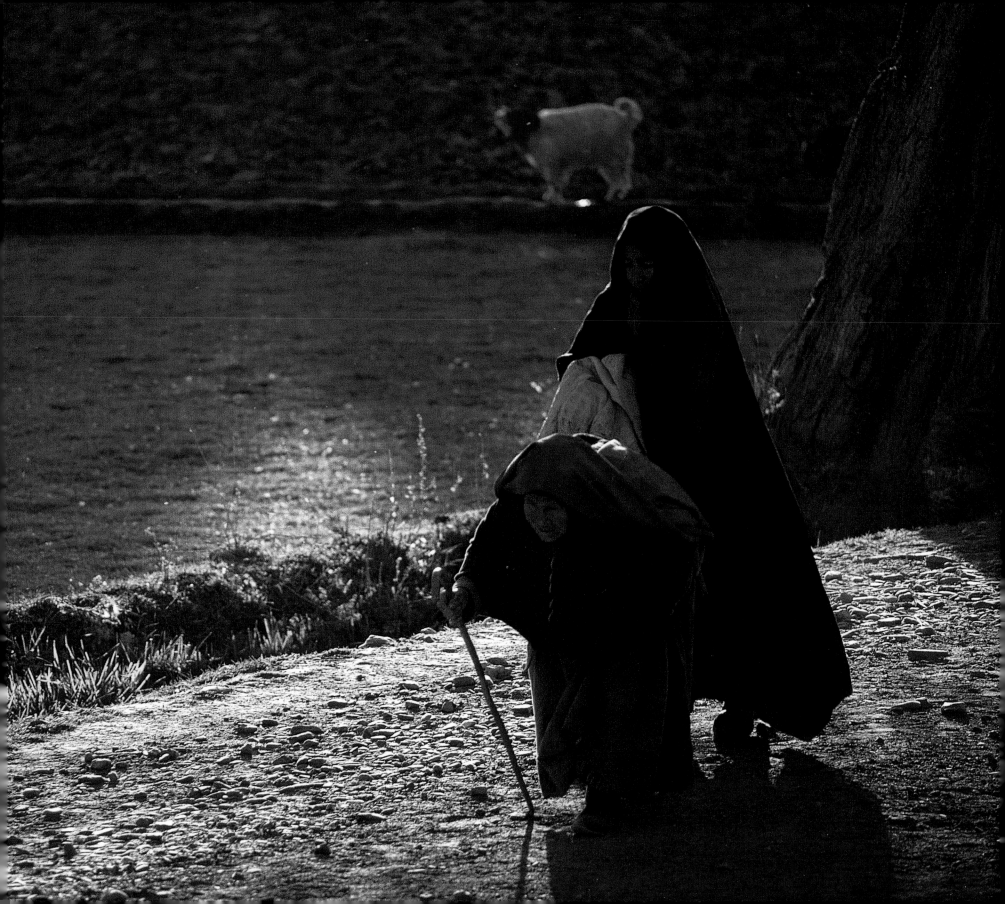

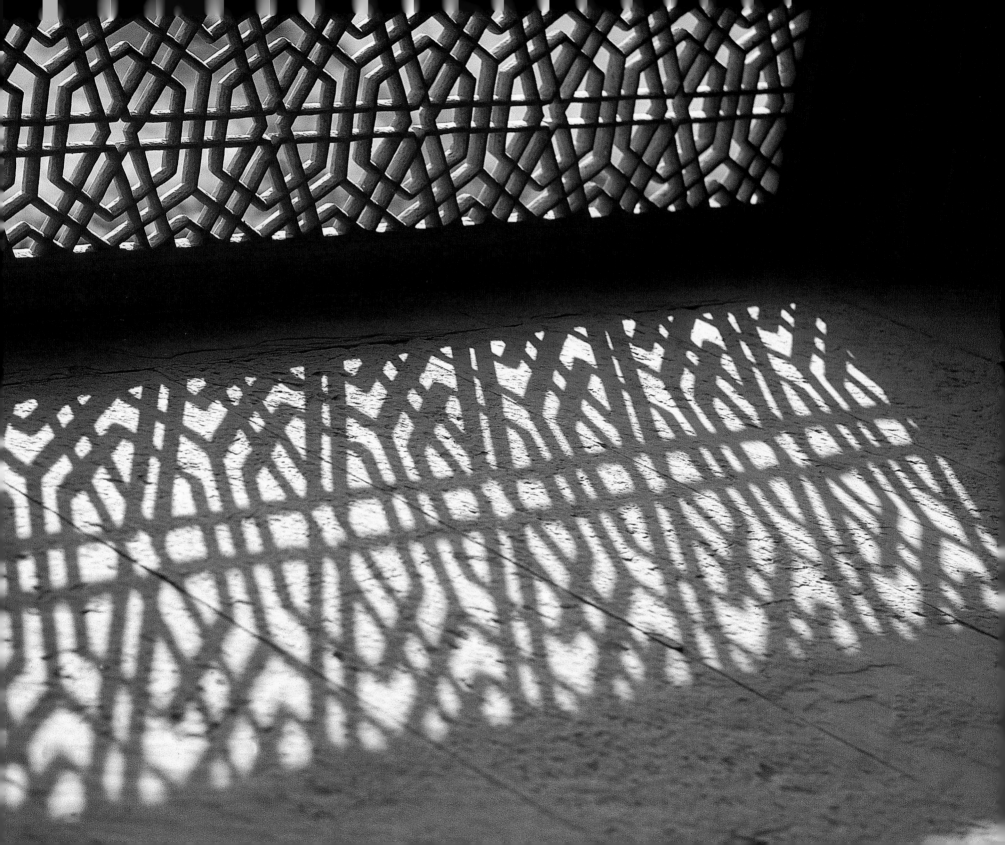

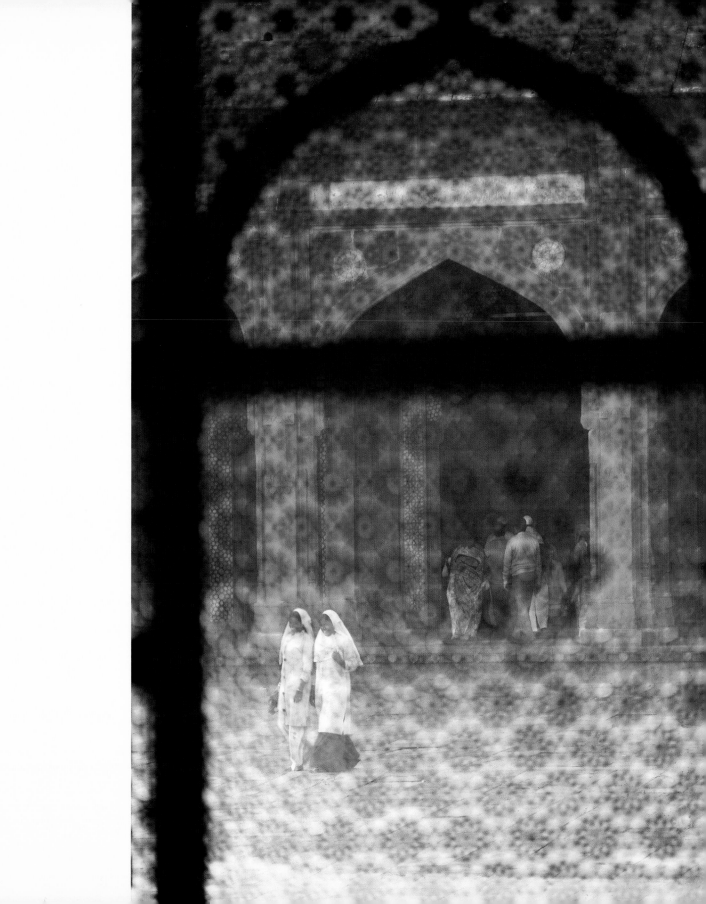

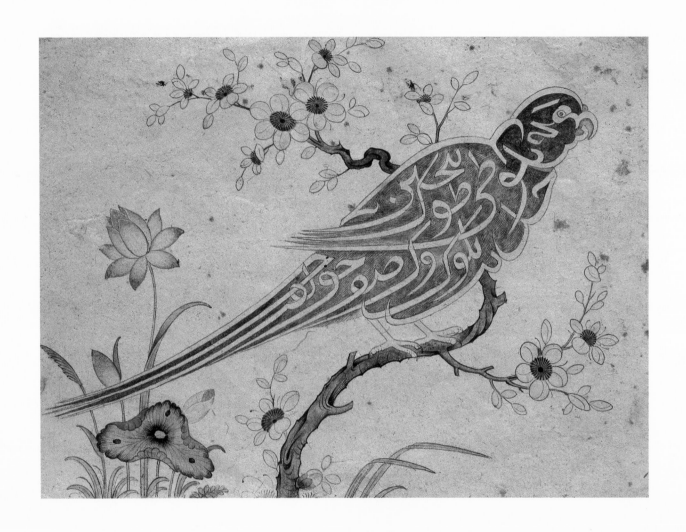

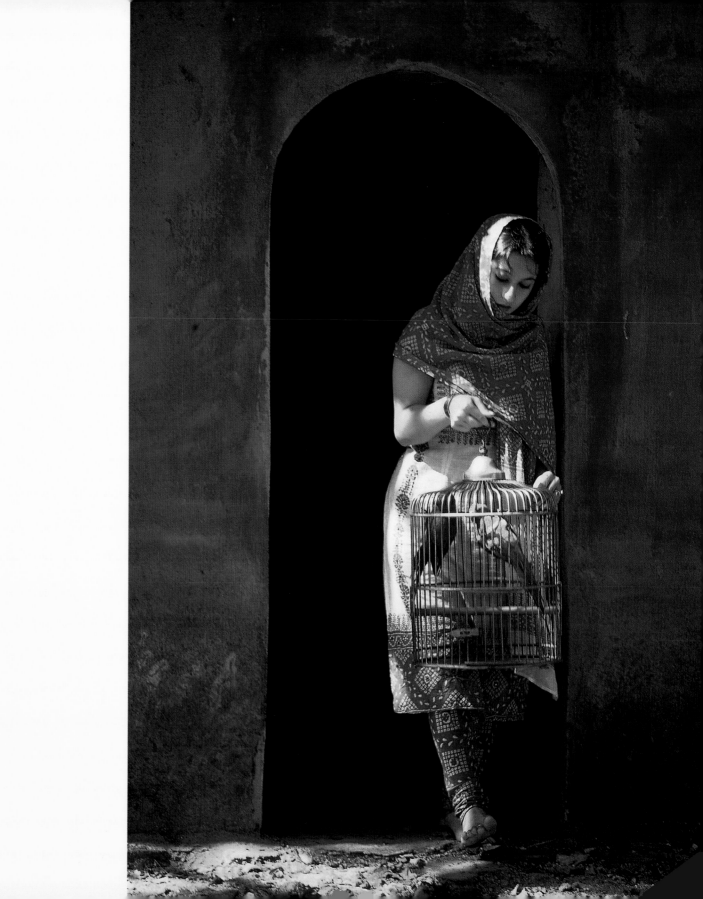

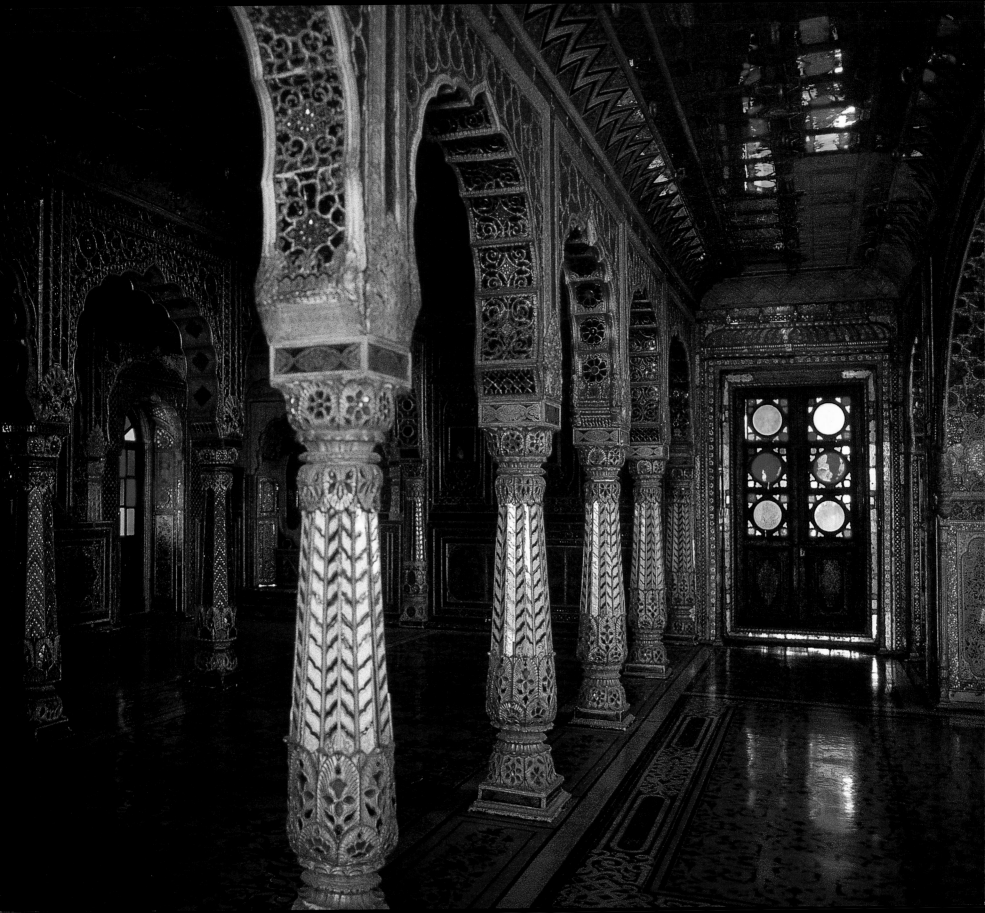

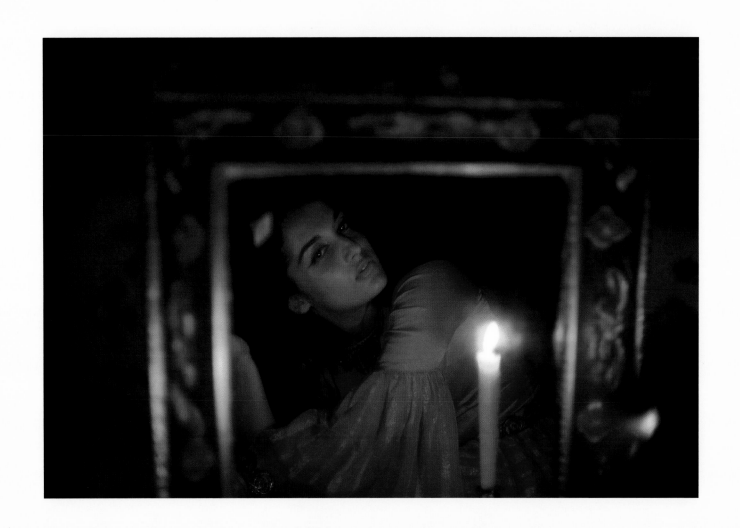

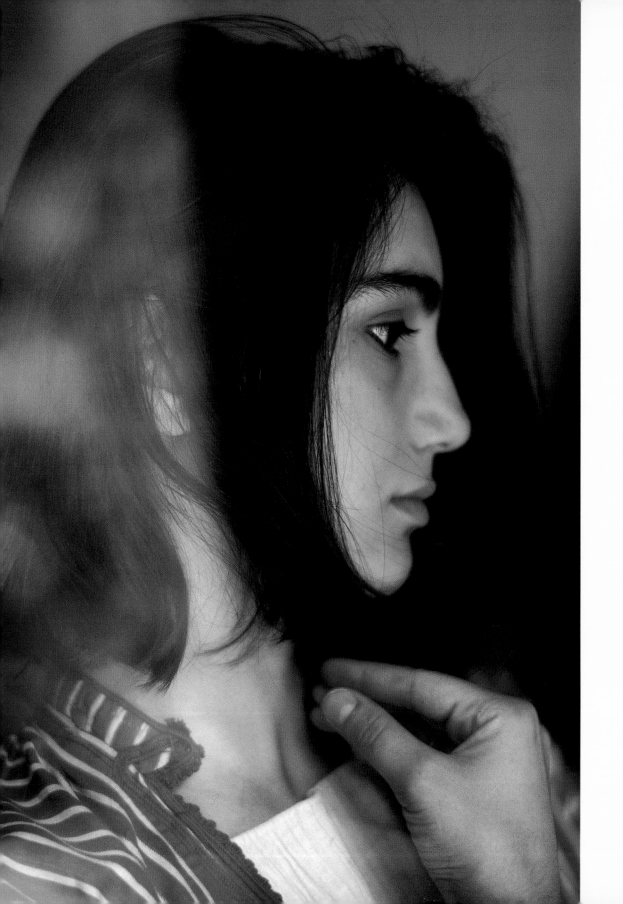

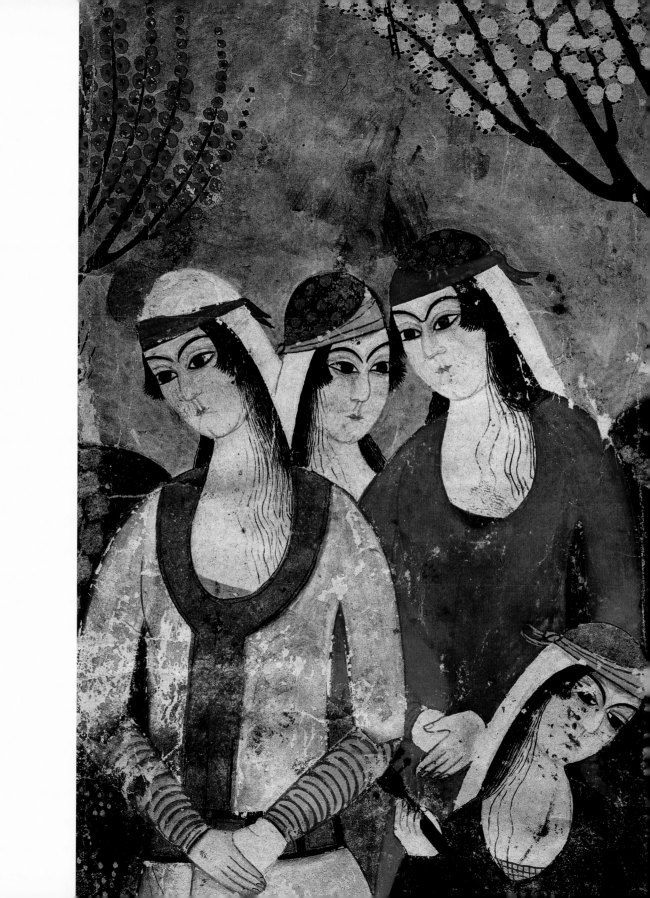

And pure, beautiful ones,

The like of the hidden pearls

The Koran, sura LVI, 22

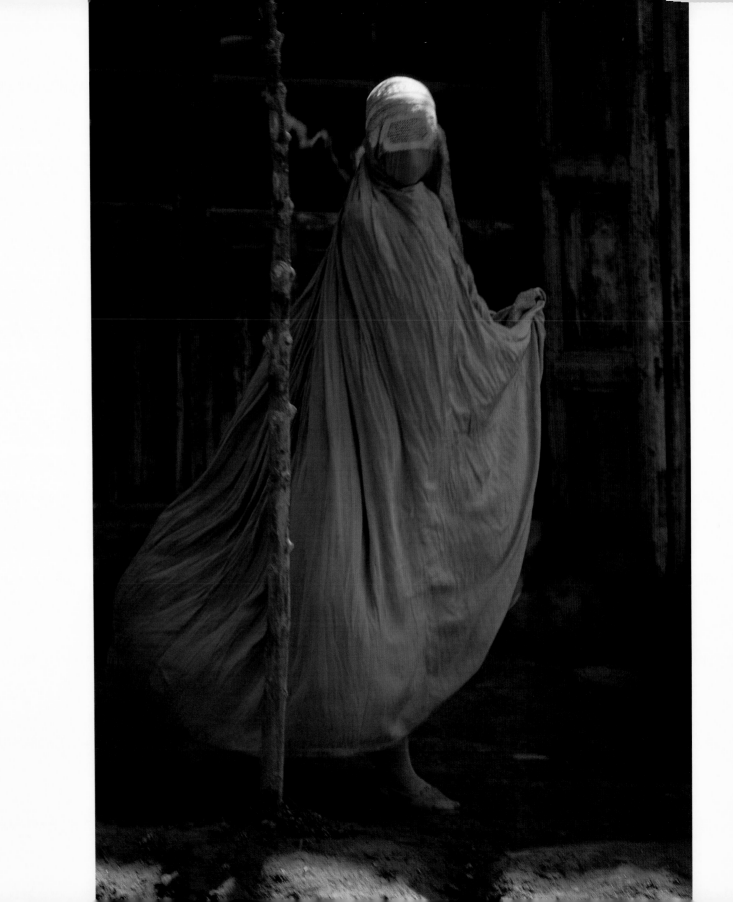

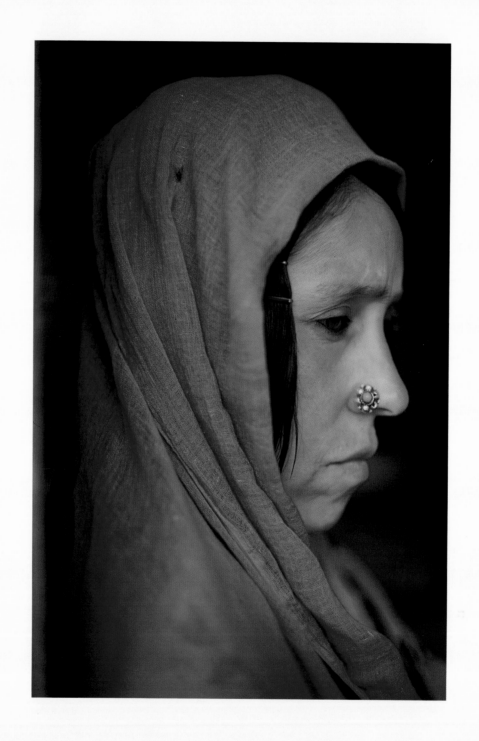

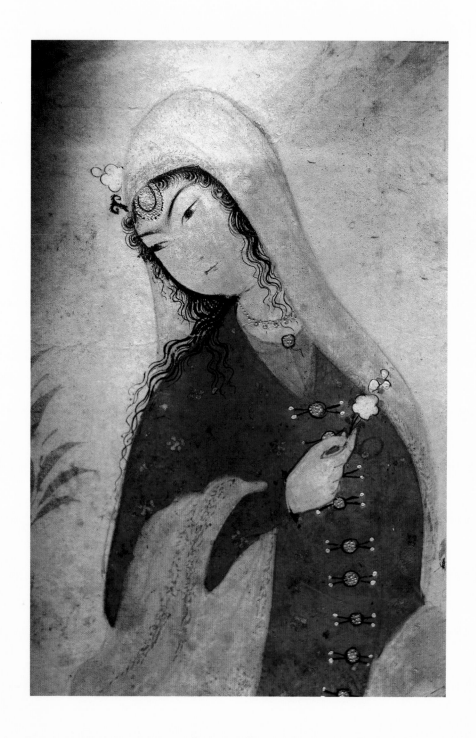

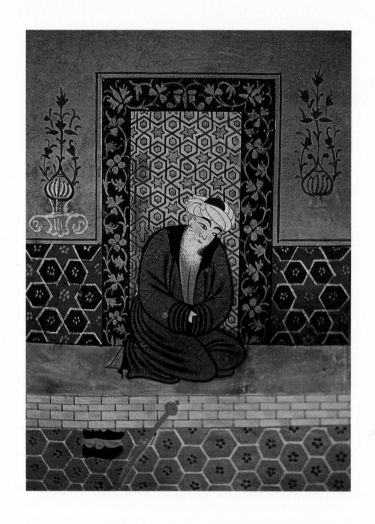

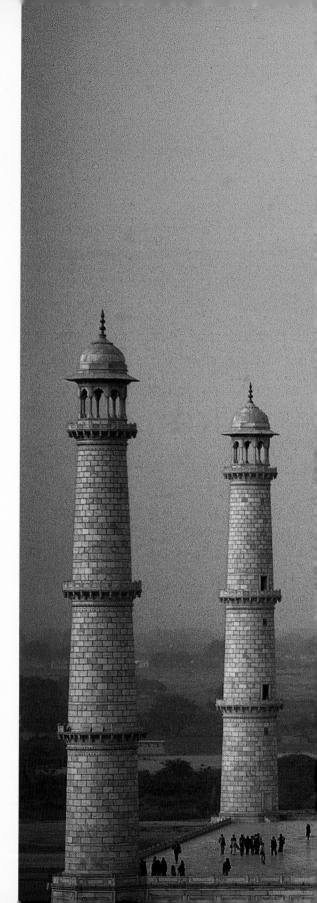

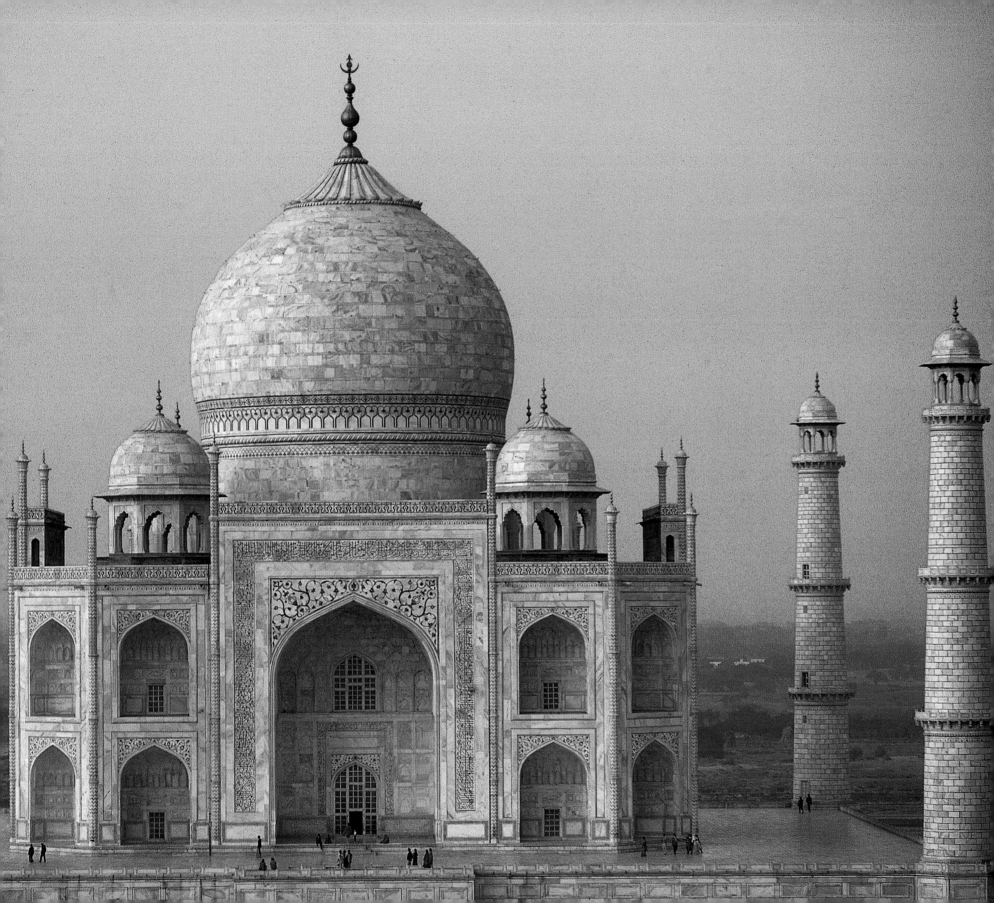

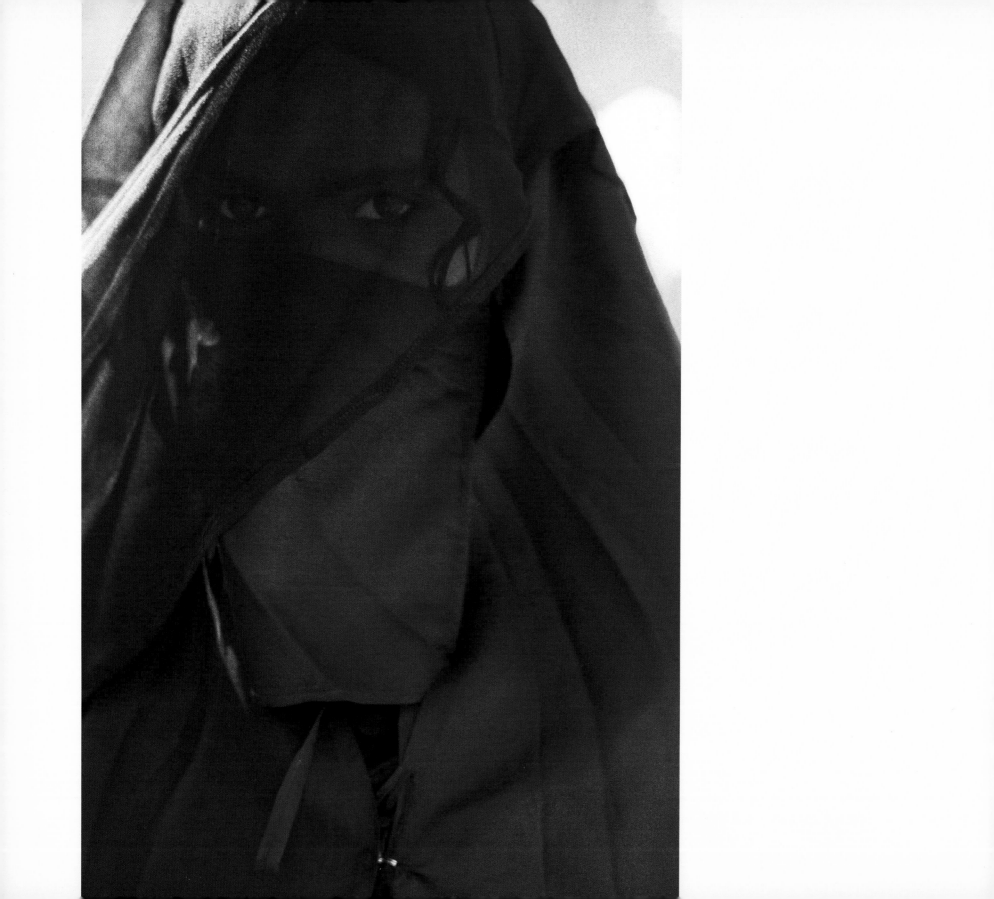

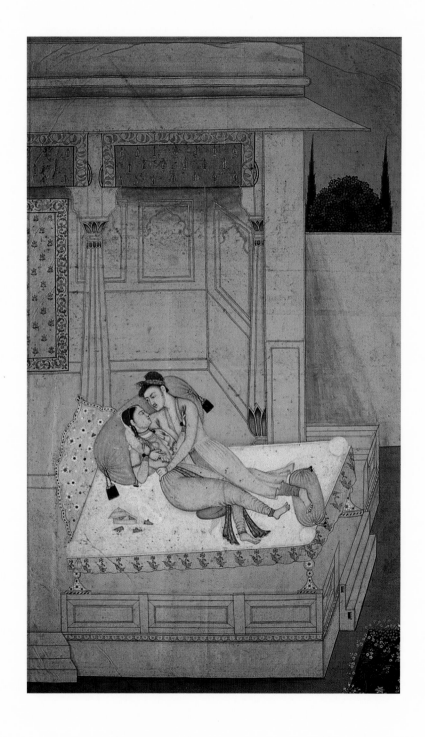

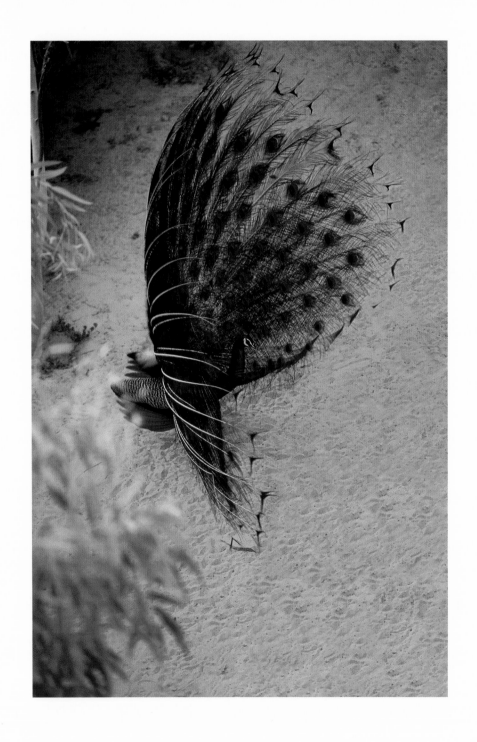

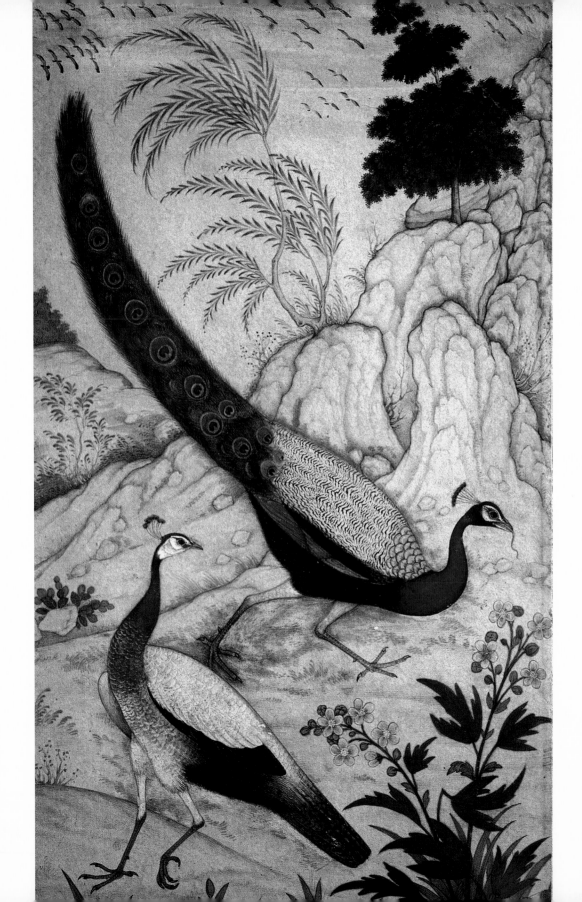

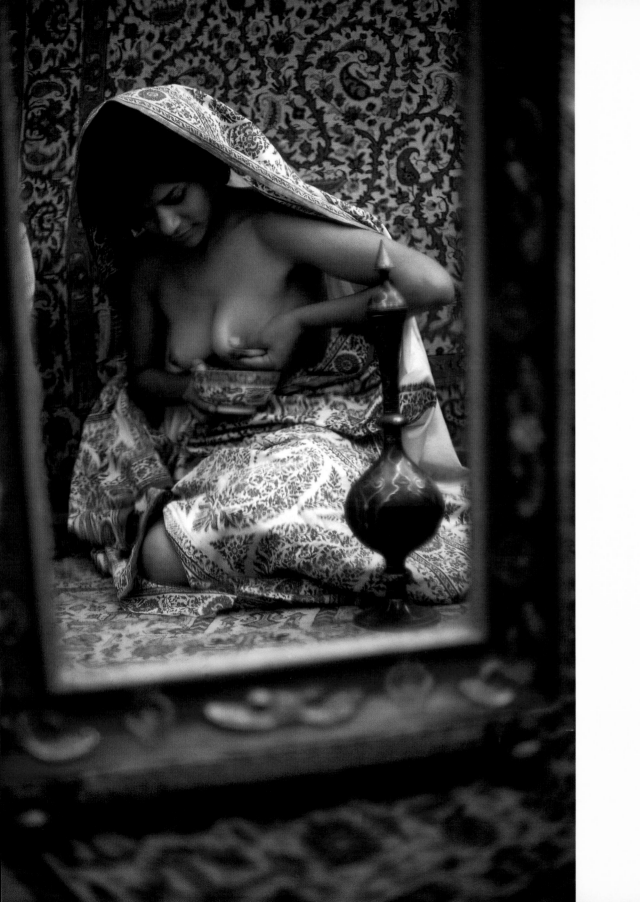

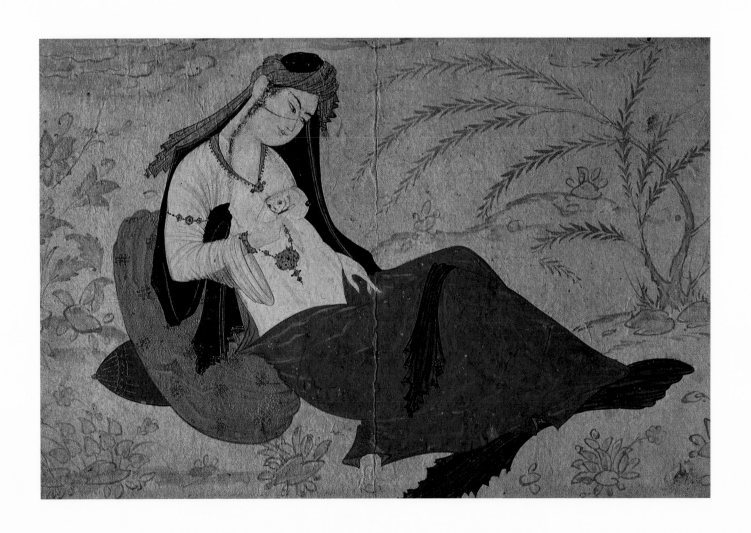

233

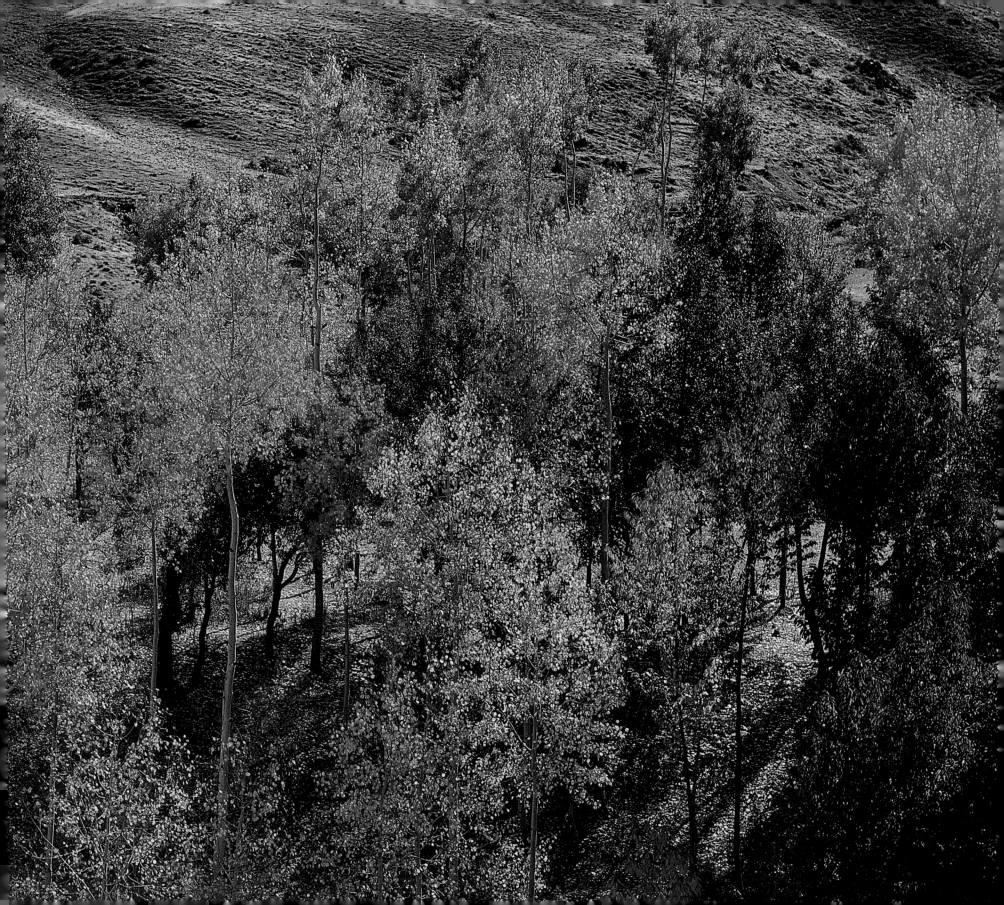

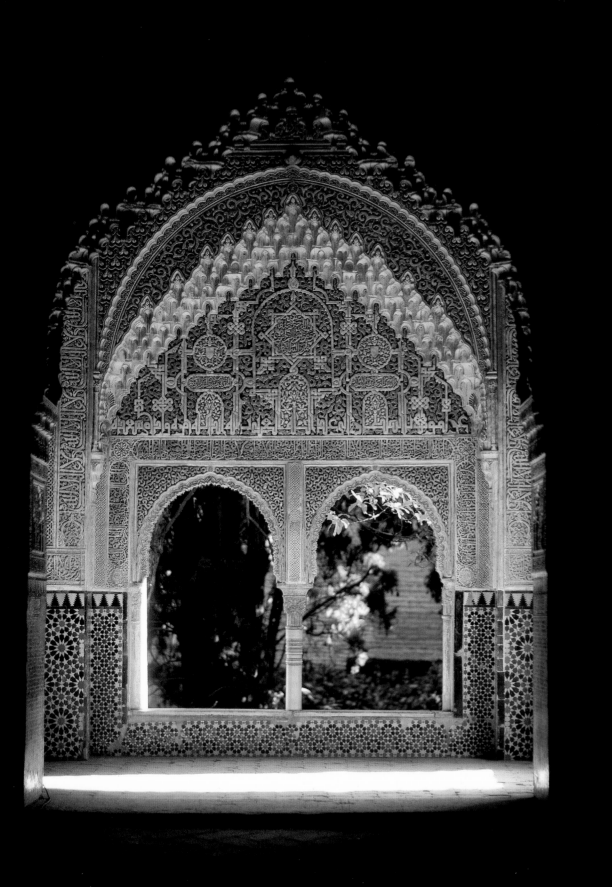

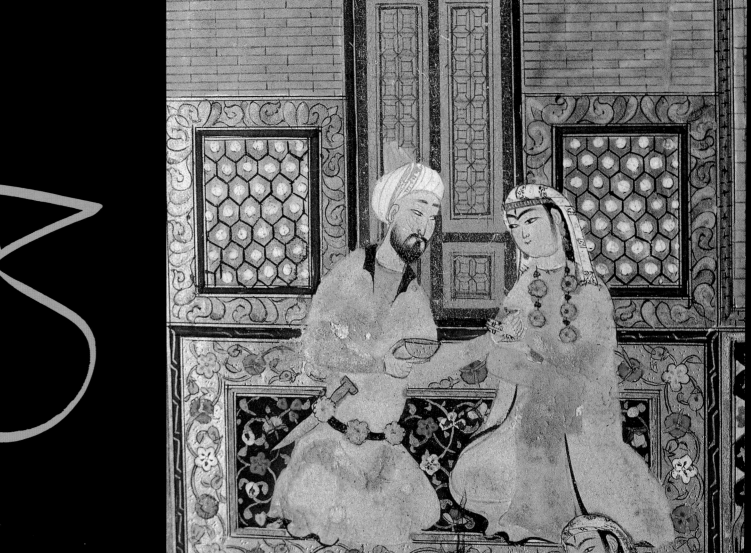

Captions

Numbers indicate page numbers.

Endpapers, front
Script of the famous Karahisari *basmalah*. Istanbul, Museum of Turkish and Islamic Arts.
The *basmalah* – 'Bismillahi-r-rahmani-r-rahim', 'In the name of God the Merciful, He who shows Pity' – forms the opening words of every sura, or chapter, of the Koran and is regarded as holier than any other written text. It plays a pivotal role in the daily life of Muslims and is repeated prior to any ritual act, such as washing and eating, and even before undertaking the smallest course of action.

2 and 5 Script by the Turkish master Emin Barin, twentieth century. Istanbul.
The traditional Mashallah wording – 'As God wishes'.

7 Mirror script in the shape of a bow and arrow. Ankara, Ethnographic Museum.
The letters form the word *haqq*, signifying 'truth' or 'divine reality'.

13 Script representing the name of Allah, sixteenth century. Baghdad, Haydarkhana Mosque.
Geometric Kufic style in the form of a triangle.

14 Script forming the shape of a lion. Persian art, nineteenth century.
The Arabic text runs, 'Ali son of Abu Talib, may he please almighty God.' (See caption for page 196.)

27 Script representing the name of Allah. Geometric Kufic style in the form of a square.

Chapter 1
From Arabia to China

29 Marginal decoration from an Ilkhanid Koran, fourteenth century. Tehran, Iran Bastan Museum.

30 Rainbow. Miniature taken from a *Book of Marvels* by Qazwini, 1279–80, Munich, Staatsbibliothek.
The *Marvels of Creation* was the classic popular scientific work of the Islamic Middle Ages.

31 Rainbow at Gilgit, northern Pakistan, June 1974.
In the majority of traditions, the rainbow symbolizes the union of heaven and earth. An intermediary linked with the rain, it heralds the descent of the celestial influences to the earthly domain.

32 Fortress of Alep, Syria, June 1975.
The fortress is regarded as one of the highpoints of Islamic military architecture.

33 City of Alep and its fortress. Miniature taken from a Turkish manuscript, sixteenth century. Istanbul, University Library.
Description by Matraki of Sultan Soliman the Magnificent's military campaigns in the two Iraqs.

Script representing the name of Allah, seventeenth century. Shah Daulat Mausoleum, Maner, India.

34 Al-Aqsa Mosque and the Dome of the Rock in Jerusalem. Miniature, nineteenth century. Cairo, National Library.

35 General view of Jerusalem taken from the Mount of Olives, February 2000.
The Dome of the Rock (just right of centre) is lit up by the first rays of the rising sun and to the left of this is the al-Aqsa Mosque. In the Koran, Jerusalem is called the *masjid al'aqsa*, the 'distant mosque'.

36 Script representing the name Ali, nineteenth century. Mahan, Kerman province, Iran.
Persian tile decorated with the name Ali, written twice, in the form of a ship.

37 Portrait of an inhabitant of Sind province, Pakistan, April 1986.

38 Donkey driver on a stone bridge, Badakhshan, Afghanistan, January 1971.
The bridge spans the River Kokcha in the vicinity of Faizabad.

39 The Turkish town of Amasya, miniature from a travel book, nineteenth century. Istanbul, Millet Library.
This picturesque Anatolian town is situated on the sides of a gorge with the Yesil Irmak river flowing at its foot

and, jutting above it, a spit of rock is crowned with the ruins of an ancient citadel.

40 The Persian Gulf. Map taken from a work entitled *Travels and Kingdoms* by the Arabic geographer Abu Ishaq-al-Istakhri, fifteenth century. Istanbul, Topkapi Museum Library.

40–41 The Dhow Port, Bombay, October 1966. Driven by the wind, some of these small craft still travel between the shores of India and Arabia during the monsoon season.

42 Arabic dhow. Arabic miniature taken from the *Maqamat* (*Playful Meetings* or *Stories*) by Al-Hariri, Iraq, thirteenth century. St Petersburg, Institute of Oriental Studies.
These stories are one of the great monuments of Arabic literature. The name of their author, Al-Hariri de Bassora (1054–1122), is known to every Arabic schoolchild, and at one time children were regularly obliged to learn sections of his narrative by heart. The stories, which over the centuries have spawned extensive copies, commentaries and illustrations, relate the adventures of two central characters who spend their time locked in verbal battles with one another.

43 Construction of a dhow, Beypore, near Calicut, Kerala, India, March 1994.
The small town of Beypore is situated on the Malabar Coast, not far from the beach where the Portuguese navigator Vasco da Gama disembarked in 1498. Beypore's are the only shipyards where dhows are still built. These traditional vessels are made from teak and tend to be commissioned by wealthy shipowners from the Emirates.

44 The crossing of the Indus. Detail from a Mogul miniature taken from a *Book of Babur*, sixteenth century. Delhi, National Museum.
In 1526 Babur founded the Muslim dynasty of Indian Emperors known as the Moguls. The crossing in question was undertaken by Babur's army.

45 Raft, Nangarhar province, Afghanistan, January 1978.
Crossing the River Kunar. In the absence of a bridge, river crossings depend on primitive rafts made of logs and branches supported by skins of cowhide filled with air.

46 Script representing the polite form of words Salaman 'alayka ('Salvation upon you') in the Nishapur Kufic style, Iran.

46–47 Camel driver, Afghan Pamirs, January 1971. Kirghiz camel driver leading his camels over this large mountain system, known as the Roof of the World.

48 Encampment of Kirghiz yurts, Afghan Pamirs, January 1971.
The yurt, a circular felt tent, is used by all the Turkic-speaking peoples of central Asia.

49 Yurts. Detail from a Persian miniature taken from a *Book of Kings* by the epic Persian poet Firdausi (pen name of Abul Qasim Mansur), sixteenth century. Istanbul, Museum of Turkish and Islamic Arts.

50 Nomad tending his fire. Detail from a miniature by Siyah Qalem taken from the *Album of the Conqueror*, fifteenth century. Istanbul, Topkapi Museum Library.

51 Turkoman camel driver preparing his meal, Tashqurghan, Afghanistan, March 1968.

52 Camel resting. Arabic miniature taken from the *Maqamat* (*Playful Meetings* or *Stories*) and executed in Iraq by Al-Hariri, thirteenth century. Paris, Bibliothèque Nationale de France.

53 Goods being loaded on to a camel, Daulatabad, Balkh province, Afghanistan, February 1973.

54 Woman in a palanquin. Detail from a Persian miniature taken from a Timurid manuscript by Jami, sixteenth century. Kabul Library.

55 Kashgai nomad women, Fars province, Iran, September 1970.
During the autumn migration these women travel by camel.

56 Bedouins in their tent. Detail from an Arabic miniature taken from the *Maqamat* by Al-Hariri, thirteenth century. St Petersburg, Institute of Oriental Studies.

57 Pashto tent, Darzab district, near Sar-i-Pul, Afghanistan, September 1978. The Bedouins of Arabia use the same kind of brown goatskin tent.

58 Caravan stop, Mazar-i-Sherif, Afghanistan, February 1968. Caravan in front of the Noble Tomb of Ali, where the Prophet Mohammed's son-in-law is said to be buried. The caravan is loaded with wood.

59 Medieval village. Arabic miniature taken from the *Maqamat* by Al-Hariri, thirteenth century. Paris, Bibliothèque Nationale de France.

60 Man with a bird on his shoulder. Detail of a marginal decoration on a Mogul miniature, seventeenth century. Paris, Musée Guimet.

61 Blind man, Yazd-e-Khast, Fars province, Iran, July 1964.

62 Palm plantation at sunset, Marrakesh, Morocco, April 1975.

63 The Arabic letter 'K' (Kaf) in Thuluth characters.

Palm trees. Detail from a Persian miniature taken from the *Five Treasures* by Nizami showing Leila and Majnun in an oasis, 1462–77. Istanbul, Topkapi Museum Library.

Chapter 2
Souks and Bazaars

65 Decorative motif in a margin of a Seljuk Koran, twelfth century. Ankara, Ethnographic Museum.

66 Sawyers. Miniature taken from an Indo-Persian manuscript about trades and professions in Kashmir, nineteenth century. London, India Office Library.

Script representing the name of the Prophet Mohammed. Iran, Ispahan Mosque.
Geometric Kufic style in the form of a cross.

67 Sawyers, Shimshal valley, Hunza, Pakistan, May 1974.

68 Jeweller. Miniature taken from an Indo-Persian manuscript about trades and professions in Kashmir, nineteenth century. London, India Office Library.

69 Portrait of a master craftsman, Tashqurghan bazaar, Afghanistan, May 1967.

70 Butcher, Sar-i-Pul, Afghan Turkestan, May 1967.

This butcher is also a restaurant owner. Turkoman kebabs – chunks of lamb roasted in its own grease – are widely regarded as a delicacy, even in the Afghan capital Kabul.

71 Butcher. Detail from a Mogul miniature taken from a *Book of Babur*, sixteenth century. Delhi, National Museum.

72 Carder. Miniature taken from an Indo-Persian manuscript about trades and professions in Kashmir, nineteenth century. London, India Office Library.

73 Carder, Khost, Paktya province, Afghanistan, January 1968. The implement used in this process is a type of bow with a string made of sheep's gut, which the carder strikes with a paddle. The presence of a second bow, attached to the first at ceiling height, intensifies the vibrations and so helps to rid the cotton or wool of impurities.

74 Grinder, Tashqurghan bazaar, Afghanistan, May 1967.

Script representing the name of Allah repeated four times. Executed by Emin Barin, twentieth century, Istanbul.

75 Grinder. Miniature taken from an Indo-Persian manuscript about trades and professions in Kashmir, nineteenth century. London, IndiaOffice Library.

76 Weighing out jujubes in a caravanserai, Tashqurghan, Afghanistan, May 1967.
The Koran says of God:
'He raised the sky
he established the balance:
Do not cheat on weight;
Judge the weighing exactly;
Do not falsify the balance.'
Sura 55, 7–9

77 Weighing out almonds. Mogul miniature taken from a *Book of Babur*, sixteenth century. Delhi, National Museum.

78 Blacksmiths. Detail from a miniature taken from a *Book of Kings*, 1428. Delhi, National Museum.

79 Blacksmiths, Tashqurghan bazaar, Afghanistan, November 1978.

80 Dressmaker, Fez, Morocco, April 1975.

81 Embroiderer. Miniature taken from an Indo-Persian manuscript about trades and professions in Kashmir, nineteenth century. London, India Office Library.

Embroidered script representing the Shahada or Muslim profession of faith – 'There are no other gods but Allah, and Mohammed is the messenger of Allah'.
The silk cloth covers the tomb of a saint at Sehwan the Noble, Sind province, Pakistan.

82 Dyer. Miniature taken from an Indo-Persian manuscript about trades and professions in Kashmir, nineteenth century. London, India Office Library.

83 Dyer in the souks, of Marrakesh, Morocco, June 1958.

84 Carpet weaver. Miniature taken from an Indo-Persian manuscript about trades and professions in Kashmir, nineteenth century. London, India Office Library.

Mirror scripts of two of Allah's names – 'Oh the Living One' and 'Oh the Immutable One'. Istanbul, Museum of Turkish and Islamic Arts.
The composition recalls a dervish's headdress.

85 Weaver, Nasarpur village, to the east of Bhitshah, Sind province, Pakistan, September 1981.

Chapter 3
Recreation

87 Decorative motif taken from an Ilkhanid Koran, fourteenth century. Tehran, Iran Bastan Museum.

88 Dancer. Miniature from the Siyah Qalem school, fifteenth century. Istanbul, Topkapi Museum Library.

89 Snow juggler, village near Ghazni, Afghanistan, December 1964.
A Pashto juggler executes a frenzied dance accompanied by his son on a large drum known as a *dhol*.

90 Flute player. Detail from a miniature from the Tabriz school, sixteenth century. Istanbul, Topkapi Museum Library.

91 Turkoman singer and flautist, Daulatabad, Balkh province, Afghanistan, June 1967.

92 Brochette seller. Marginal detail from a Mogul miniature, seventeenth century. Boston, Fine Arts Museum.

93 Brochette seller, Pul-i-Khumri, Afghanistan, November 1978.

94 Wrestlers. Detail from a Mogul miniature taken from a *Book of Babur*, sixteenth century. Delhi, National Museum.

95 Turkish wrestlers, Eyüp quarter, Istanbul, April 1964.
This type of wrestling is called *yagli güres*, 'oil wrestling', because the competitors smear themselves with oil from head to foot to make their skin slippery and harder to grasp.

96 Bloodletting, Morocco, June 1958.
A barber bleeds his client in a country souk.

97 Doctor bleeding a patient. Detail from an Arabic miniature taken from the *Maqamat* by Al-Hariri, thirteenth century. St Petersburg, Institute of Oriental Studies.

Script composed of two Arabic letters, Lam and Alif, known as 'Lam Alif'.

98 Tavern scene. Detail from a Persian miniature, sixteenth century. Paris, Musée du Louvre.

99 Tea house, Aqtcha, Afghan Turkestan, May 1967.

100 Lute-maker, Fez, Morocco, November 1975.
The late Mohammed Ben Harbit was the last lute-maker in a line dating back to the kingdom of Andalusia.

101 Lute player. Detail from a Turkish miniature taken from the *Book of Feasts* by Vehbi, eighteenth century. Istanbul, Topkapi Museum Library.

102 Conversation. Detail from a Persian miniature taken from the *Rosary of the Pious* by Jami, sixteenth century. Cairo, National Library.

103 Conversation, Fez, Morocco, October 1975.

104 Itinerant barber, Ispahan, Iran, June 1968.
The twenty-ninth story in *The Thousand and One Nights* is called 'The Young Man with a Limp and the Barber of Baghdad'. An extract reads, 'I regard all professions as precious necklaces, but this barber is the finest pearl on the necklace. He has more wisdom and greatness of soul than the wisest and greatest of men; and his hand rests upon the heads of kings.'

105 Barber trimming a dignitary's beard. Mogul miniature, eighteenth century. Bombay, Prince of Wales Museum.

Persian-style script representing the name Mohammed, Ahmedabad Mosque, India.

106 Fruit seller. Miniature taken from the *Five Treasures* by Nizami, fifteenth century. Istanbul, Topkapi Museum Library.

107 Fruit seller, Hazarajat, Afghanistan, October 1964.

108 Falconer, Tauz Bulak village, Afghan Turkestan, January 1973.
Master Djoura Eshan and his falcon.

109 Falconer. Persian miniature, Ispahan school, seventeenth century. Paris, Musée du Louvre.

110 Breaking in a horse. Miniature by Siyah Qalem taken from the *Album of the Conqueror*, sixteenth century. Istanbul, Topkapi Museum Library.

111 Breaking in a horse, Andkhoy region, Afghan Turkestan, February 1973.
Traditional training in preparation for a *bozkashi* competition (see caption for pages 112-13).

112 Turco-Mongol horseman shooting an arrow. Persian miniature, fifteenth century. Istanbul, Topkapi Museum Library.

112–13 The riders' game, Daulatabad, Balkh province, Afghanistan, February 1968. The *bozkashi* – meaning literally 'catch goat' – is the favourite game of the horsemen of the steppes and involves a fierce battle for the remains of a decapitated animal, originally a goat (*boz*), though these days a calf is usually substituted. The animal's carcass is placed in the middle of a circle drawn with quicklime and known as the *hallal* or 'justice circle'. The players, ten or more (up to an indefinite number), gather at the edge of the circle and when the referee gives the signal they launch themselves upon the decapitated beast. To win a point, a rider must take possession of the carcass and circle with it round a pole, planted some way off on the steppe, before returning to deposit the carcass in the 'justice circle'.

Chapter 4
Work and Days

115 Page of decorative mirror script taken from a muraqqa (composite album) known as the Album of Shah Tahmasp. Istanbul, University Library.
This mystical knot translates as 'I have surrendered myself to my Creator'.

116 Ploughing scene. Detail from a Persian drawing with highlighted areas in brown,

silver and black, sixteenth century. Paris, Musée du Louvre.

117 Early-morning ploughing scene, Ranipur region, Sind province, Pakistan, December 1982.

118 Villager with his sheep. Detail from a Mogul miniature taken from a *Book of Babur*, sixteenth century. Delhi, National Museum.

119 Peasant pulling his sheep through a bed of rushes, Aïbak region, Afghanistan, September 1964.

120 Negotiation, Daulatabad, Balkh province, Afghanistan, February 1973.
A goat dealer bargains with a customer in the cattle market.

121 Man with a goat. Persian miniature, fifteenth century. Istanbul, Topkapi Museum Library.

Script representing the traditional Muslim protective words, 'I take refuge in God the Magnificent against Satan the stoned one'.

122 Man in a coat, Tashqurghan, Afghanistan, April 1968.
Mahmad Niyaz (the man with a rose, page 149) stands in front of his covered stall in the bazaar. He made saddles for horses and donkeys.

123 Man in a coat. Detail from a miniature by Siyah Qalem taken from the *Album of the Conqueror*. Istanbul, Topkapi Museum Library.

124 The patriarch Abraham offering hospitality to a fire-worshipper. Persian miniature taken from a *Bustan* ('Orchard') by Saadi executed during the time of the Delhi sultanate at Mandu, India, fifteenth century. Delhi, National Museum.

124–25 Tea house, Herat, Afghanistan, May 1971.
Samawat (from the Russian *samovar*) is the Afghan name for a 'tea house', although the Persian word *tchaï khana* is also used. The two copper samovars are constantly in use, tea being served from one while water is boiled in the other. The tea is served in magnificent china bowls and there is a choice between warming black tea from India and refreshing green tea from China. Each customer has his own individual teapot and – unless he asks for his tea without sugar – receives a saucer containing either caster sugar or *noqqoul*, sugar sweets in the shape of mulberries.

126 Conversation. Miniature from the Siyah Qalem school, fifteenth century. Istanbul, Topkapi Museum Library.

127 Two men deep in conversation, Mazar-i-Sherif, Afghanistan, March 1968.

128 Preparing a meal. Detail from a Persian miniature taken from a manuscript entitled *The Ball and Mallet*, sixteenth century. St Petersburg, Institute of Oriental Studies.

128–29 Preparations for a feast, Aqtcha region, Afghanistan, February 1973.
On feast days open-air kitchens are set up and the entire village is fed at the expense of the wealthiest householders.

130 Donkey driver on the steppes, Balkh province, Afghanistan, September 1964.

131 Nasreddine Hodja. Turkish miniature, eighteenth century. Istanbul, Topkapi Museum Library.
This character from Turkish folklore is linked with the qualities of humour and wisdom and represents popular common sense. He is said to have lived in Anatolia in the fifteenth century, since which time the humorous stories associated with him have spread from the Mediterranean to central Asia.

132 Partridges. Persian miniature, seventeenth century. Istanbul, Topkapi Museum Library.

132–33 Partridge fighting, Tashqurghan, Afghanistan, May 1967.
The Afghan partridge – *kauk* in Persian – is trained as a fighting bird and captured exclusively for this purpose. It is fed on wheat during the winter and on almonds, ricot kernels and raisins in the summer, and

traditional techniques are used to strengthen its claws, wings and beak. Contests take place in the spring at dawn, before the sun is high. Enthusiasts gather in a large circle and two referees, one for each competitor, step into the centre of this simple arena and set the birds down. The two birds launch themselves at one another and begin fighting with great skill and courage, pecking and battering each other, and providing a splendid spectacle that never ends in death. While they are fighting their owners and the spectators place bets on the likely winner.

Chapter 5
Surrendering to God

151 Wooden door, Fez, Morocco, April 1975. Medersa Bu Inaniya, fourteenth century.

152 Handbarrow. Detail from a miniature by Behzad (*Construction of the Castle of Khawarnaq*), executed at Herat, taken from the *Five Treasures* by Nizami, 1494. London, British Museum.

153 Labourers, Mazar-i-Sherif, Afghanistan, February 1968. Restoration of the Noble Tomb of Ali.

154 The call to prayer. Exterior wall painting, Summer Palace of Sultan Tippu. Srirangapatnam, Karnataka, India.

155 Script representing the Shahada or Muslim profession of faith, 'There are no other gods but Allah, and Mohammed is the messenger of Allah', fourteenth century. Pakistan, Punjab, Multan, Mausoleum of Shah Rukh-i-Alam.

Minaret, Afghan Turkestan, March 1973. Muezzin calling the faithful to prayer from the top of the minaret of a small country mosque.

156 Collective worship. Mogul miniature from the *Clive Album*, eighteenth century. London, Victoria and Albert Museum. A prince conducts prayers in a mosque.

157 Bowing worshipper, Fez, Morocco, April 1975. Prayer scene in the Karaouine Mosque.

158 Above: Chinese-style script representing the Shahada or Muslim profession of faith inscribed on a medallion: 'There are no other gods but Allah, and Mohammed is the messenger of Allah'. China, Hebei province, Canghzou Mosque. Below: Chinese-style script of the *basmalah*.

158-59 Prayer for the dead, Linxia, Gansu province, China, January 1997. Members of the Chinese Muslim community face the coffin of an important religious dignitary for a funeral service in the mosque's courtyard.

160 Invocation. Detail from a Turkish miniature, eighteenth century. Istanbul, Museum of Turkish and Islamic Arts.

161 Asking for God's blessing, Dargah d'Ajmer, Rajasthan, India, August 1966. Young Muslim praying in the courtyard of the Shah Jahan Mosque.

162 The Mosque of Sultan Selim known as the Selimiye. Turkish miniature taken from a *Book of Kings* about Sultan Selim (1566–74), sixteenth century. Istanbul, Topkapi Museum Library.

162-63 The Selimiye, Edirne, Turkey, June 1975. The Selimiye is the masterwork of the architect Sinan and represents the highpoint of Ottoman art. In his memoirs the great Turkish architect, then aged 80, writes, 'Architects of any standing in Christian countries regard themselves as manifestly superior to Muslims since to this day the latter have never succeeded in building anything to compare with the dome of Hagia Sophia. This assurance has been for me a source of profound pain. However, with the help of Almighty God and the encouragement of Sultan Selim, I have succeeded in constructing for his mosque a dome surpassing Hagia Sophia's by four cubits in diameter and six cubits in height.'

164 Ablutions. Detail from a miniature by Behzad illustrating a *Bustan* ('Orchard') by Saadi, fifteenth century. Cairo, National Library.

165 Washing fountain, Bursa, Turkey, September 1976. Before each of the five daily prayers, a Muslim should purify himself by washing.

166 Address in a mosque. Arabic miniature taken from the *Maqamat* (*Playful Meetings* or *Stories*) and executed in Iraq by Al-Hariri, thirteenth century. Paris, Bibliothèque Nationale de France.

167 Friday sermon, Balkh province, Afghanistan, May 1971. Abu Nasr Parsa Mosque, fifteenth century. The Imam (prayer leader) delivers a sermon every Friday from the *mimbar* or 'preaching seat'.

168 Dervish telling his beads. Persian miniature, fifteenth century. Istanbul, Topkapi Museum Library.

Script representing the Koranic wording *Allahou akbar*, 'God is Great'.

169 Invocation, Ajmer, Rajasthan, India, March 1985.
Dervish invoking the name of God.
The man is telling his rosary (*tesbeh*), which is composed of one hundred beads corresponding to the name of Allah and his ninety-nine attributes or Beautiful Names.

170 Dome of the Shah Nimatollah Mausoleum, Mahan, south of Kerman, Iran, February 1975.
This famous pilgrimage site, restored in the seventeenth century and again in the nineteenth, houses the tomb of a fifteenth-century saint. The facing in blue ceramic tiles with its pattern of stars (seventeenth century) recalls the story of the miraculous spider's web that was woven across the entrance to the cave in which the Prophet took refuge with Abu Bakr, so saving him from his pursuers.

171 Persian cupola. Detail from a Persian miniature from the Tabriz school, Sefevid era, taken from a manuscript dated 1502 telling the story of Jamal and Jalal by Mohammed Asafi. Sweden, Uppsala University Library.

172 Picking roses. Arabic miniature taken from a Syrian manuscript, *The Disclosure of Secrets*, by Ibn Ghanim al Maqdisi, fourteenth century, Istanbul, Soliman Mosque Library.

Rose petals being picked before being distilled and turned into rose water.

173 Man making rose garlands, Ajmer, Rajasthan, India, November 1982.
Believers place these garlands on a saint's tomb when they wish to receive his blessing; on the anniversary of the saint's death his tomb resembles a mountain of roses.

174 Thistles, Tigray province, Ethiopia, summer 1962.

174–75 Mirror script representing the name of Allah and the name Huwwa ('He'). Turkey, Bursa, Great Mosque.

175 Floral motif. Detail from a decorative motif on ceramic, taken from the ceiling of the Büyük Karatay Medersa (1251). Konya, Turkey.
These stylized flowers are a fine example of nature transposed into art.

Chapter 6
The Memory of God

177 Illuminated page of a mirror script in the form of a knot taken from a fifteenth-century manuscript. Poetry anthology by Jami. Turkey, Konya, Mevlana Museum.

178 Whirling dervish, November 1986.
The Mevlevis, a Muslim order of ascetics founded in the thirteenth century by Jalaladine Rumi at Konya in Turkey, are known in the West as 'whirling dervishes'.

The photograph was taken in the Mevlevi *tekke*, or monastery, of Usküdar, located on the Asiatic shore of the Bosphorus, facing the city of Istanbul.

179 Cupola, central Anatolia, Turkey, September 1976. The interior of the dome of the Great Mosque of the Old Malatya (1247).
The design is strongly reminiscent of the dervishes' famous whirling dance; the secrets and inspiration of the dance seem integral to the dome's conception. The arrangement, using a mixture of bricks – some plain and unadorned, others glazed with turquoise –

195 produces a dynamic impression of movement and an irresistible urge to dance. In the light of this, these verses by Rumi in the *Rubáiyát* make perfect sense:
'O day, arise! Atoms are dancing,
Souls are dancing, in transports of ecstacy:
Where the dance leads, I will whisper in
 your ear.
Every atom, in the air and in the desert,
Is like a madman, I tell you.
Every atom, whether sad or joyful,
Is in love with this Sun that cannot be
 spoken of.'
The central motif represents a six-branched star with the name of the Prophet Mohammed written along its sides.

180 Mevlevi script in the form of a flute player. Ankara, Ethnological Museum.
The dervishes' dance begins with the recitation of the famous prologue to the

Mathnawi, in which the ney, or 'reed flute', appears as a symbol of the mystic's soul lamenting its alienation from the world of the spirit. The giant letters of this calligraphic composition on the walls of the prayer room in the Great Mosque of Bursa in Turkey, correspond to the Arabic letter Waou, which is also the conjunction 'and'. The letter is written here four times in Thuluth characters of diminishing size. The text in small Kufic characters inserted between these 'ands' corresponds to sura 63 (the 'Sura of the Hypocrites'), verse 8, which reads, 'And glory belongs to God and to his apostles and to the true believers, and hypocrites know it not'.

181 Ney player in the garden of the Mevlevi monastery of Galata in Istanbul.
The flute is 'the confidante of him who is separated from the Friend; its notes rend our veils' (Rumi, *Mathnawi*, I, ii s).

182 Dervish. Detail from a miniature by Siyah Qalem taken from the *Album of the Conqueror*, fifteenth century. Istanbul, Topkapi Museum Library.

183 Dervish looking towards the camera, Ajmer, Rajasthan, India, April 1984.

184 Man with a sad look. Detail from a Persian miniature by Farrukh Beg, 1610–50. London, Victoria and Albert Museum.

184–85 Praising God, Mazar-i-Sherif, Afghanistan, November 1978.

Dervish on the steppe making the traditional gesture of thanks.

186 Two dervishes. Detail from a Persian miniature taken from a *Bustan* ('Orchard') by Saadi, fifteenth century, painted during the time of the Delhi sultanate at Mandu (M.P.) in India. Delhi, National Museum.

187 Dervish with an axe, Mazar-i-Sherif, Afghanistan, February 1968.
The axe serves symbolically to separate error from truth.

188 Two men embracing, Ajmer, Rajasthan, India, March 1985.
Courtyard of the Shah Jahan Mosque.

'Lam Alif' script (see caption for page 97).

189 Embrace. Detail from a Persian miniature taken from a *Book of Kings*, sixteenth century. Istanbul, Museum of Turkish and Islamic Arts.

190 Angels and birds. Detail from a miniature taken from a *Book of Kings* by Firdausi, fifteenth century. Istanbul, Topkapi Museum Library.

191 The blue door, Mazar-i-Sherif, Afghanistan, November 1978.
Mazar-i-Sherif Sanctuary.

192 Empty landscape, Wardak province, Afghanistan, September 1978.

This photograph was taken from the Ghujarah Pass in the golden light of late afternoon in autumn. The two figures climbing the mountain give an idea of the scale.

192–93 Basmalah script in a series of loops. Istanbul, Soliman Mosque Library.

193 Abundance, Istanbul, Museum of Turkish and Islamic Arts.
Illustrating a poetry anthology of 1398, this Persian miniature evokes mystic gardens.

194, The tree of life, exterior and interior. Plant motif on a marble window in the Little Mosque of Sidi Sayed (1572) in the heart of Ahmedabad (India). Photographed from the outside and the inside, these pictures illustrate two of the divine names al Batin ('inside') and al Zahir ('outside').

196 Lion fighting a dragon, February 1975. Calligraphic painting, eighteenth century. Ankara, Ethnographic Museum.
Ali, the son-in-law of the Prophet, is known in Iran as the Lion of God, which allegedly kills the Dragon, symbol of concupiscence. Here the two animals form a Persian distich taken from the *Diwan* by Farid-oud-Din Attar (who died in the thirteenth century), which reads, 'It is not given to each to slay the spirit of evil within the body. To cut the serpent into pieces in the cradle is the work of the Lion.'

223 Afghan woman dressed in blue, Herat, Afghanistan, June 1967.
'And pure, beautiful ones, the like of the hidden pearls' (Koran, sura LVI, verse 22).

224 Uzbek woman with turquoise, Sar-i-Pul, Afghan Turkestan, May 1967.

225 Woman with a flower. Persian miniature, seventeenth century. Afghanistan, Kabul Museum.

226 Meditation. Persian miniature taken from a *Bustan* ('Orchard') by Saadi, fifteenth century, painted during the time of the Delhi sultanate at Mandu (M.P.) in India. Delhi, National Museum.

226–27 The Taj Mahal, Agra, India, December 1981.

228 Veil, Hyderabad, Deccan, India, January 1984.
Muslim woman in the old town of Hyderabad.

229 Lovers. Mogul miniature, eighteenth century. St Petersburg, Institute of Oriental Studies.

230 Peacock, Jaipur, Rajasthan, India, July 1987.
Temple of Jarkhand.

231 Script representing the name of Allah in Thuluth characters, Ottoman era.

Istanbul, Museum of Turkish and Islamic Arts.

Peacocks. Mogul miniature by Mansur, 1610. Boston, Sackler Museum.

232 Intimate moment, Tehran, Iran, June 1964.
Scene in a mirror showing a woman squeezing her breast to extract milk.

233 Woman extracting milk from her breast. Persian miniature, sixteenth century. Istanbul, Topkapi Museum Library.

234 Oasis. Miniature by Siyah Qalem taken from the *Album of the Conqueror*. Istanbul, Topkapi Museum Library.

235 Autumn colours, Lake Van region, eastern Anatolia, Turkey, October 1976.

236 Alhambra Palace, Granada, Spain, April 1975.
The mirador of Lindaraja 'demonstrates how stone can be transformed into a vibration of light: the lambrequins over the archways, the friezes, the delicacy of the columns, which seems to belie all notion of weight, the brilliancy of the green ceramic-tiled roofs and even the jets in the fountain – everything contributes to the same impression' (Titus Burckhardt, *Art of Islam*).

237 In poetry, this letter, taken from a composite album, represents the curl

of a hair of a loved one. Istanbul, University Library.

The Princess of China in the Sandalwood Pavilion. Detail from a Persian miniature taken from the *Pavilion of the Seven Princesses* by Nizami, sixteenth century. Private collection.

238–39 Script of a Turkish basmalah in Thuluth characters, Ottoman era. Istanbul, Museum of Turkish and Islamic Arts (see caption for page 139).

Endpapers, back
Script that appears repeatedly throughout the Alhambra Palace in Granada – 'No victor but Allah'.

Acknowledgments

L'Orient dans un miroir was first published twenty-three years ago by Hachette Réalités thanks to the enthusiasm and dynamism of a series editor by the name of Hervé de La Martinière, who believed in the book's potential interest. The first edition has long been out of print, and this new version is double the original in length since we have continued to travel and to pursue our research while deepening and extending our approach to the subject matter. We are pleased to have this opportunity to thank Hervé de La Martinière – who has since founded his own publishing house but remains faithful to his first instinct – most warmly for his confidence. This book is also the mirror of a friendship.

We extend our thanks to those people who, over the last forty years, have helped us to give concrete form to our crazy mirror project. There are too many of them to mention individually, but they include administrators, diplomats, scholars and Islamic experts. We would like to thank most particularly the librarians and museum curators, who have collaborated with us in invaluable ways, the collectors and artists, the artisans, traders and shopkeepers, nomad camel drivers, dervishes, modern-day troubadours and all those who travel along the great road of the Orient.

Translated from the French *L'Orient dans un miroir* by Ruth Sharman
and Robert Vollrath

First published in the United Kingdom in 2003 by Thames & Hudson Ltd,
181A High Holborn, London WC1V 7QX

www.thamesandhudson.com

British Library Cataloguing-in-Publication Data
A catalogue record for this book is available from the British Library

ISBN 0-500-51154-3

Printed and bound in France